IT'S COMPLICATED

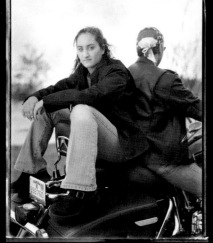 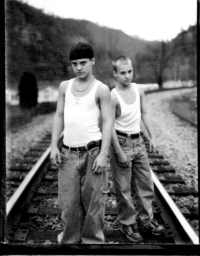 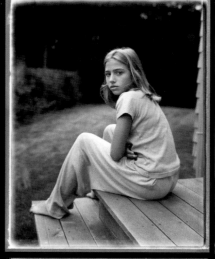 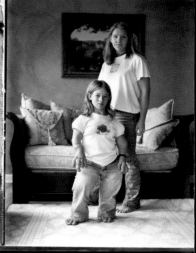

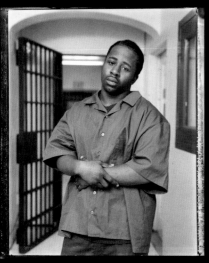 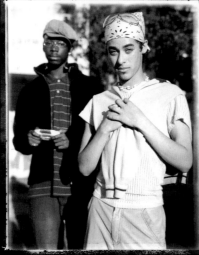 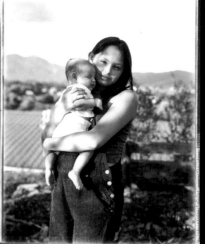 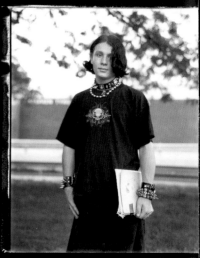

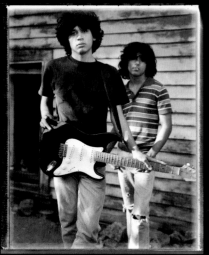 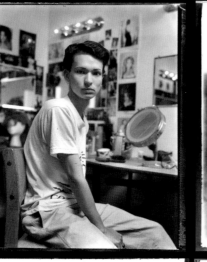 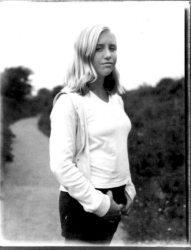 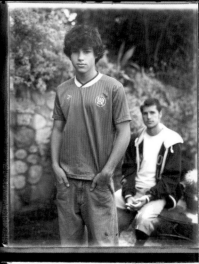

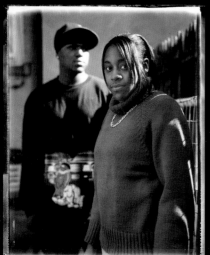 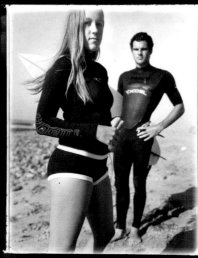 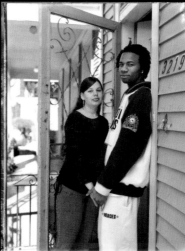 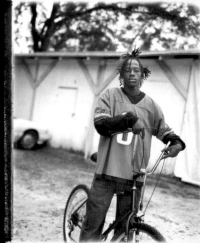

THE AMERICAN TEENAGER

ROBIN BOWMAN

Portraits + Interviews

Afterword by Robert Coles

umbrage_{editions}

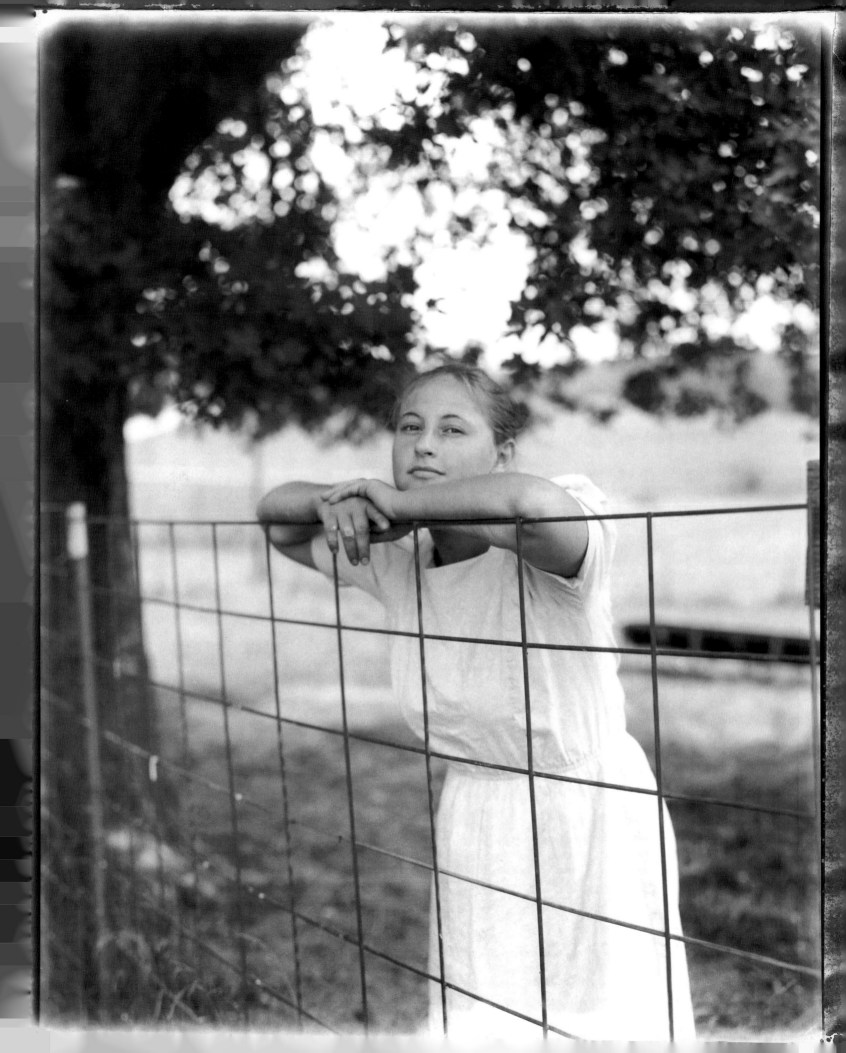

sreyan sva-dharmo vigunah

para-dharmat sv-anusthitat

sva-dharme nidhanam sreyah

para-dharma bhayavahah

Better is one's own duty imperfectly carried out than
following perfectly the law of another.
Better is death in the fulfillment of one's own law
for to follow another's law is perilous.

–The Bhagavad-Gita, Chapter 3, Verse 35–

Know your part, know and be yourself,
know your gifts and talents. Don't get stuck in comparisons.
The tiny flower harmonizes with the huge tree.
Beauty manifests in multiplicity: hence uniqueness.

–Ruth Lauer-Manenti–

I dedicate this book with love to my mother Phoebe Bowman.

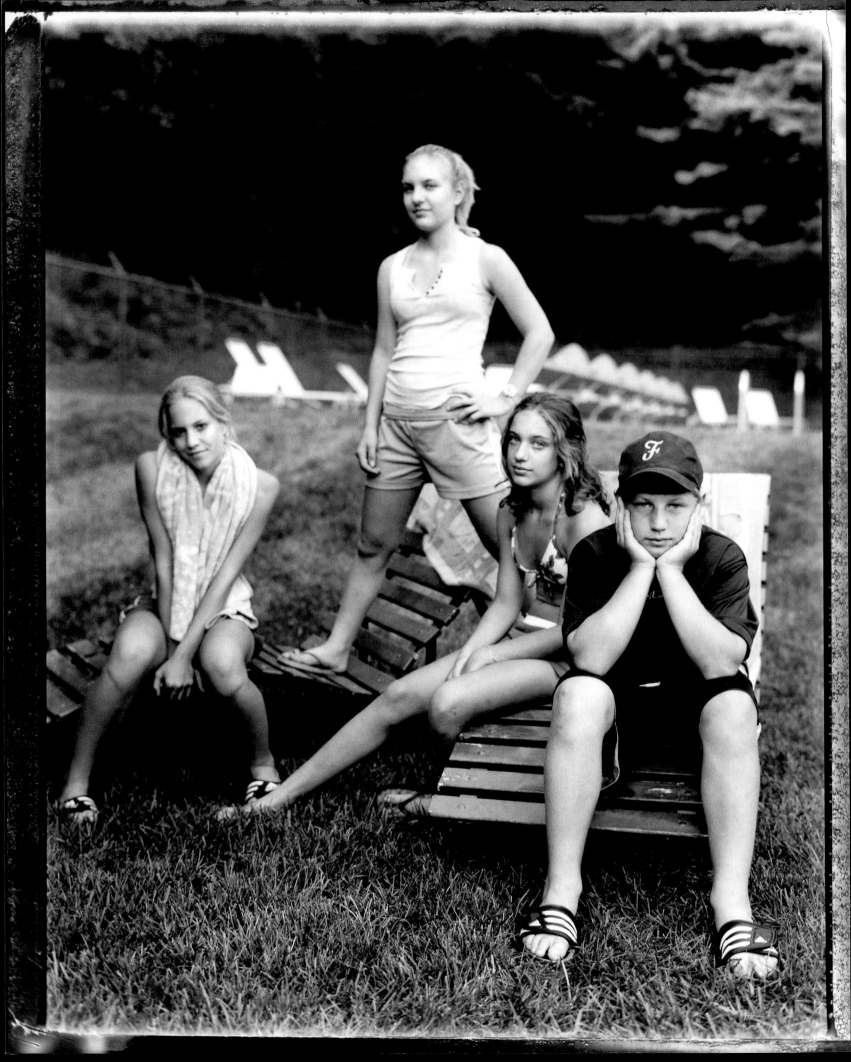

ARTIST STATEMENT

This story begins in the summer of 2001 when a friend invited me to spend a couple of weeks with her extended family in a remote cabin in Canada. Seeking an escape from humid New York, I gladly accepted. The cabin was filled with teenagers, an age group that didn't even exist in my world in New York at the time, but I was immediately caught up in the excitement, openness, vulnerability, and idealism that infuse so many young people, regardless of circumstance. I was riveted by them and spent most of my two weeks there in the woods taking photos of these young people and learning the stories of their lives.

I usually travel with more cameras than one would ever need, but for some reason, on this trip, I had brought only an old-fashioned Polaroid 110B. Using this camera was a whole new approach for me and the results were inspiring. I felt deeply the photographs I brought back with me had managed to capture the intensity and complexity of these young people. While I had not yet fully conceptualized the project that would become this book, it was clear that I had encountered something–a shooting style and subject matter that I had to pursue.

I traveled the streets and subways of New York City looking for more teens to photograph. In the still pre-digital age, the Polaroid's ability to provide instantaneous footage piqued young people's curiosity, and when I gave them a chance to tell their story, it was remarkably easy for me to convince them to pose for and talk to me. I started to develop my process—meet a young person, take their picture, engage them in shaping the image, and then, afterwards, find a quiet spot to ask questions and learn more about their lives.

Meeting these teenagers began to have an effect on me—I couldn't get enough. Each one was so different, so compelling, and so earnest. I felt that by connecting with these kids, I was growing as a human being; their stories were enriching mine.

Before long I became absorbed by the notion of discovering the "American Teenager." It became obvious that I couldn't accomplish this by staying in Brooklyn, so I decided to get in the car and go. In March of 2002 I embarked on the first of eight trips I would ultimately take over the course of four years. By the time I finished this project I had traveled 21,731 miles through most of the regions and corners of the nation, met thousands of

young men and women, and formally photographed and interviewed four-hundred nineteen of them, all of whom are represented in this book.

Once I got going, I committed to shooting this project in a particular style—one that was very different from how I was trained: photograph first, ask questions later. I'd learned that if I knew too much about my subject before I shot, the results would be more about the conclusions I'd drawn and be less about the person in front of me. I continued to use the "Polaroid method" so that the kids could immediately see the results of the photos. This engaged them in collaboration and generated trust.

I sometimes met my subjects through family, friends, and schools. But more often than not, I met them on the street and had to convince them that though I was a stranger with out-of-town plates, they could trust me, and that I was genuinely interested in what they had to say. I remain honored that these amazing young people allowed me into their lives. It is deeply important to me to do their images and stories justice in this book. I also want to emphasize that these photos were collaborative—the teenagers were able to see their images and reassess how they wanted to appear in the final shot. The process was a shared experience, one that helped foster a personal and artistic bond.

After the shoot I'd start my interview. I'd look for a quiet space and, when I could, I used my car. It helped to muffle the sound of nearby traffic and also provided an intimate space that allowed for a more intimate exchange. I asked each subject the same twenty-six questions. The text you see in the book is taken directly from these interviews.

I was not there to judge these kids or to rescue them. My intent wasn't even to definitively answer any questions, only to ask them and record the response. These young people will change and grow and, I hope, become who they want to become. What we see and hear in this book merely records a moment in time when our paths crossed.

When I started this project I had no idea that teenagers like—and in fact need—to talk about themselves. I was continually amazed at how unguarded they were. Many of those I spoke with made it clear that our conversations gave them an opportunity to be listened to in a way that is usually lacking in their lives. I've struggled tremendously with

how to represent them in this book: I do not want to gloss over the hardships and indignities that some of them have faced in their lives, yet it is equally important to me to demonstrate their resilience by recording their hopes for the future. I was deeply impressed to see both hard experience and real hope co-exist in so many of these individuals.

I also recognize that this project drew me in, in part because of my own intimate recognition of the dichotomy between the surfaces and depths of people. My own teenage portrait would have shown a blond-haired girl who looked privileged and sheltered. But if I had had the opportunity to be interviewed, I might have said something about my father's alcoholism, and abuse, and my parents' divorce, and our fractured family. I was never able to fully express my feelings about those experiences at the time. Would my life have been different if my story had been told and if the real image of my life had been taken and shared?

In the end, I want you all to know these kids as I do, and yet I know that is impossible. I can only hope these photos give you a glimpse of my serendipitous, profoundly beautiful journey. This project underscores the similarity and diversity that make up this country and this generation, and remind all of us that people are not necessarily who they appear to be. I hope it will allow families in Jamesport, Missouri to learn about what they share or don't share with families in Wayland, Massachusetts. We were each a teen once, and many of us will one day have teenagers who will become adults and our future leaders. It is undeniable that our children affect and reflect who we are as individuals and as a nation. Perhaps by coming to know our kids, adolescents on the cusp of adulthood, we can become acquainted, or reacquainted, with ourselves.

Robin Bowman

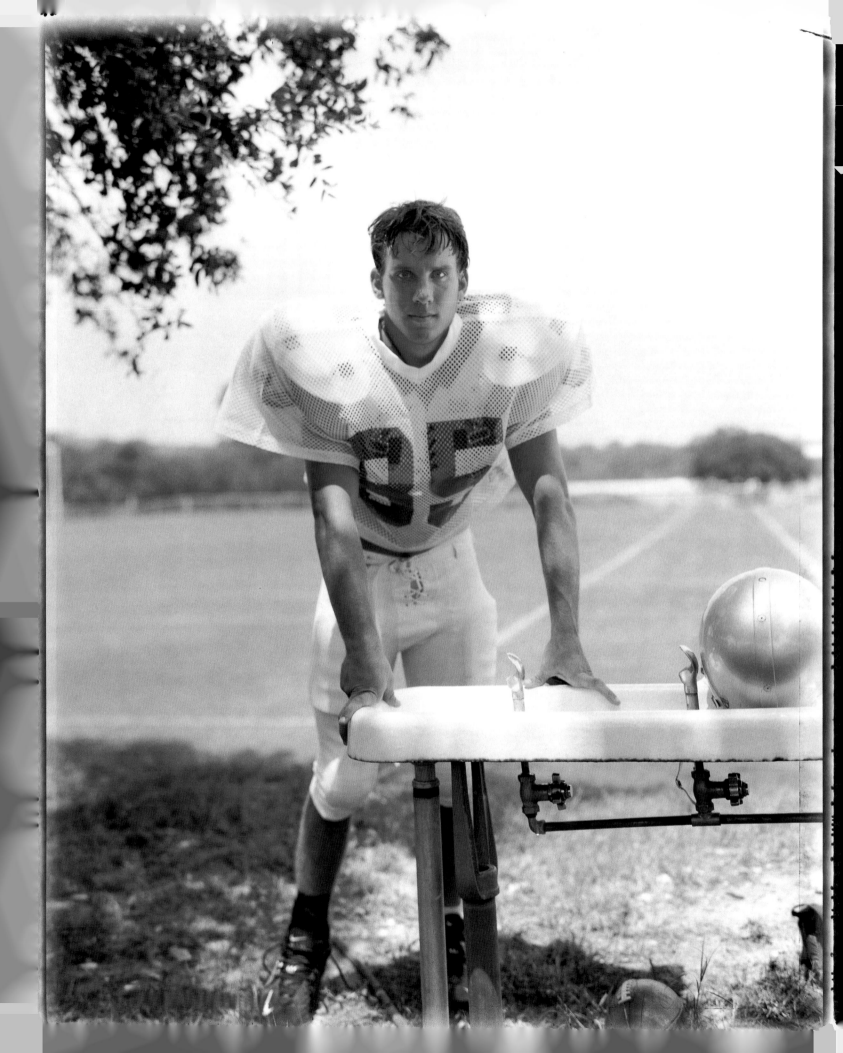

PHOTOGRAPHS + INTERVIEWS

26 QUESTIONS

1 What is one of the biggest things that has ever happened to you and how did it change your life?

2 What is your earliest memory as a child?

3 What makes you the happiest?

4 What is your biggest fear?

5 What is your most frequent emotion?

6 What is the toughest thing about being a teenager and why?

7 What is the easiest thing about being a teenager and why?

8 What do you like most about yourself?

9 What bothers you the most about yourself?

10 Do you think you can have an impact on the world– make a difference in life, and if so, what kind of impact do you think you can have?

11 Do you believe in a God? Do you pray?
 What do you pray for?
 Do you follow any organized religion?
 What does this belief give you?

12 Tell me about your family.
 Do you have a mother and a father?
 How do your mother and father get along?
 Who do you live with?
 How do you get along with them?
 Do you have brothers and sisters?
 How do you all get along?
 Do you think family is important?
 Do you want a family of your own one day?
 What kind of family do you want?
 What do you consider to be the perfect family?

13 Where do you get most of your information?
 Do you use the Internet?
 Do you use the phone?
 Do you watch T.V.?
 Which of these is most important to you?

14 Are you in school?
 What grade are you in?
 What do you like most about school?
 What is your favorite subject and why?
 What is your least favorite subject and why?
 Do you think school is important and why?
 Do you think you will go to college?
 How will you pay for college?

15 Do you have a boyfriend/girlfriend?
 What is the longest relationship you have ever had?
 Have you been sexually active?
 If so, do your parents know about this?
 At what age did you lose your virginity?
 Do you think you were ready for it?
 Do you use protection?
 How do you feel about teenage sex?
 Do you have friends who are sexually active?
 How do you feel about abortion?
 If you got pregnant, what would you do?

16 Have you ever personally suffered from discrimination?
 Tell me the instance.
 Has anyone you have ever known suffered from
 discrimination?
 Have you ever discriminated against anyone and why?
 How do you feel about discrimination?

17 Have you ever experimented with drugs?
 Which drugs?
 How often do you use?
 Do you smoke?
 Do you drink?

18 Who do you respect the most and why?

19 If you could be someone else in the world–who would
 that be and why?

20 As you look ahead in your life what do you think
 you will become?
 Fantasy? Reality?

21 Is money important to you?
 Would you consider your family to be (financially)
 upper-class, upper-middle, middle, lower-middle,
 or lower class?
 When you go out into the world as an adult, do you
 want a similar lifestyle to the one you grew up in?
 Do you want to earn more money? Less?

22 What is one of the biggest problems in the world
 that you would like to fix?

23 Do you believe in and support the war that we are
 in with Iraq?
 If you could vote in the Fall, who would you choose
 for President of the USA?
 (this question I started asking in January 2004)

24 What is your ethnic background?
 What ethnicities are most of your friends?

25 Do you have a job?
 How much money do you make?
 How old were you when you got your first job?
 If you don't work, where do you get your
 spending money?
 What do you spend your money on?

26 Where were you on September 11, 2001?
 What impact has this had on your life?
 Has this made you more fearful?
 Do you feel any differently towards other ethnic
 groups, religious groups, or foreigners?
 Have you made any changes in your life because
 of this attack?

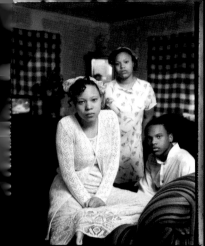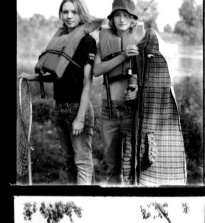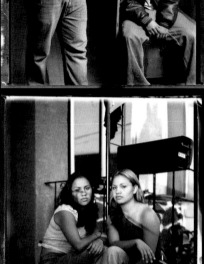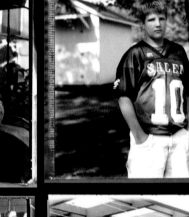
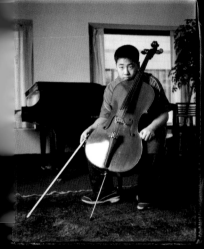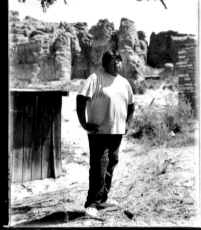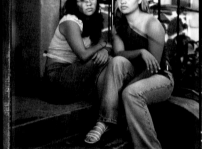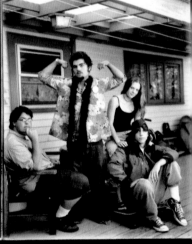
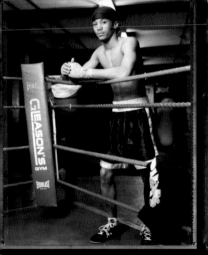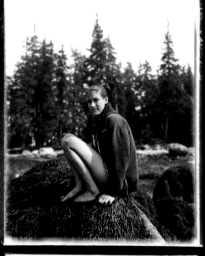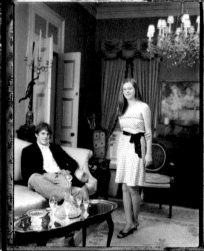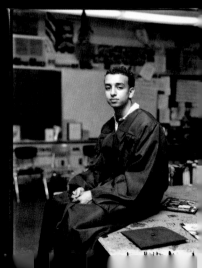
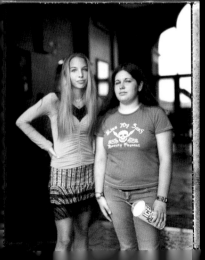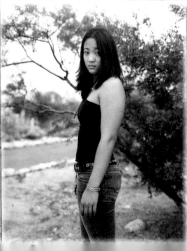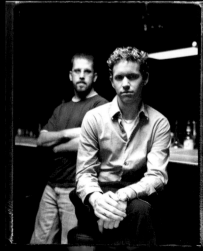

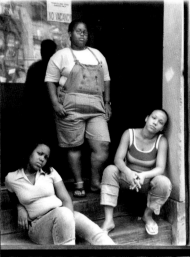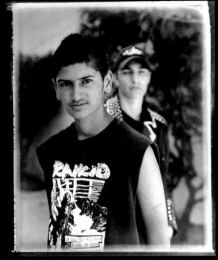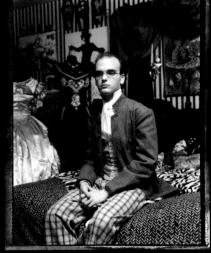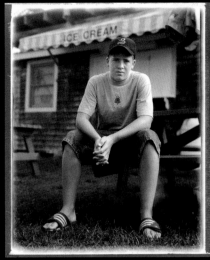
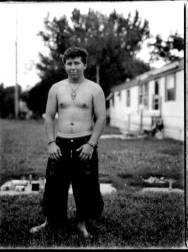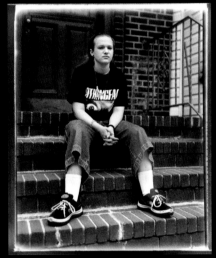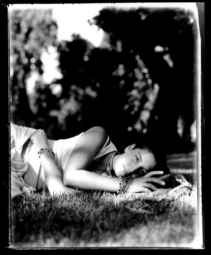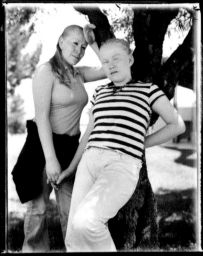
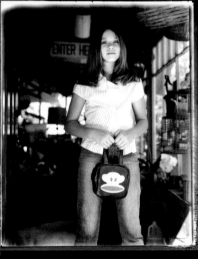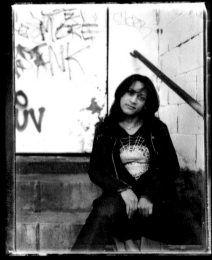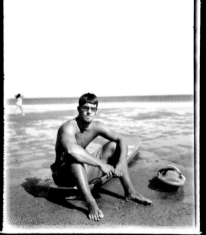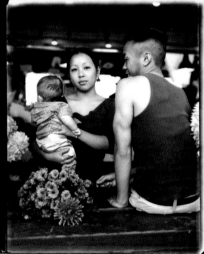
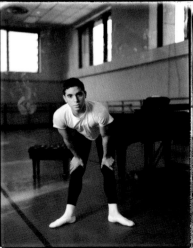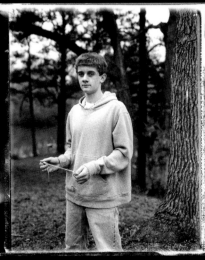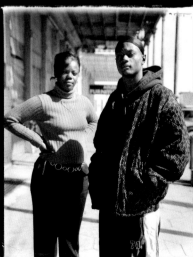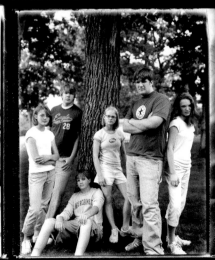

9/11 changed my life. That day I was supposed to be in school, and it happened, and I went straight to the mosque and from that day on I covered—I started wearing hijab, that's Islamic headdress—and I just changed my life. No more bars. No more dancing. Not going out with friends that much. Getting into Islam was like, "Whoa, this is what I have to do, this is an obligation."

My biggest fear is God. Definitely. I have no fear of men, no fear of animal. When I was younger, I used to ask my dad, "Daddy, what are you scared of?" And he's like, "God." And I'm like, "What about a big shark that comes and eats your head?" He's like "No, honey, God."

In every household there is some type of discrimination, whether it be from religious or racial background…. I used to be like, "Damn Jew," but that's about it…. I didn't take it that far unless they were being mean and giving me bad looks—I'm going to have to make it equal, just out of not being tolerant. I would just give them a dirty look.

I had this thing about www.muslimsingles.com on the Internet, because I was new to the religion and I wanted to meet people, get different people's perspectives and yadda, yadda, yadda. So, Ihad, he emailed me saying, "Hey, what's up?" and me being very open and honest, blah, blah, blah, "How are you, how's everything, you live in Brooklyn? Cool, let's go meet up. We'll go paint pottery." And we did. And I was like, "What a sweetheart!" He brought me flowers.

On our second date we went to this really cool place on 100th street, and we sat in the old back room at a little table—and he said, "Hazzy, how would you feel…would you marry me?" And I turned bright red because I didn't know. I was like, "Swear to God, are you serious?" And he was like, "Yeah I want you to marry me and be my wife," and I'm like, "Holy Shit!" and I was like, "Yeah, I'll marry you."

I've known Ihad maybe a month and a half. We got married last Friday. I was crying because everyone was in a white wedding dress and I was in slacks and sneakers. We just came back from joining a mosque and it was raining and my feet were wet and I was just like, "Wahh…!" I don't know, it happened so fast…. I married him because he was a good Muslim. Thank God. I didn't marry him because I was blindly in love with him. I wanted him to improve my being, improve my religion, get me straight up to heaven.

Hasnija Abdul Moumen, age 19
BROOKLYN, NEW YORK

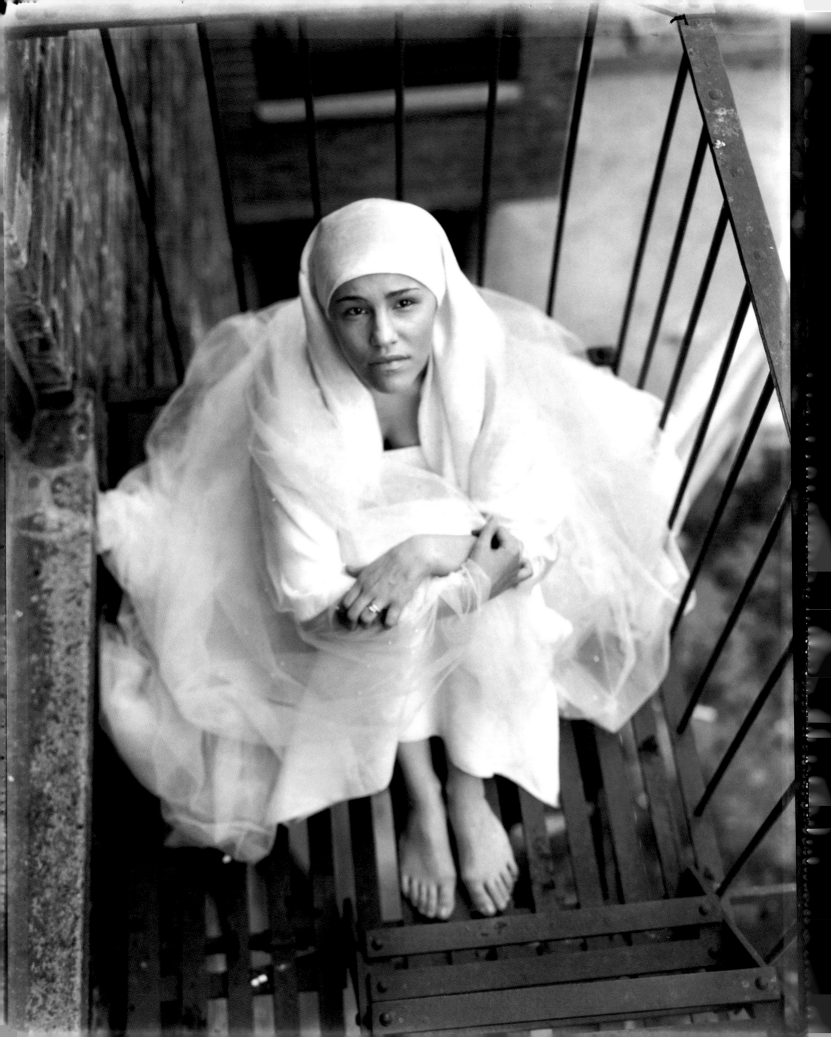

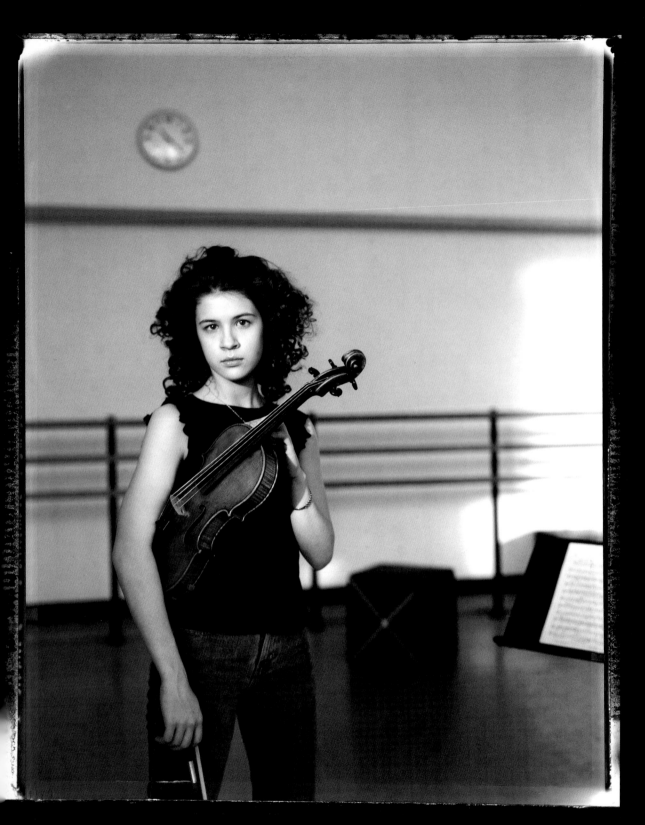

I have a lot of energy, so I guess my most frequent emotion is excitement, because when I get up in the morning I'm happy to do something even if it's not music…. In music, well, in music and in life there's something, it's not religion, it's kind of religion, it's the power of positive thinking… it helps you have enthusiasm and to have energy and believe in yourself and I think that is what everyone needs whether they have religion or not….

I guess the biggest thing that ever happened to me was starting the violin… when I was four years old. I love performing, and it changes my playing when I get in front of an audience. I'm concentrating on having fun. I don't get really nervous anymore because I think people are here to hear good music…. So I go out and play and I have fun.

It is possible that I could become a professional violinist. I would like to, that is one of my fantasies.

On 9/11 I was at home and my mom was home-schooling me, and my sister called us because she saw it happen from the highway…and my dad used to work there. He was not working that week. He was supposed to be there, on the 96th Floor. So we just realize how lucky we are.

I'm sure I could do something to have an impact on the world and it doesn't have to be music but right now I'd like it to be music. Going back to 9/11, they had musicians playing for all the workers and they said that did a lot. Music brings everyone together no matter what they are. Probably my biggest fear is not doing anything to make the world better or not doing something that will make it more beautiful or make people appreciate it.

Brittany Sklar, age 14
GARFIELD, NEW JERSEY

I'd say that when my father died, that changed my life…. But my mom was very strong and she took over the business that he had, a karate school. And she has always supported me and my brother, so nothing we've ever had has been a burden and she teaches us that nothing is impossible.

I love to dance, honestly. Everything that's happened to me for the past day, or week, or however long it was; when I dance I just kind of zone out of what's going on. Aside from that I really like to help my mom. That makes me happy, whether it's around the house or at the karate school.

I don't have anything that I am afraid of. I mean, there's moments that come along. I gave a speech at my school for our graduation from middle school. Speaking in front of people is at one point fearsome for me, but it is also exciting.

The toughest thing about being a teenager is the decisions you have to make every day: Do I want to be a dancer? Do I want to pursue my academics more? And then there's just generally other issues. Like peer pressure. Luckily, because I'm so committed to ballet and school, I don't come across them because I don't really have much time to.

I don't think that it is right to have sex until you're married. I just think that is unethical and we've learned that ever since middle school. I don't understand why people can't obey that rule.

I honestly can't think of someone else I would want to be. There's people I would like to be like—like Aesha Ash, the only African-American female in the New York City Ballet. There's people like Oprah. You want her generosity. There's people like models out there—you want their looks. There's people I just want to be like.

Morgan Richardson, age 15
MT. VERNON, NEW YORK

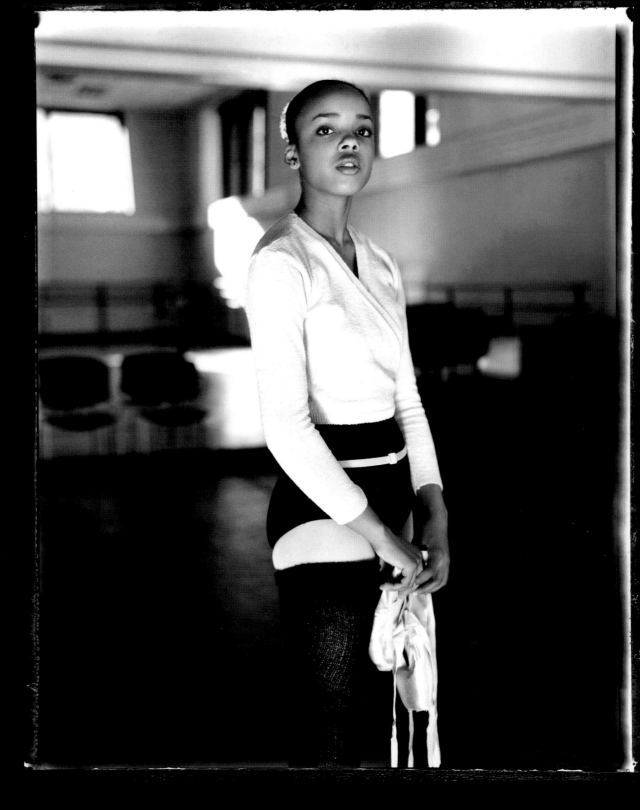

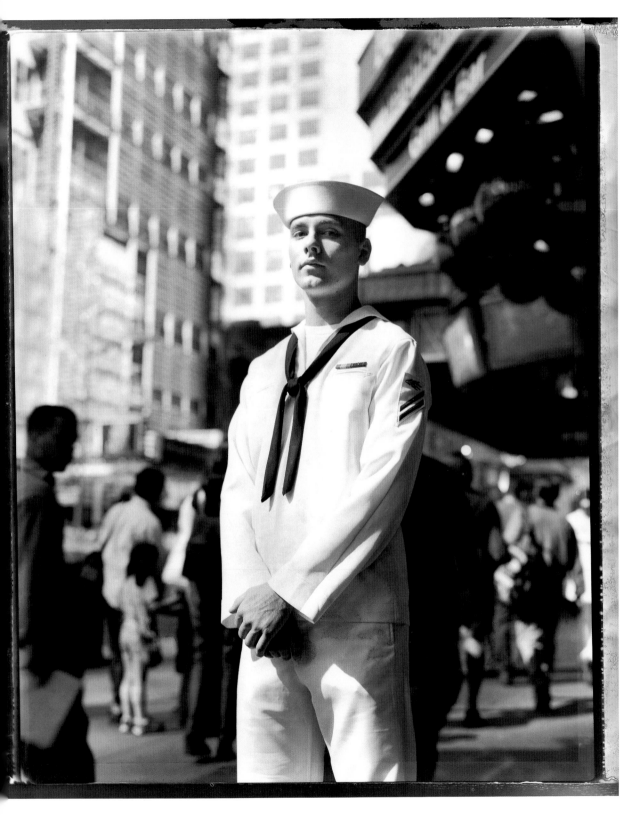

I'm from Georgia, so I've suffered from reverse discrimination, you know the black people "cracker this" or "cracker that", "white cracker", "white boy" or "whitey"…it's just funny; I think it's funny as hell. Words don't really bother me. People don't know you, how are they gonna say something about you? I see people, there're a lot of rednecks where I live who are like, "nigga" this, "nigga" that, and I'm like, "Man, shut the fuck up!" and they say, "What you gonna do about it?" and we start getting into it. I'm just like, whatever. I think it's stupid, just ignorant people. I'm sure I've discriminated against someone on one or two occasions (laughs)…. I wouldn't put it past me!

My dad was in the Navy for twenty-three years…he had fun, so I figured I'd try it out and see if it lasted…. On 9/11 I was on my ship (U.S.S. Iwo Jima) in Norfolk, VA. A guy called up and he said, "They just bombed the two World Trade Centers and the White House." We were like, "Oh my God," and we ran to turn on the radio. Since then it makes you more aware of who you talk to and what you do…not more fearful, just more cautious. It worries me every time we have watches…. You see a boat come by you don't know if it's coming towards the ship or just cruising by. Any minute, you know, we could be sent over there, to Afghanistan, to Iraq. I wish I would've joined the Marines so I could go down there and shoot at people…. I'd rather do the ground action. I'm hoping to get a special assignment to go do something.

I don't look at other ethnic groups differently since 9/11. I think all of them are the same. Everyone stereotypes people even if they think they don't, yes, everybody does. It's just how far they go with it.

Blake Barlow, age 18
EASTON, GEORGIA

There's so many mixed messages aimed at teenagers. Like for example with sex: the media will be "Oh, have sex!" and stuff like that. And you know, since America was always a puritanical society, we're being bombarded with two different messages. "Don't have sex" and "Have sex." There's so many mixed messages and the media has such a powerful impact, but then your family does too, and your friends do too.

Yes, I've had a boyfriend... (laughs). With me guys are so frustrating; I don't understand them and I don't think I ever will. Because frankly the guys in our grade have no sex drive. They don't want girls. They are just not interested. I don't understand this because usually it's the guy pursuing the girl but now, like this year especially, it's the girls pursuing the guys! I don't understand that at all!

It's impossible, but I would just love to have peace in the world. It would be so perfect if no one was always angry at each other, and always fighting. It's ridiculous. In this protest, that's what we're trying to do. But that's impossible. We can't have no war in the world, because there's always going to be conflict, differences of opinion. And those opinions are going to clash and people are going to argue. You know with something like this protest, I couldn't protest alone. I don't think I could have a really big impact by myself, just one person, because to act in large numbers is essential.

I think the feeling of being really loved or accepted makes me the happiest.

What do I like most about myself? That's a hard question...when I persevere, I guess. I know when I try something I'll keep on going.

Claire Louge, age 16
Ithaca, New York

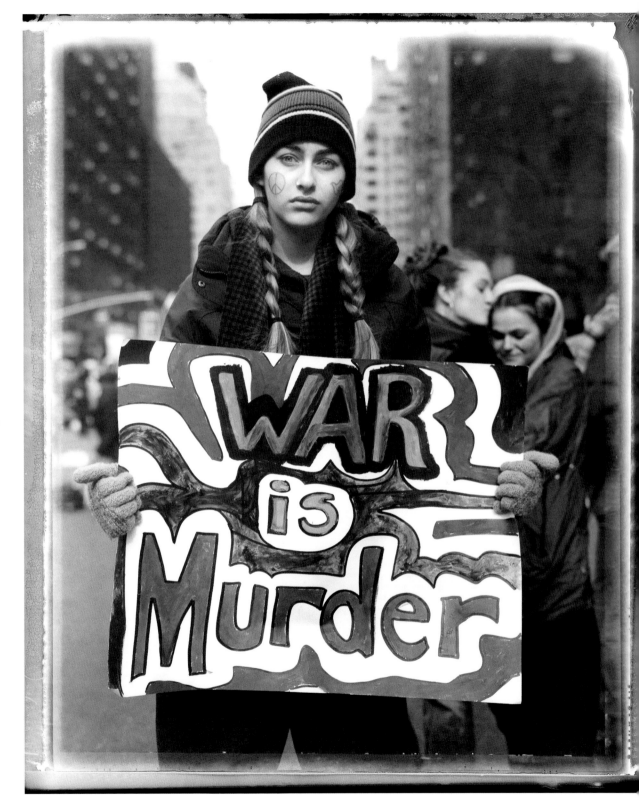

The biggest thing that ever happened to me was when I was fourteen, and I was getting into a lot of trouble. My neighborhood was bad and I used to hang with a bad crowd and I went upstate to boot camp and I did eighteen months.... I got arrested for robbery, assault. I see a whole different thing about life now, you know. I'm an older person, a better person. I went to Europe and I fought boxing, you know. And that just gave me an outcome, another whole look about life.

I feel a lot of sad sometimes. Because my mother and father, they're on drugs, you know, hard drugs, like crack and stuff, and my grandmother takes care of my mother's kids, which is me, my brothers and sisters, which she don't have to do. One of my brothers is handicapped. He's deaf. He can't talk. He can't walk. That's a lot of responsibility for my grandmother. So I feel sad about that sometimes but I don't let it hold me down. I take my anger out on the punching bag.

I pray for my mother, hope she can turn her life around. I see my mother whenever she feel like coming. I don't know where she lives at. I don't know where she sleeps. She turned down rehab I don't know how many times. So she's not, like, wanting help. My grandmother don't trust her. She steals her money when she comes to the house. My grandmother has to lock her door when she leaves. That's not right.

My biggest fear is getting older and becoming a bum on the street or something, and having nowhere to live. Sleeping in cold parks. That's my biggest fear. Because nobody grows up and says, "I want to be a bum." It just happens.

I think I can have an impact on the world if I stay in the gym and I turn professional one day and if God blesses me I could be the world champion and everybody could look back and say, "Oh, that's Shavaris, he used to live on Gates Avenue and he moved his grandmother and his family out of the projects, you know." An impact on the world like that.

Shavaris Buie, age 18
BROOKLYN, NEW YORK

Photographed January 31, 2002 at Gleason's Gym, Brooklyn, New York

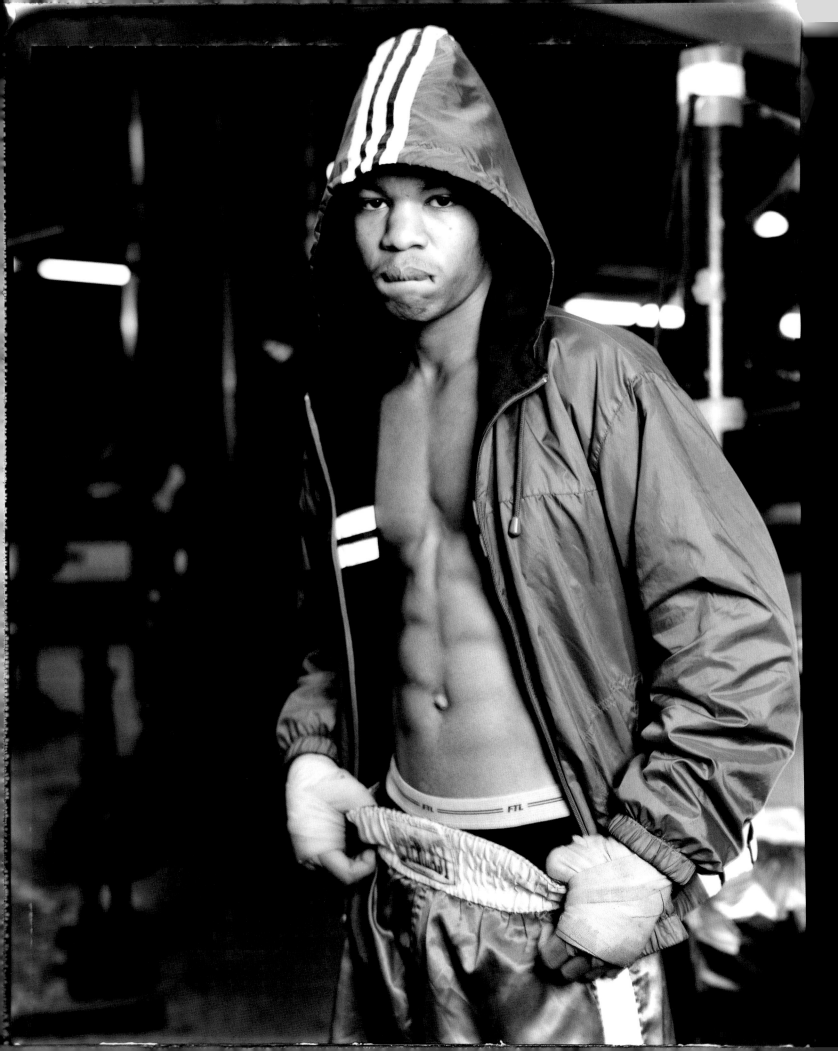

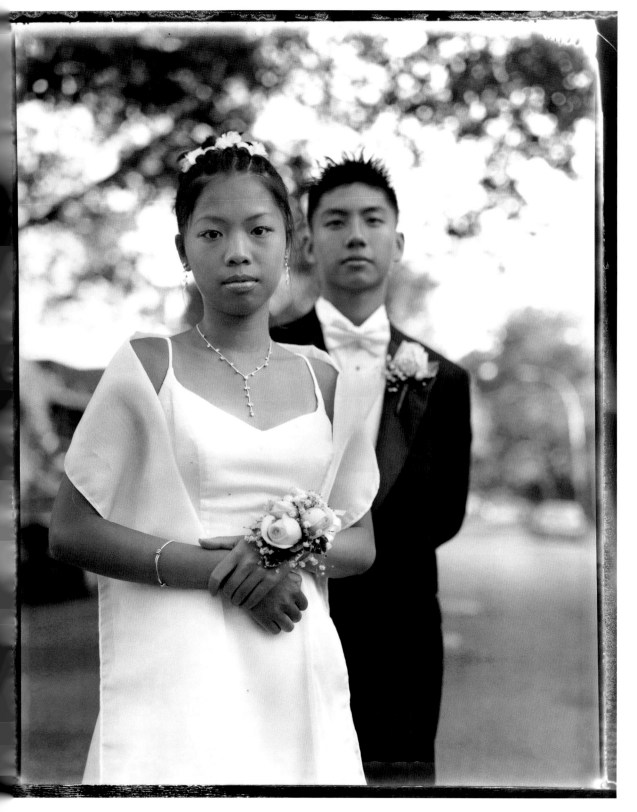

When I was a little girl I used to live in a very racist neighborhood…it caused me to not know myself. There were a lot of colored people, and seeing that Chinese people lived in a brand new house they were of course jealous in a way, 'cause they lived in the projects. So it caused them to mock us or take what we had by robbing us…. I just hid so I wouldn't get picked on, you know? I was scared.

I'm always trying to find who I am, 'cause a chunk of my life I was just like what people thought of me: "Oh you're that Asian girl; you're the quiet one…." I like to keep defining myself until I'm that person that I'm supposed to be…. I'm happy to be both Asian and American, 'cause I celebrate both holidays and it's like my tongue is split into two; I have two dialects. And it's nice to live double, sort of two lives.

Darin and I promised, no matter what, we'll go to senior prom with each other. We made that promise in ninth grade… 'cause we're best friends. I'm excited about my prom, but right now I still have the stress about doing hair, fixing my makeup, looking the best….

Mary Yee, age 18
BROOKLYN, NEW YORK

My biggest fear is that I won't be able to make my parents proud enough of me….

I think about having a family of my own a lot. Probably, I don't know, three kids and a wife…. I think, you know, there's not a family who won't have problems and issues. I think a family should have challenges to better know each other and just learn more about each other.

Sometimes I feel that I don't question enough things around me and I don't challenge the feelings of others. I just go along with it and I like to think that I could maybe become stronger and a deeper person in that way.

Darin Chin, age 17
NEW YORK, NEW YORK

I think I can have an impact on the world, because I'm a teenage mom finishing school.... I think the world will see that I finish, or some girl can say, "She finished, why can't I?" My aunt takes care of the baby while I'm at school.... I was back in school one week after I had the baby.

I go to Bronx Tech. Last year I was on the honor roll... I like some of the teachers. I like the way they teach, some of them.... Books. I love books. My favorite subject is science. Chemistry.... If I could be somebody else in the world, I think I would be someone doing forensic science.

What makes me the happiest? My baby and my fiancé. We happy.

Karen Riddock, age 18
BRONX, NEW YORK

Having a kid changed me dramatically. I'm more responsible. I got to go out there and get a job, a good job. Pay bills. My fiancé Karen and I are committed for the rest of our lives together.

I'm happiest when I see Karen smile. My biggest fear is losing her; doing something stupid like cheat on her.

I most often feel like I have a bad attitude. Well, I see something I don't like, or it don't go my way, I have a bad attitude. I take it out on everybody.... If people would go by my rules, how I want things to go, life would be good. I could have an impact on the world—if people listen to me.

For me, one of the toughest things about being a teenager is waking up at three o'clock in the morning. The baby. Or when you walk the streets with fear with gangs and stuff. Got to keep your head up, stay out of trouble.... Selling drugs—you see the money and you want it, so you're gonna go out and do it, but I don't do that stuff.

Romale Russ, age 19
BRONX, NEW YORK

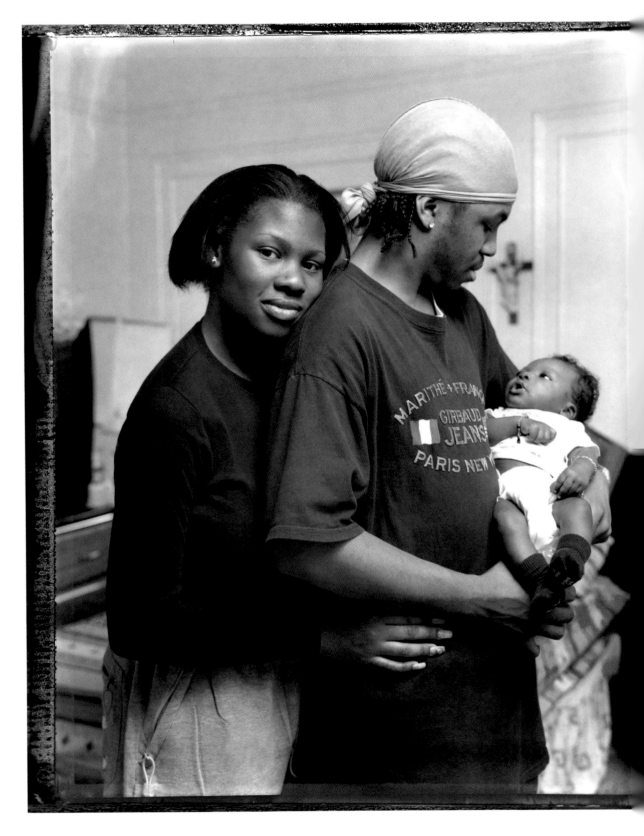

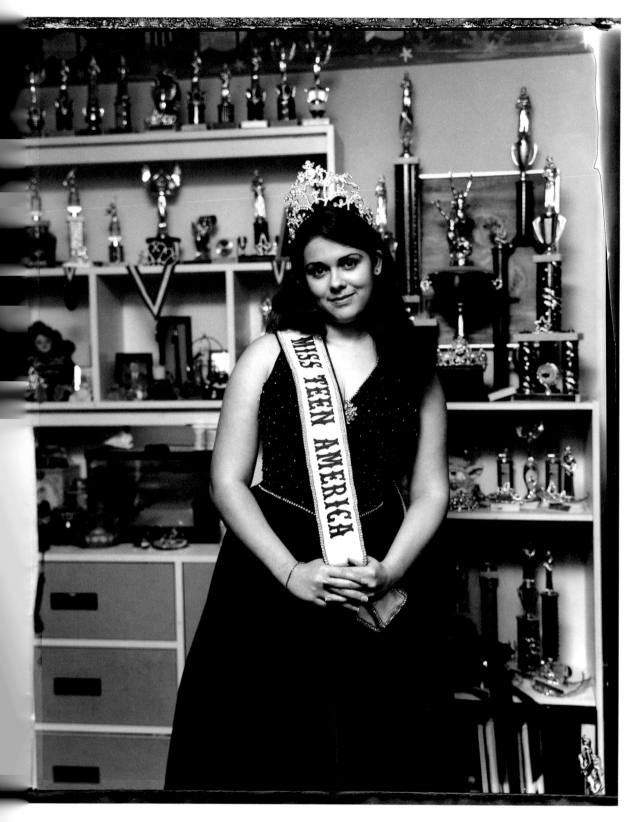

The toughest thing about being a teenager is having to deal with other teenagers, 'cause they're so judgmental of each other and it's so hard to fit in with other teenagers.

I guess I was discriminated against when I was Miss Teen America, just 'cause I was different from everyone else and I had that title. I was treated differently in high school. Even when I was doing appearances, the majority of the people I met were very friendly, especially the kids. The kids just loved seeing me, but there were some other teenagers I'd see and they'd walk by like, "Oh, it's Miss Teen America. Whatever." They were just obnoxious and I just had to ignore that.

I mean, it hurt 'cause I worked really hard for this title; I put a lot of time into it. Grades counted, I had to give a speech, talent was in it, community service hours counted…so there was a lot in this title and I just worked really hard. So it just hurt that people just kind of think that it's all about beauty when this pageant really isn't. They didn't really even know the whole story.

I do have a boyfriend. We've been together for three years…. Am I going to marry this guy? Yes. I think so, yes. When school's done and he's got a job and stuff. I mean, we're not in a hurry or anything, but I know he's the one.

I don't agree with teenage sex, 'cause teenagers change their minds so frequently; it's just better to wait until you know and are positively sure that he's the one. And just save it for a special moment.

I think discrimination is wrong. Everyone here is an American and they came to this country for the same reason, so even if they're different for whatever reason, they still shouldn't be treated differently.

Heather Konitshek, age 18
DARIEN, CONNECTICUT

Sometimes I feel anger towards people who stare at me, and anger towards the parents that they don't teach their kids manners. Some people just let their kids stare. And others, when I say something to the child, get mad at me and say that I don't understand. And I do, I understand more than anybody. When someone is staring or says something mean to me, then to protect myself, I will obviously not say something as mean as they did to me, but just say something to protect myself. Say something like, "By you staring at me, you're the one who should be stared at," or something. I've never said anything really mean; I more like to stick out my tongue at them.

A big thing that happened to me was going to the Little People of America conference, because all of my life I've been surrounded by average-size people, and going to this conference made me realize that there are other people that I can talk to about problems I have. It's just a real eye-opener. Now I have a lot more friends to communicate with, and I realize that I am better off than a lot of other little people. And that I should be grateful for what I have.

I haven't dated—ever. I have been really close to guy friends, but I haven't dated and I don't really know many people who are interested in dating a little person. It makes me mad that they don't want to know me better and that they look at the outside more than the inside.

Being around my friends makes me the happiest. We hang around at school a lot. And we go to each other's houses and to malls and stuff. Just like regular teenagers. I would still like to know what it feels like to be average-sized; to have a boyfriend....

But I like everything about me. I wouldn't change anything.

Courtney Paslick, age 17
NASHVILLE, TENNESSEE

I'm estranged from my parents back in Albany. I got in trouble for drug use with the police, and after that my family pretty much gave up on me and that really hurt me so I just ended up leavin'. I got picked up by a traveling carnival that comes here to the Rockland Lobster Show or whatever, and I ended up here. I love Maine. It's quiet and huge and beautiful and there's not buildings everywhere....

What's not to say about drugs? They suck, they're stupid and they'll screw up everything. Drugs will ruin your life. I did them and I liked them and I got into 'em really heavy. And then I just started makin' poor choices. I had everything goin' for me. I was on the right track; my family was so proud of me. I went to a private military academy in New York and after three years of almost makin' it I dropped out in my final year. Started runnin' away from home every other day and just bad stuff, stealin' money, doin' whatever I could to get wrecked, basically. Me and Mom got along until a certain point. Once I started screwin' up though, my mom got so disappointed in my choices that she just couldn't bear to look at me anymore.

I'd have to say childhood memories make me the happiest. I look back at all the pictures I have of all my family and I kind of miss it a lot. I remember spending time with my puppy and my grandfather. 'Cause when I was younger my grandfather was so proud that I was a boy and I was the first one born. He bet on it, matter of fact. He was like, "I know this is gonna be a boy." Me and my grandfather spent a lot of my childhood years together....

Me and my girlfriend, the mother of my child, were together for maybe seven months. I mean, we were off and on, fighting all the time but for some reason we stayed together and had a beautiful boy. I actually left while she was pregnant. She had cheated on me one night with one of my good friends. It really set me off. You know she was with me, and then she was with him.... I was so angry. I know it is my child now. I know it is for a fact. He looks like he got pulled right out of my butt.

I wanted a boy. It could've been anything, but I was really psyched that I had a boy. I would've just been disappointed in myself if it was a girl. I spend almost every free moment I have with him. I would like to get married someday, have a family. One boy, a wife, and me, and a big dog.

I don't do the heavy drugs anymore. I smoke my weed or whatever, but. And I still got a crazy part of me. Family is important. Family is one of the most important things in life, I think. If there is such a thing as a perfect family, though, I've never seen one.

Jason Kramer, age 18
ROCKLAND, MAINE

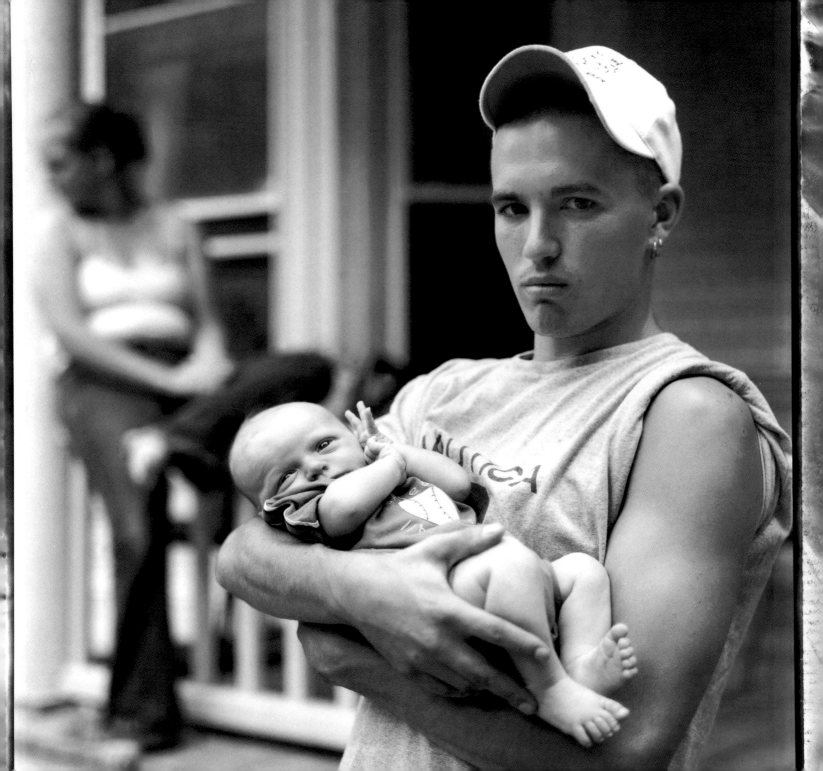

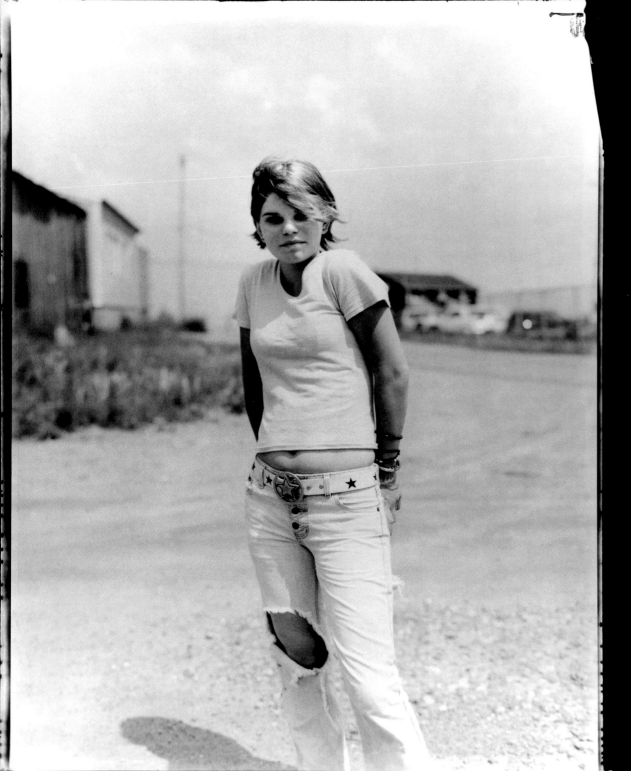

I don't live with my mom…maybe someone else would, but I don't consider this to be a big thing.

I left…. My mom didn't want me just like on the street so she put me up here in a shelter until I turn 16. My Mom called the cops. I had permission to leave and I didn't stay home. I left becuase I don't like it the It's not a good place for me to live. I don't have a good reason. I can't live with my mother. We don't get along….

I don't really feel anything…. I just feel—I'm here, I don't know. I'm just kind in the middle of nowhere. I guess I'm happy with where I am and what I'm doing but…

My face…. I don't like to look at it. It's so round and too big, too…. I don't know, my eyebrows, the shape of my face, my nose, ears—I don't like it.

People make up their own rules and their own beliefs and they say that it's God I figure whatever's gonna happen happens. don't know sometimes I just believe in fate and not God, that everything that happen is set to happen.

I think family is important cause the have to be, I guess. It's like a rule. I am never, ever going to have a family. There's way too many people in this world. I don't believe in getting married.

I don't know how many shelters I ha been to…four or five. I don't do drugs real anymore. I drink. Alcohol—whatever's there. Whatever's in front of me. Oh god, alcohol's easier to get than anything. I used to drink every day. Sometimes I'd do it in school. I've only done that a few times. Five or ten times. And now…every once i awhile. Sometimes I'll do it a few nights… sometimes I go on a little binge (laughs).

Sharon Ann Mason, age 15
WINDHAM, MAINE

Are my parents gonna hear this interview? I don't care, they know I smoked weed… because the second time I did it I crawled in bed with them! I was really scared 'cause I was blazed. The one place I was really comforted when I was a child was in the middle of my parents—I'd just talk to them and they'd calm me down. So that's what I did…. It's so funny. I was in bed with my parents and I was, like, tripping, and my sister calls up drunk. So they have one kid on drugs and another kid on another drug. My sister always does the drunk phone calls—she's the "drunk dialer" as we call her (laughs) —like, who would call their parents!?

Probably being diagnosed with cancer was the biggest thing that ever happened to me. I had just graduated from eighth grade at St. George's Episcopal…. I had six rounds of chemo and then I had a limb salvage done, and then I had seventeen more afterward…. I'm an above-the-knee amputee at this point.

At the beginning it was more like, "Why is this happening to me?" and just questioning myself, God, the world…. There was a grieving period and a mourning period, and then I was doing all right, really. I kept a positive attitude; I had plenty of friends coming by and seeing me and keeping my spirits high….

I'm doing great; I'm having a lot of fun with it actually. It's my Mister Nubby, I call it (laughs).

If I'm really good at running I'll go for a running career…. I'm walking now but I will be running soon. There's a prosthetic that allows you to run competitively….

I've wondered like, if there's a God, why is He doing this to me? And then my dad's also taught me that God doesn't do this to you, it just happens and He's there to help you through it.

Ford Sutter, age 16
METAIRE, LOUISIANA

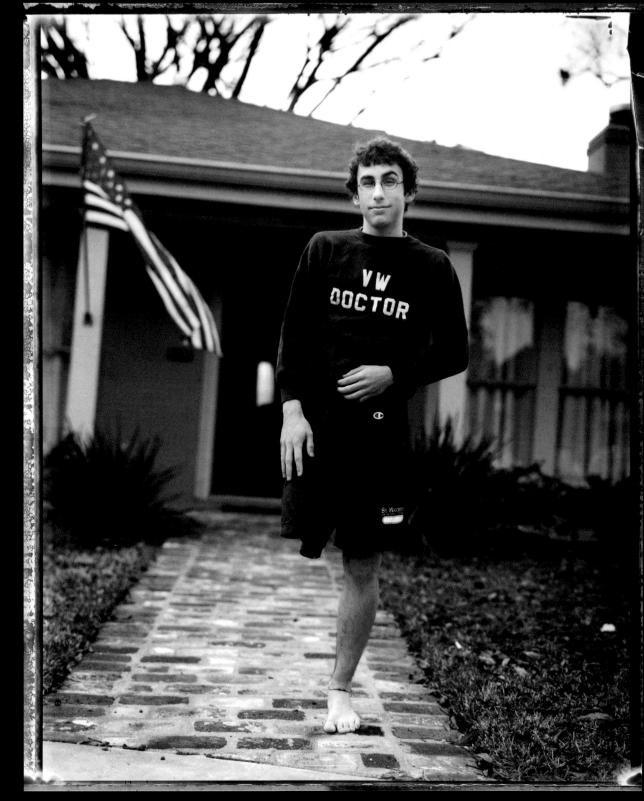

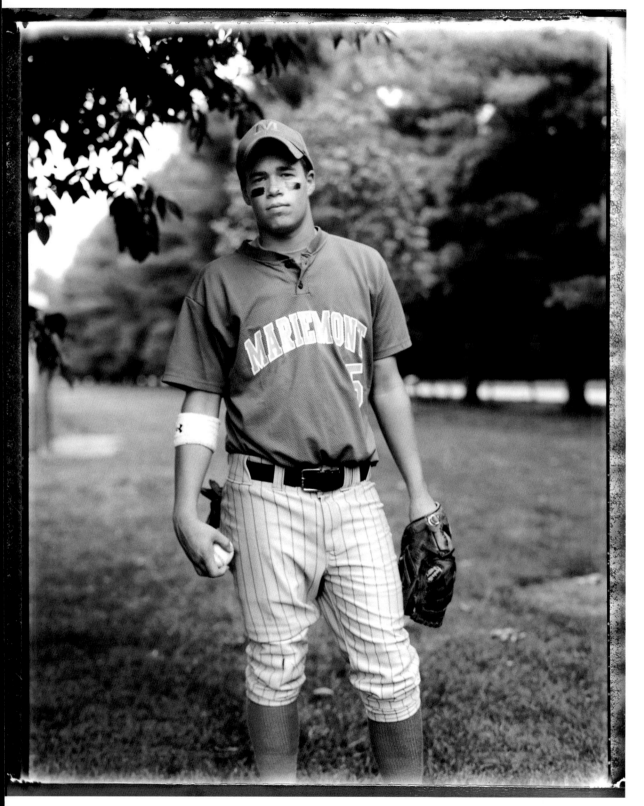

My parents have been married for about twenty-five years. I think my parents have a good healthy relationship most of the time. They have their problems like everyone else, but they work it out…. I'm very close to my dad, not so close with my mom. One of the problems with my mom is that we're both the same and so we don't get along, because we're both opinionated and don't like to be wrong so we get into a lot of fights and arguments sometimes….

The thing that bothers me most about myself is the fact that I've so much ability in sports and school, and yet I don't push myself as much as I need to and I don't strive to be better every day. I just kinda take it for granted and then some days I'll try to push it, but it kinda comes and goes and I think I could be accomplishing more.

My fantasy career would definitely be playing baseball for a living…. But in reality I think I'm better suited to become a businessman and follow in my dad's footsteps as a salesman and possibly form my own business, and I'd really like to end up going into business with my dad….

When I become an adult—then I want more than my family has. I've always strived to do better than what my dad's done in life. He was a three point student; I wanna be a 3.5. He was a good athlete; I wanna be a great athlete. I wanna go out and do better than that and provide something better for my kids, so that then they're motivated to go out and provide something more for their kids, and so on and so forth.

What makes me the happiest is succeeding in sports and other things that make my dad proud. My biggest fear is not living up to my parents' expectations and falling short of accomplishing things that they accomplished.

John Srofe, age 16
Terrace Park, Ohio

I don't like my daddy too much. He left me when I was about seven or eight. I haven't seen him since then. My mother is my father. I say, my mother *is* my father…my father and my mother.

I got two sons and one daughter here, and one in Chicago. I had them with three mothers. I don't believe in marriage…. No, ma'am, I'll never get married (laughs). I don't know, it hard. It hard to find somebody to see eye to eye. But I respect females…all females. 'Cause they the most precious.

I dropped out of school the beginning of my eleventh grade year. I was sixteen. I realized it was a mistake a year ago, realized that I was doin' wrong. The thing is, it come back and haunt you when you go look for a job. I can't get a job without a diploma. Then, watchin' all my friends in college, and I see I ain't makin' it with my life yet.

It been a year since I've been drunk. One night, me and some friends we were ridin', drinkin', and you know, smokin' on our cigarettes…just chillin'. I seen these people fightin' and they was intoxicated. Well the fight shouldn't have even really happened, 'cause it was really about somebody steppin' on somebody's shoe. So they were drunk, they just start fightin', and alcohol make people act wild and they don't know how to control it…. My friend, he died over it. We was pullin' up, drivin' up, and then we did heard the gunshot and he fell to the ground. He was a real close friend…. I decided then to stop drinkin'. Make my life right.

What do I like most about myself? My willpower to do better. And I want a business where I help children when they have problems, like peer pressure. Like a counselor or something.

Richard Benjamin Jr., age 19
Selma, Alabama

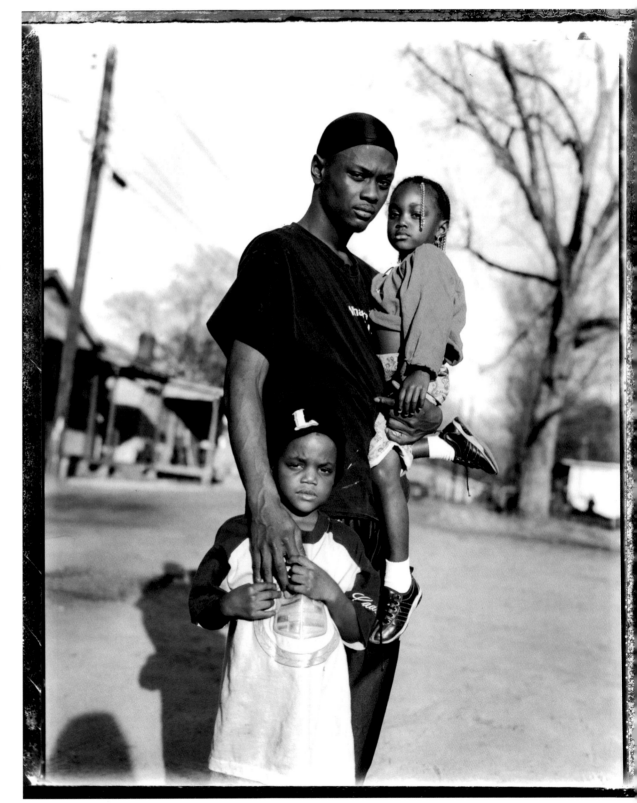

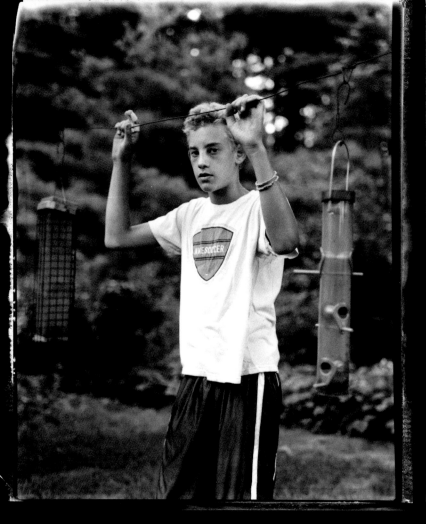

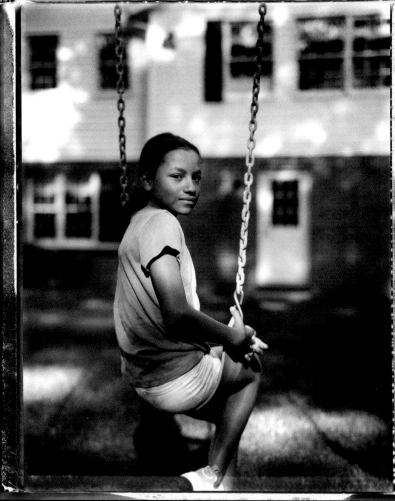

I might respect my dad or mom the most. Maybe my dad just because he has really taught me a lot about life, and manners and discipline. He mixes in with doing all that—which I really need to know—lots of fun, and I respect him for being able to do both. Not many dads know how to do that really well and he's the best dad. Same with my mom. Our family has one of the best relationships of any family I've ever known.

With my parents help I might become something, go pursue my dreams, 'cause everyone says "Follow your dreams."

My grandparents and my people that came before me were Jewish, so they suffered the Holocaust, which is terrible. I feel badly about discrimination. I don't like it at all and I'd like to try to stop it actually. I'd really like to become friends with people that are different than me, different races.

Alex Stern, age 14
Wayland, Massachusetts

Photographed August 13, 2001

Being adopted makes me feel special, because…my birth mother really cared about me and she couldn't take care of me, so she gave me up for adoption. My parents thought I was really special, and they adopted me. I'm proud of that. I am originally from El Salvador. I was adopted when I was two.

My mom told me that she had to speak a lot of Spanish at first, 'cause I really didn't know any English. My mom told me my first American words were "milk and cookies."

There are not many blacks or anything in my town…it is mostly white. I don't really feel different because I'm in a white family right now, so I don't really feel too much different.

I'm more thankful for things because I'm just really lucky that my parents were willing to adopt me and take me under their care.

Maria Bartlett, age 13
Mariemont, Ohio

Photographed June 24, 2004

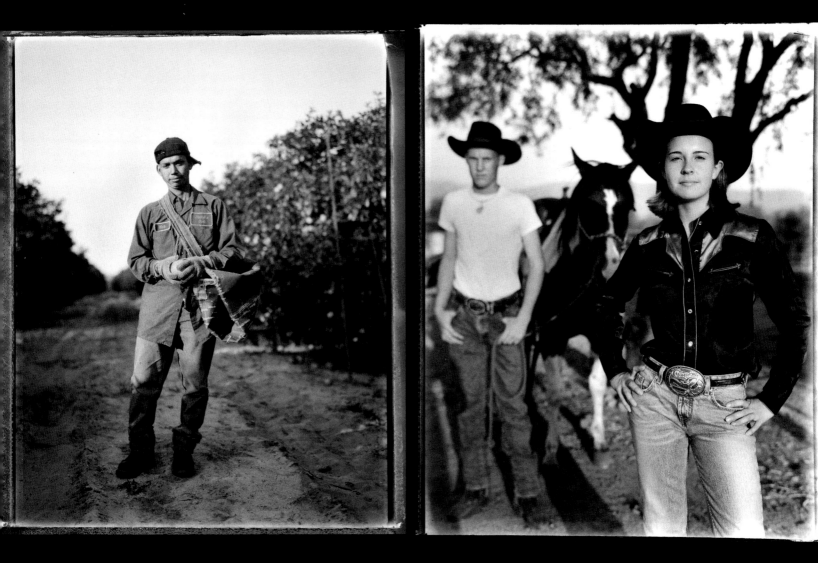

I am from Honduras…. I came to Guatemala, then to Mexico to get to the United States…. It took twenty-two days. It was a hard time.

When I was twelve years old I got my first job in agriculture in Honduras. When I started working it was, like, twenty lampedas a day—like $2.00 a day.

When I'm here in Florida I pick grapefruit and oranges. When we go up north we pick tomatoes…. I make about $400 a week, when it's a good week.

Money is important to me because I help my family…. The money allows my sisters to go to school.

My parents have been married twenty years. In the family we are three brothers and three sisters…. I am the oldest one in the family.

Have lots of money, that's a fantasy for me.

I like being here. I want to become an American citizen.

Hilario Lopez, age 19
MIGRANT WORKER FROM HONDURAS

Photographed January 28, 2004 in Fort Pierce, Florida

Last year in a rodeo I got knocked out, and it really messed with a chemical imbalance in my head and made me very angry at some times, or very sad, and I have no control over anything. It really hurt my relationship with my girlfriend, Kendall, and even with my parents….

Mark Fisher Niehuis, age 18
QUEEN CREEK, ARIZONA

Probably the toughest thing about being a teenager is trying to juggle everything… to get into a good school you're supposed to volunteer and have a job and do all this stuff, and all I want to do is rodeo!

Obviously my parents haven't ever kept me from anything I need, and so everyone calls me "spoiled rich girl" and tells me I only do things good because my parents buy me nice horses…. It makes me feel horrible! I can't ever accomplish anything on my own, it's all 'cause my daddy has money.

Kendall Prall, age 17
TUCSON, ARIZONA

Photographed August 12, 2002

When my parents got divorced I was about ten years old. The reason they got divorced was because my mom was, or decided, or found out, she was a lesbian. I'd say that's one of my most influential moments. It just changed the way that I looked at things, and caused me to try to grow up faster, to mature, or at least to look at things from a perspective that a lot of my peers and classmates weren't looking at things at that point.

I was raised in the Episcopal Church and when I was about fourteen, to be honest with myself, I had to admit the lack of interest I had in Christianity. Not only the lack of investment I felt but also the large number of questions that I had about it. I felt I didn't want to be sucked into something just because it was tradition or something that my family believed.

I think my biggest fear is sex. It scares me because to me it comprises my independence, and also the idea of having a child really terrifies me.

Right now I'd say no, I won't ever get married. That's largely due to the fact that my dad is now on his third marriage, my mom is on her third partner or relationship (you know, long-term relationship). That, along with the way I see marriage as a institution in the U.S., made me become a little disillusioned toward marriage. I think that maybe it's overrated to a certain extent and I don't think it's necessary today. People do it because they're expected to. I would like to have a child some day but I'd like to try raising a child without being married to someone, maybe with someone, but not necessarily married to them.

Recently, I think I feel lonely, if that's a legitimate emotion. I feel like I'm looking for something, something that I can't find. I don't mean a girl or a boy or something. I just mean something that makes me feel lonely, kind of.

The person I respect the most is my older brother Andrew, because he is the most selfless person I know, and I think I'm the most selfish person I know, and I always try to be more like him in that way.

The American political system is pretty fucked up right now, and I hope that sometime in my lifetime I will see a pretty dramatic change in that. I would like George W. Bush to be long gone. The war in Iraq is ridiculous and I think it's embarrassing to Americans. I think George Bush is an embarrassment to Americans, too, not as an individual, but as a representation of the lack of information and the lack of awareness in America.

The easiest thing about being a teenager is still having a sort of romantic perspective or outlook on the world: not being jaded or disillusioned; and knowing—hoping—that you have time to do what you want and to achieve what you want.

Patrick Roberts, age 19
LAWRENCE, KANSAS

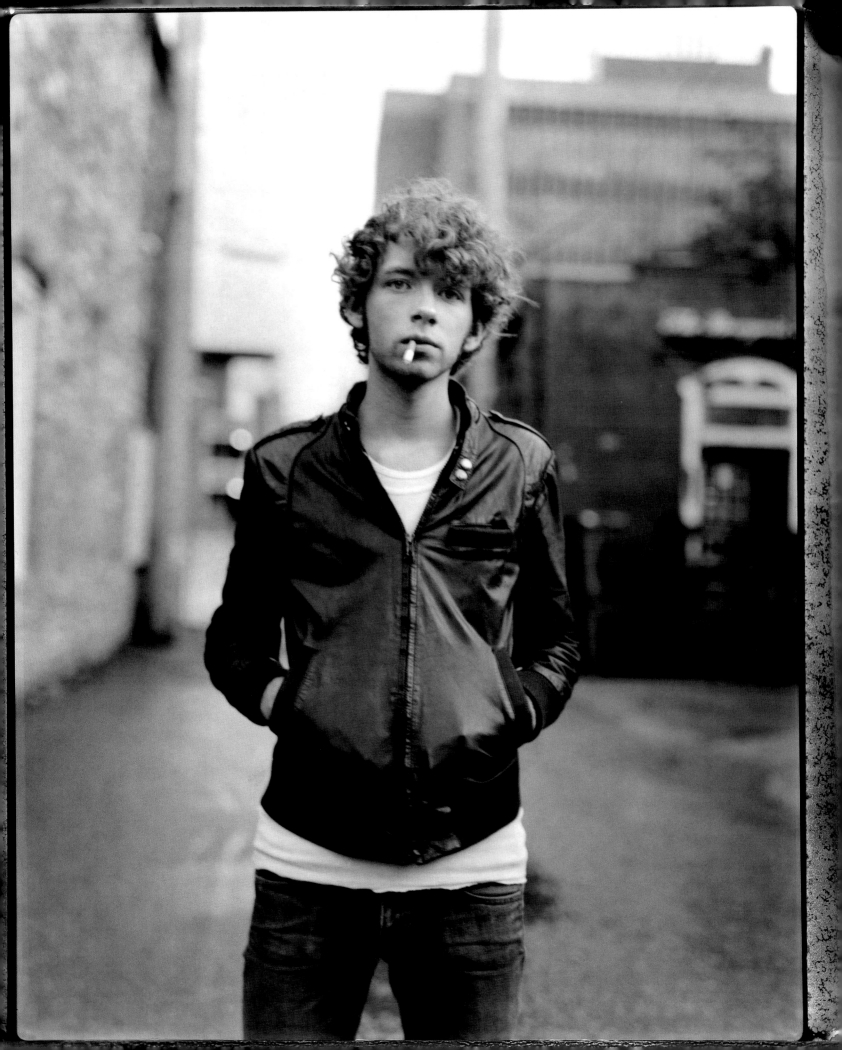

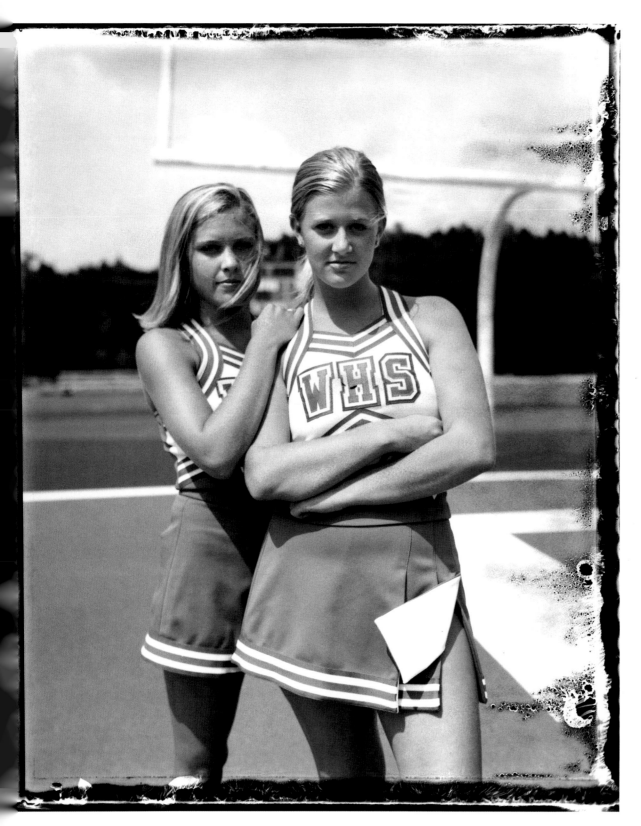

I grew up in a Christian family but then I really accepted God after my freshman year in high school. I just experienced some bad times when I was in ninth grade…it was sort of a slap in the face that made me realize I'm helpless without God. I need Him.

My parents were divorced when I was eight or nine years old. They're both remarried. Now it's good.

Money is important to me because I like to buy stuff with it, but I think I could do without it. My lifestyle has been pretty luxurious! My family doesn't struggle by any means.

I've always wanted to travel around the world, as a missionary. I've wanted to go to Africa and teach English, like, live with a tribe or something and teach English as my living and just, like, interact with the kids and everything….

Catherine McIntyre, age 18
Austin, Texas

I guess everyone always says it's so hard to not drink or not have sex or whatever, but it's never really been a struggle for me. The stereotype of your teenage years is it's hard not to do that stuff and you're going to end up doing it.

My parents separated when I was six. They got divorced the next year. I was just so used to coming home, and then dad would come home an hour or two later, and then all of a sudden everything was just different…. Now it's made me more appreciative of my mom because I've realized how much she's had to do for my sister and I, but I guess it just made me, like, when I'm old, want to keep a family that's close together and cherish having it.

I don't think I'm gonna be President or anything, but I think I could make a change in the world by just being a good mom and raising kids.

Lauren Billingsley, age 17
Austin, Texas

The hardest thing about being a teenager is peer pressure. People force you to kiss or something…. [They'll] be like, "Come on, just do it, no one will know."

I'm happiest when I'm with my family and friends…. My parents divorced when I was seven or eight. We live with my mom most of the time, and we see our dad every other weekend or every two weekends…. My sister can tell me anything and she taught me how to tie my shoes and stuff and she is younger than me.

I do want a family of my own one day. One where my children can tell me everything, where they wouldn't be like, "Don't tell Mom!" if they did something wrong. And I would just tell them, "Don't do it next time," and I'd be easy on them.

I get shy around a lot of people and I try to be outgoing but it's hard. I'm scared I'll do something wrong…. I guess what I like most about myself is that I would never do something wrong. Something in me just tells me to do what I think.

Carlisle Eden, age 14
THE PLAINS, VIRGINIA

Boys are the toughest thing about being a teenager. They expect so much from you and they go way too far with things. Always. The best thing about being a teenager is your friends. They always help you out if you need anything.

I'd like to just end war. I always have a fear of my brother having to go. I don't like it at all. My dad had to go. I don't know which war. My grandfather had to, too. I think it was Vietnam…. I would like to make peace…. I just think everybody gets in too many fights and they don't forgive. And that's how divorce happens and I think I'm going to change that when I'm older. I don't know how yet. I'm thinking.

Mariah Eden, age 13
THE PLAINS, VIRGINIA

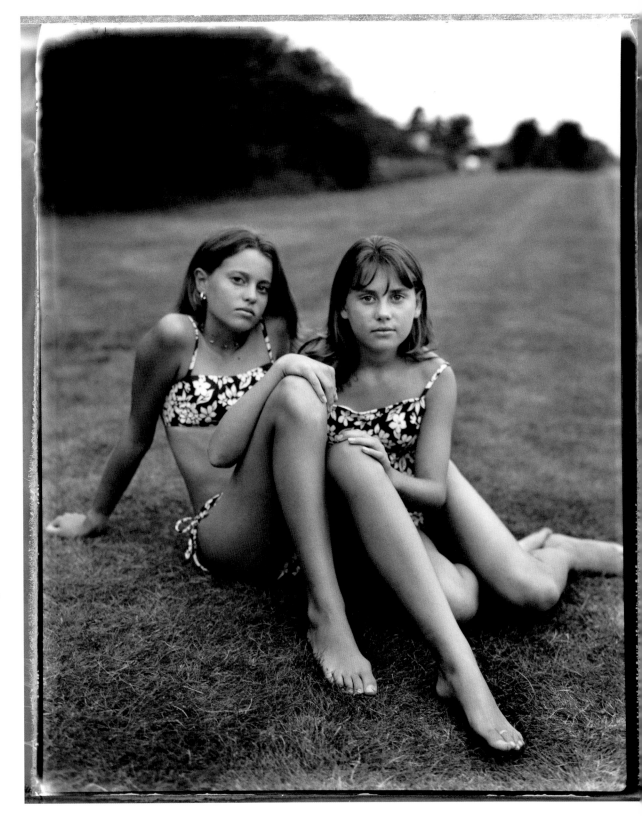

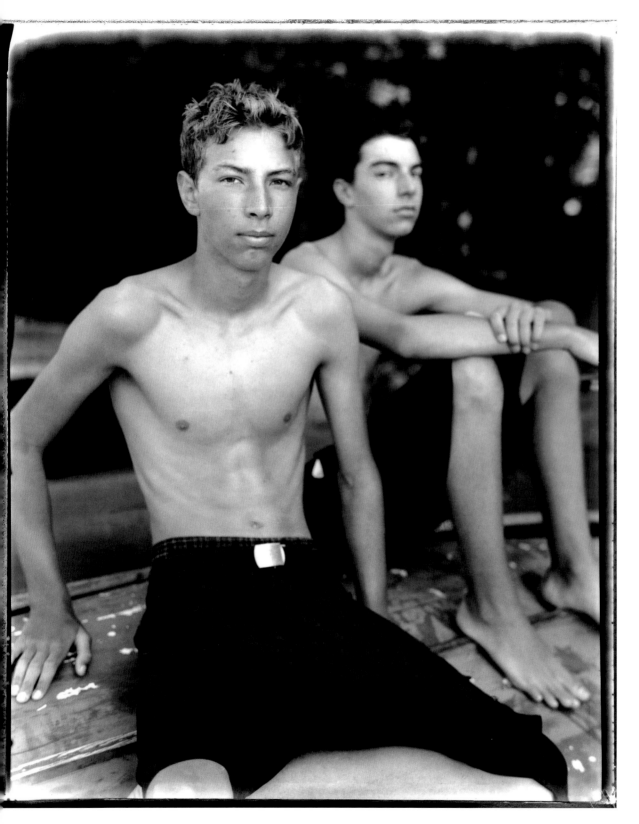

I've had a lot to be sad about, and for a really long time I just kind of numbed it out, you know, didn't really feel it. Things like my parents' divorce. I think everyone has their ups and downs, and I'd say more often I'm depressed, but when I'm happier it's at a greater magnitude. So, if happiness comes less often, at least it's more intense.

I know right now I'm not ready for kids or anything, but I really want to pass on my family heritage….

In theory, I don't like what abortion does, but I kind of see it as almost a necessity for our society in some cases where mothers can barely fend for themselves…. A lot of people say it's a woman's choice, and in a way it is, but any responsible male partner would say it's half his as well…. I believe very strongly that a man has half the power in that situation, if he chooses.

I think the ultimate job would be in teaching.

Discrimination doesn't matter to me. When I see a person, I see a new opportunity.

Brian Brown, age 15
AUBURN, CALIFORNIA

I like my brother a lot…. Especially with our parent's divorcing, it forced us to be pretty close…it was just kind of this unspoken bond, simply because we knew we had each other.

I hope that our current president George W. Bush is booted out of office. This man's presidency has been a catastrophic failure of everything that we believe in as decent people of such a "great country," as he puts it. But I also feel that there are much bigger issues to tackle.

I daydream about what if I wrote some, you know, groundbreaking philosophical book about something, and formulated some radical theory that hadn't come up before…. That's a fantasy for me. I hope to be intellectual and creative enough to maybe—you know, whether I'm rich or not I don't really care; if it had some profound effect it would be really nice.

Mark Brown, age 17
AUBURN, CALIFORNIA

My biggest fear has, over the years, been being uncomfortable and not knowing what's going to happen. It happens if I go and meet new people, or if I am doing new things and I'm usually more afraid before I go because…. I think I might be uncomfortable and I'm afraid of not knowing exactly how things are going to turn out.

I think right now in this period of my life—this changes over years, but right now—a big drive or emotion I have is worrying and insecurity…not knowing exactly what I'm doing and always questioning myself, this entire summer I've been questioning staying at home versus doing something, so…basically a questioning or doubting or worrying feeling.

A lot of times even though I do things, I don't do things; I hesitate. And there are times that I really wish I would live in the moment and take advantage of things and a lot of times I don't…. I don't like how much I regret things, and that is one of the things I don't like most about myself.

For me the toughest thing about being a teenager is you're expected as a teenager to be having the best time of your life…from an adult perspective…adults looking back and saying, "This is the best time, you should have no worries." For teenagers, for me, we don't feel that way at all, and are worried. And so, it's sort of, not feeling that you're missing out on the best time of your life, but that it's going to pass you by and you're missing it.

Elea Walker, age 17
Sewickley, Pennsylvania

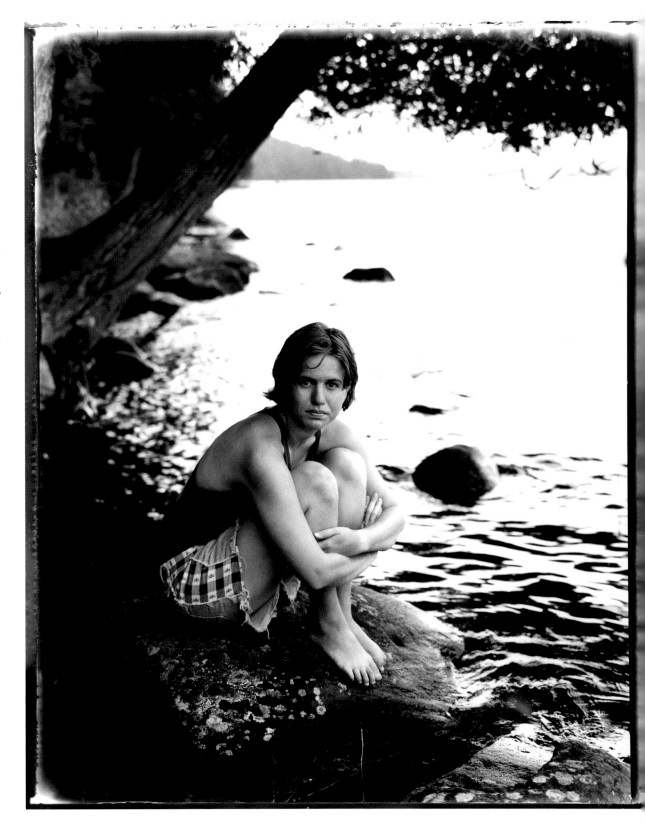

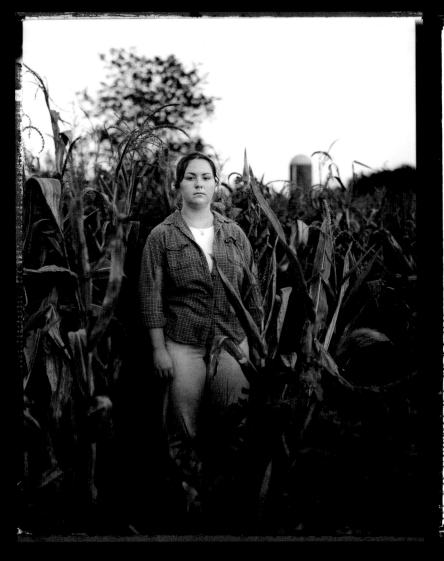

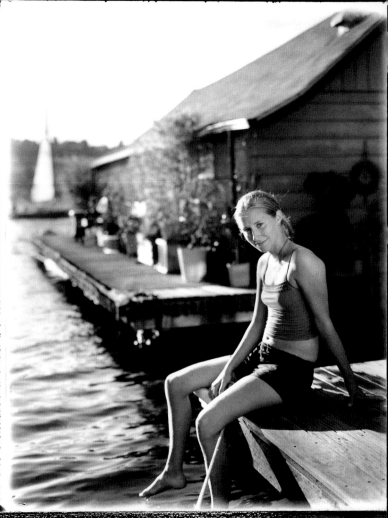

What bothers me the most about myself is probably my size. I feel I'm overweight and need to lose weight to fit in.

I probably respect my mom the most because she has to put up with keeping everybody in the house from arguing and making sure we all get fed and have clothes to wear and making sure we have money and stuff.

The biggest problems in the world is racism. Because it's everywhere and we can't get away from it because we're all here and we've all been mixed, so let's just get used to it and live life.

I can try to change the world by being happier, because they say a smile's contagious.

Melissa Raver, age 18
ODIN, ILLINOIS

Photographed September 1, 2001

When I was three and a half, my dad died of cancer. It's very interesting how young children deal with grief. I thought I saw his soul drifting away as a star. I saw this really bright thing flying out the window. I think it was like a plane or something, but in my mind I was like, oh, that's his soul.

School obviously isn't everybody's cup of tea, but I love it. I might just end up sticking around universities for the rest of my life and doing research.

It would be nice to have some extraordinary talent which could help me do something to leave an impact on the world, for the good of most people.

I have been living on a houseboat my entire life. I used to tell people that it would rock me to sleep at night. It definitely makes me yearn for water…just having this whole community watching you grow up.

Lily Walkover, age 17
SEATTLE, WASHINGTION

Photographed September 21, 2002

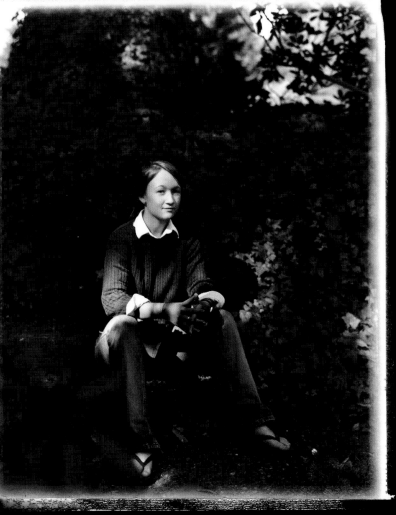

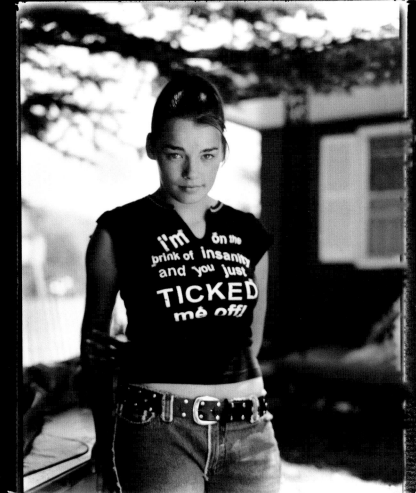

My earliest memory is seeing my father cry. I remember my mom and my dad got in a fight (because they used to fight a lot before they got divorced) and he was just sitting on the stairs and I just remember coming up to him and seeing him crying. It's just been this memory like, I've written stories about it. It's haunted me, I guess.

It's really hard when there's this huge stereotype that when you're seventeen you have to act this certain way, that you're a hooligan, that you do everything wrong. We're just mini-adults. In fact, I'm kind of a big nerd. I like learning. I like interacting with people my own age. But when I find something fascinating, especially science (something of a passion), I just want to learn more and more.

My fantasy job would be head astronaut or something like that.

Taylor Reiss, age 17
BELLEVUE, WASHINGTON

Photographed September 21, 2002

I don't like staying with my mom…she's not there. She's crazy…she acts like she's twelve. I did have a job, but she took my paycheck. She had just barely moved into this one place and needed, like, dishes and this and that, so she took my paycheck.

I think I could have an impact on the world. I've always wanted to be a pediatrician, and then I wanted to be a surgeon, and then I wanted to be a photographer. I think I'm just going to do, like, two of them. I think I'll stick with the pediatrician and photography.

But really I've dreamed of being in a beauty pageant and being Miss America or whatever. But I know it's not going to happen…. I have no idea what I am going to be, I just hope it is something good.

Diamond Aviles, age 15
MONTELLO, NEVADA

Photographed August 10, 2002

I've been gay-bashed before. It happened about a year ago. It just made me open my eyes up to realize that you can't trust anybody that you barely know, because I didn't barely know this kid. He came to my door and just beat me up, you know. I was in the hospital for two days. He had one of those big brass knuckle things and he hit me in the head a couple of times with those and beat me down to the ground. It actually makes me scared to go home to Indiana, because he had told a lot of my friends that if he ever sees me again he is going to kill me this time.

I was raised Pentecostal, growing up in a family we went to church. To this day, I don't go to church every Sunday, but I still go to church. I mean, I pray before I eat lunch, dinner, I pray every night before I go to bed. People have told me that gays go to hell and everything, but I'd like to see in the Bible—they say it's in the Bible. Until that day, I will believe everyone is treated equally—gay, straight, whatever—and we all go to Heaven.

My dad was a deacon in the church. The pastor was my uncle. My dad just found out I was gay three years ago and he disowned me. I don't think the church would support me, knowing that I was gay. I don't think they would allow me to go in.

I can remember when I played with my mom's dresses when I was a little kid. I think I was like seven or eight. Somewhere right in there. That's why, when I came out two or three years ago, she knew all my life… she had time to accept it.

I've been doing drag for about thirteen months now. I had my first pageant last year around Valentine's Day and I won Miss Valentine Savannah 2001. It brings out the flamboyant side of me as a boy. When I'm a boy, I'm gay, yeah, I act gay, but when I'm in drag I can let it all out because I'm a woman, you know?

I would probably have wished not to be gay. It's not a problem being gay or anything but you just have so many people that are homophobic and stuff, and it's really hard on the gay community to get along with straight heterosexual people. But these days people are starting to be cool with gay people. I mean, it was bad growing up.

But I'm very, very kind to people. I'm very open-hearted to people. I give people advice. I'm very respectful of people. I'm just a nice kid—a nice guy. In fact, I think I'm just an all American boy.

Brittany Nolans, age 19
SAVANNAH, GEORGIA

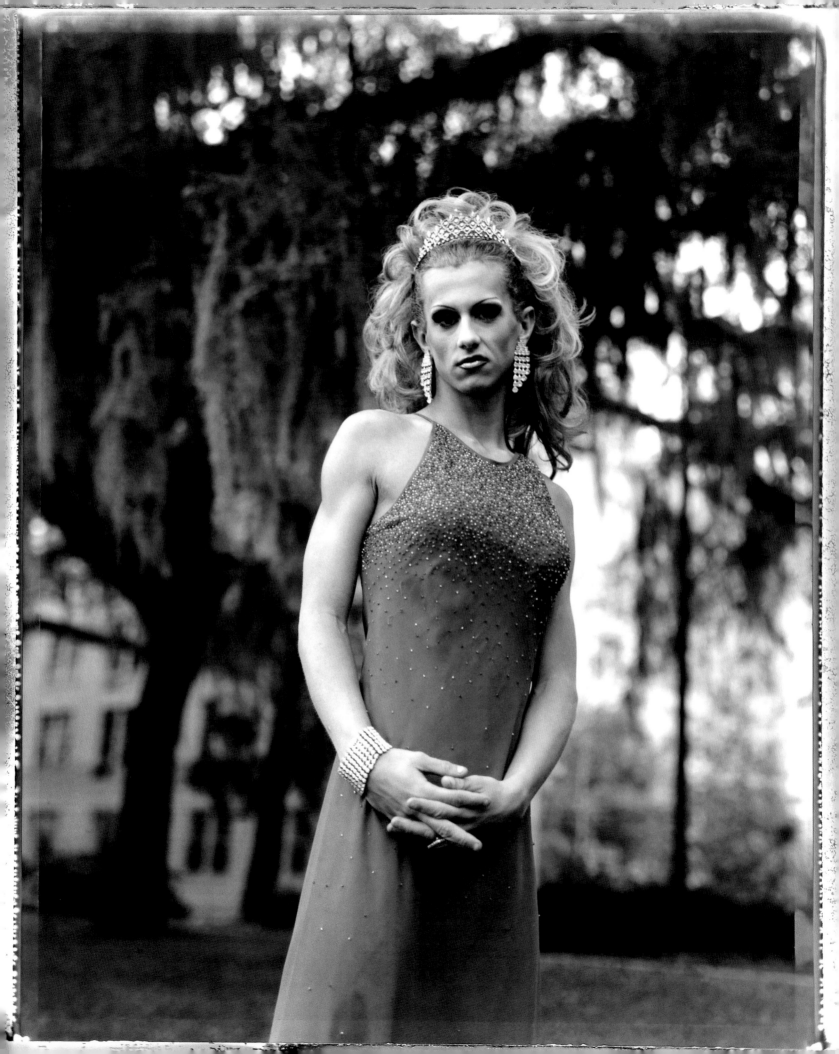

I doubt I'll go to college. I guess I got this job, and I don't want to make time for college…. I started working, and then after that I pretty much knew I would want to work the rest of my life instead of school.

I got my first job when I was sixteen years old. Because I was worried, I thought I was going to be a daddy. You get scared, so I thought, I'm not going to be scared no more. I'm just going to get a job and that way if something does happen I won't be in as bad a shape then, if something did happen.

I'm lucky to have this job 'cause they pay really good: $15.50 an hour…most miners only get forty hours a week and here we get sixty hours a week and on overtime that pays real good money…time and a half. I guess while I'm young I don't have to sleep as much as an older person…. We start at six every morning, and we work six days a week, sixty-eight hours a week.

One of the biggest things that's ever happened to me would probably have to be my girlfriend, and it changed my life from where I was doing basically, just things for me, now it's things for me and her both. We're planning to get married…. We've been going out a little over three years…. She's nineteen too. Meeting her made me want to raise my own family, have a great job, do everything for, you know, her and me and the family, that's what I want.

My dad worked in the mines for twenty-two years in West Virginia, and then he hurt his back so he's disabled now. He's at home. We don't get to do as many things as we used to because of his back and because I work a lot of hours. Some days he's in pain and some days he's not. Some days I come home and he's trying to get into the house and he'll just fall over. Some days he's walking around fine. In the future I would like to be a foreman here at a mining company…. Maybe superintendent. I'd like to be a superintendent, or maybe even a mine inspector. I would like to do any one of those.

My biggest fear is dying, while the emotion I feel most is probably love.

Michael Blankenship, age 19
MAJESTIC, KENTUCKY

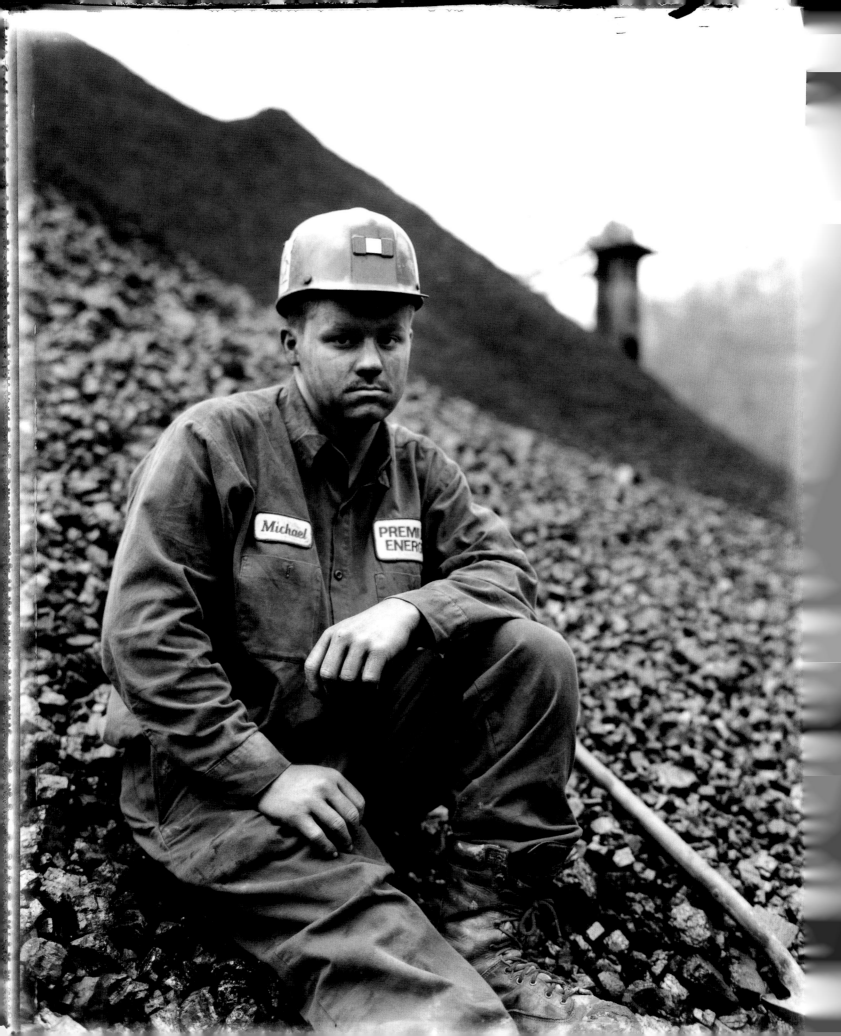

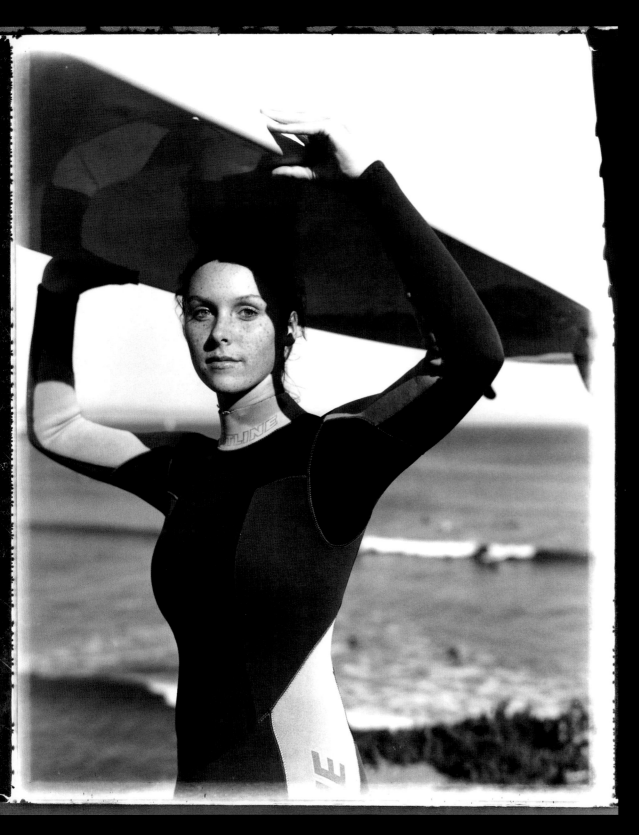

I feel like surfing is so many things I can't even explain what it is! I love surfing because it's so breathtaking, and it can be relaxing and a way to get out of the stressful ways of life, and also it's just so, almost dangerous. You get in so many dangerous situations where it's like a life and death situation. I see how easy it is to die and it's brought me close to that feeling, going underneath the water for so long and going, "Oh, I wonder if I'm gonna get up?" Almost dying—that's thrilling, especially when you're a teenager, I mean, shit, that's great!

I remember when I was in pre-school and I didn't like when my mom left me; I wanted her to stay. The teachers knew I used to run after her in the parking lot. So they closed the door and locked it and I was a very small little girl and I was just flipping out. I took a chair and I broke the window! There was a little side window and I broke it and crawled through and ran after my mom's car.

All of a sudden teenagers have to go through getting zits and all the gross stuff and changing…it's the beginning of womanhood. And men! Men! Men! Oh, my gosh, I hate men! I hate men, but I love them at the same time! I think that's a big thing. And teenagers, we create our own drama, it's like we create our own hell when we're kids.

Oh, gosh what's my biggest fear? I don't know…this is really hard for me to answer. I don't like when people are dishonest towards me. Can that be something? I guess I don't really fear much of anything.

Ariel Ogilvie, age 18
LOS GATOS, CALIFORNIA

I killed somebody. My boyfriend cheated on me and I found out. I went to the house to speak to the girl but it didn't happen how I intended. I didn't get to speak and I shot her and she died. I was sixteen.

I really can't express how I felt at that moment because it's kind of hard to remember exactly. But I know I was stuck. I was in shock. I never meant for it to happen so when it did happen, when the gun went off, I was stuck. I was surprised. That was never my intention. I just blanked out.

I was pregnant when I got locked up. I lost the baby. Miscarriage, stress, not having the proper medical care. This might sound crazy, but I think God did it for a reason, because my boyfriend's locked up now. I'm locked up. What would we have done for the baby? But I do want a family. I want to get married, I want two kids.

My earliest memories is of my mother being an addict and having to try to raise myself. Ever since I've been locked up she's been clean and I'm very proud of her.

Life in prison sucks. Every day is hard for me, because every day I wake up not wantin' to wake up where I'm at. You have a lot of people here who just don't give a fuck about nothin'. They just always want to start trouble with you. You have a lot of officers that care, but you have a lot of them which are just plain old assholes. They look at you like you're not human.

Killing that girl bothers me a lot. I feel bad and that's something I'm gonna have to live with every day of my life. I ask God every day for forgiveness. It's not nothing that I'm proud of, but I can't change it.

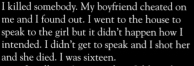

Aramitha Holland, age 19
BUFFALO, NEW YORK

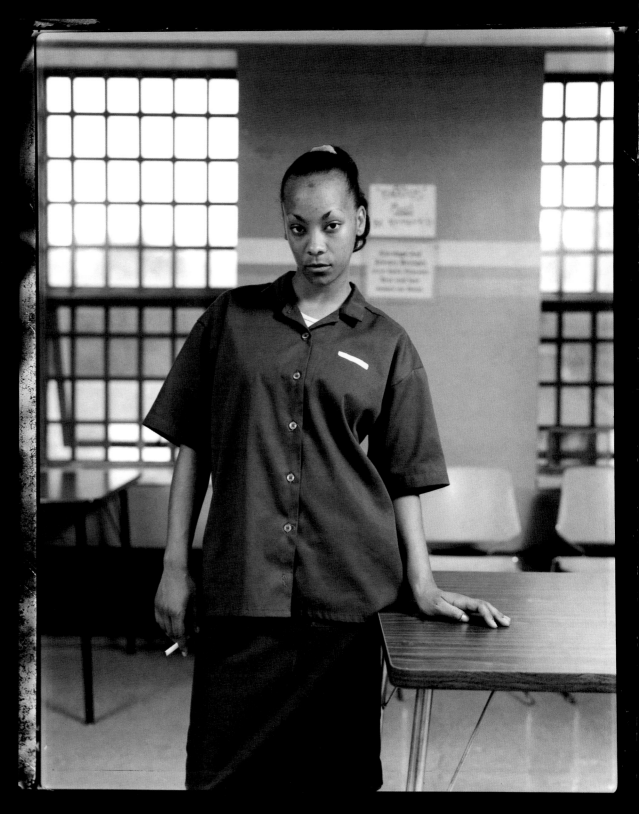

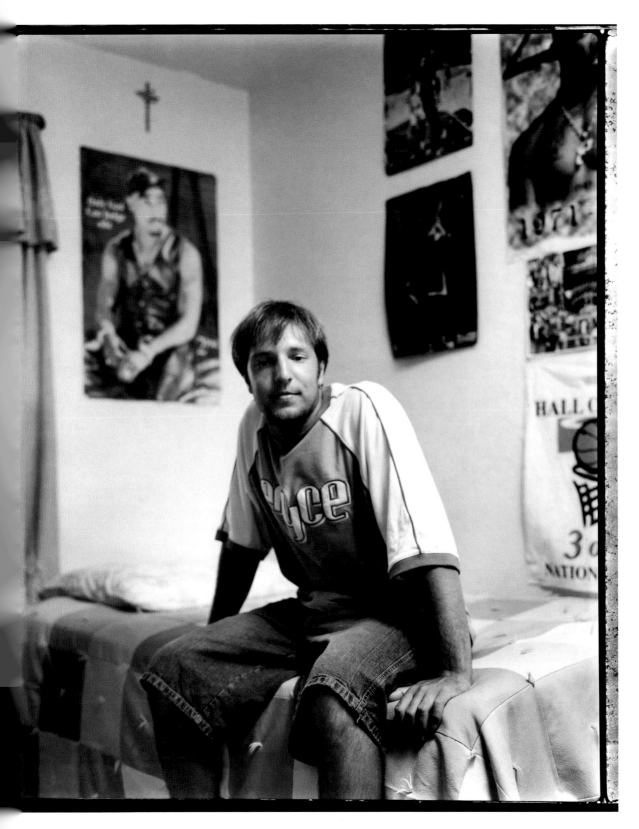

Moving to America totally changed my life. I moved from a city of about 300,000 people to a small town of about 2,000. Back then, I went exploring the first day on a bike and I figured I'd figure out this town. Well, I came back in about fifteen minutes wondering where the rest of it was.

My family broke up when I was around eight. My mom came to America to try and get away from the poverty of the Ukraine…. You don't have a chance to, you know, better yourself like you do in America.

I never thought that I would leave the Ukraine. As the first year or two went by, I kept contacts with all my friends and wrote them, but as time went on I forgot how to read and write in Russian. I learned English, which I used to hate, and now I speak without an accent. I guess no one can ever tell that I'm foreign. I don't know, I just got Americanized (laughs)!

Of course I've suffered discrimination. Especially when I first came here. You know, people, "I have lived here longer than you have, so you're scum." It's like, okay, I mean look at them, they're idiots. I mean, they're gonna work in a car shop the rest of their lives while I'm going to go and do something else…. I dislike a lot of people, I'd have to say, but never for their beliefs and religion or race or their color, or anything like that.

I wasn't, you know, surprised or anything by 9/11. And I guess I'm not really all that upset about it, because I think America had it coming…because of arrogance, and of the way they treat other countries.

I guess my dream would be to head a corporation, you know be a CEO. Be the boss…the boss of all bosses, that's my dream.

Dimitriy Vanchugov, age 18
POSTVILLE, IOWA

I had heart surgery and brain surgery when I was seventeen. I had a corruption of my aorta, which is pinched, and so it caused an aneurism to rupture to my brain.... For a while I was just really obsessed with death, like, "Wow it could happen at any second." I was never really scared, it was more like an awakening, what we take for granted and everything. I wrote my own eulogy and I wrote a lot of prologues—sort of poetry—about what I'd want to say, to convey to my family members, or just people I knew before I died....

My parents have been married since they were twenty-five. It's really cliché, they just stopped talking to each other, stopped caring. It's like a song, stay together for the kids, you know? It's been going on for probably the last two or three years. It wasn't really noticeable until my heart surgery, a kind of thing when your family should pull together and be there for you. My dad just took off and went on business trips, and my mom was there for me, and she was kind of resentful about that.

All through my childhood just, like, my parents presented God as not really like, "God exists", but like, "Here's all the facts about God. Decide for yourself if you believe in it or not." And when I experienced my brain surgery and heart surgery, I realized a lot of the faith that I never really noticed before. When I had brain surgery there was a time when I noticed angels above my bed and things like that, so....

I think I will become an English teacher, because that's just my goal. I want to teach seniors in high school, and to become a writer and as fantasy goes, I have a band, so I'd like to be a rock star.

Austin Anderson, age 19
BERKELEY, CALIFORNIA

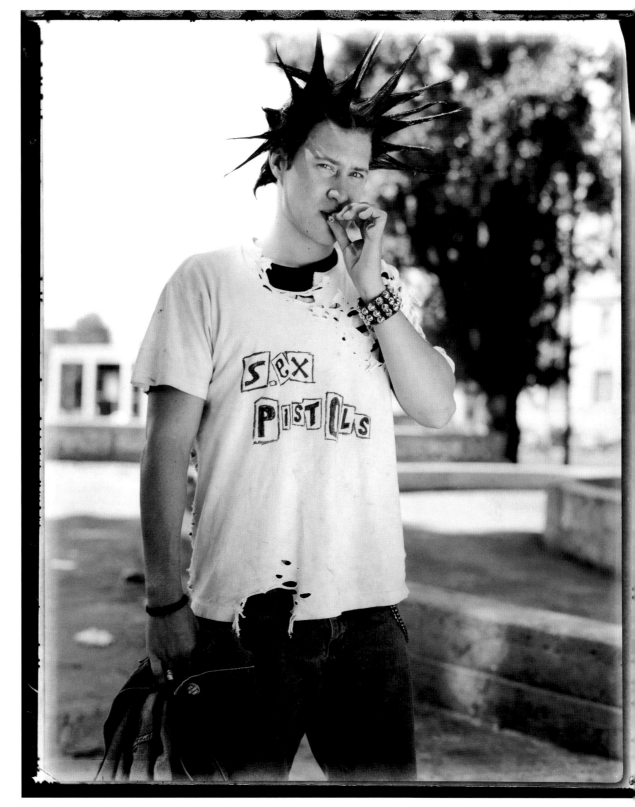

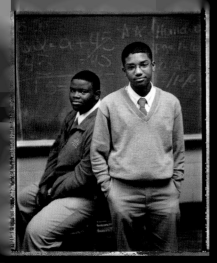 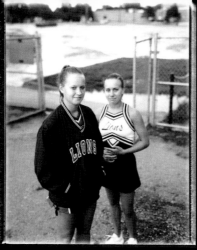 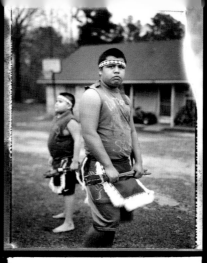 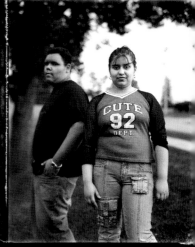

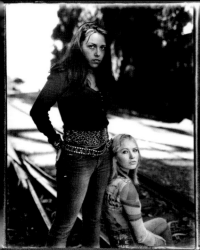 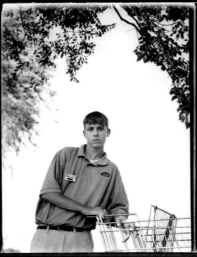 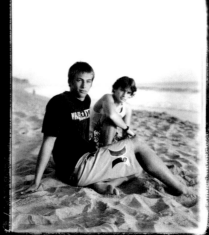 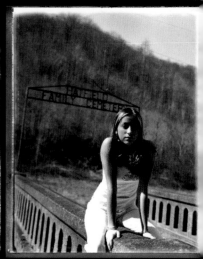

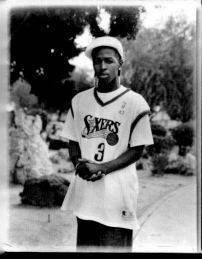 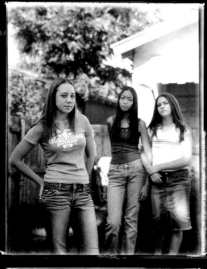 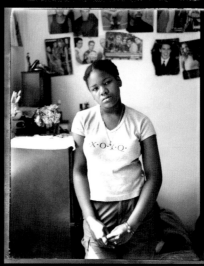 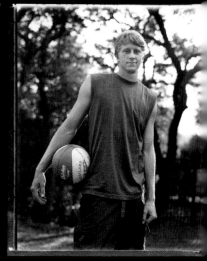

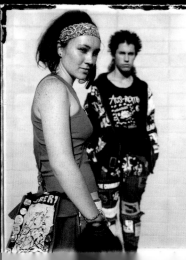 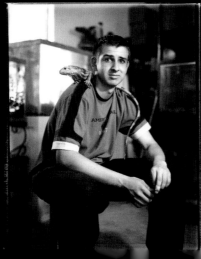 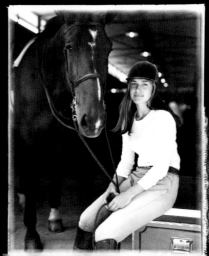 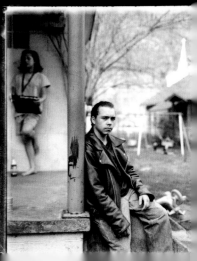

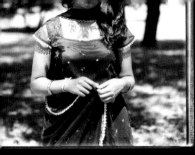
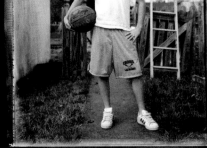
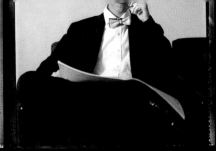

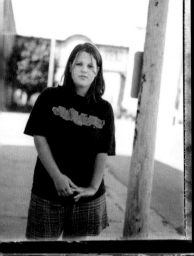
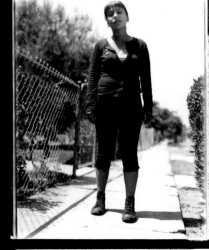
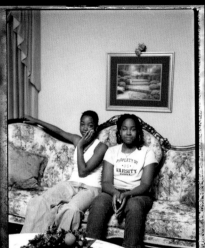
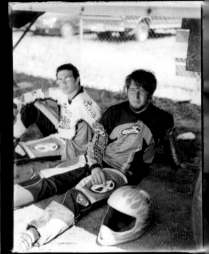
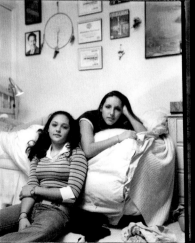
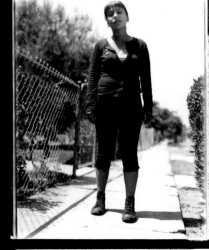
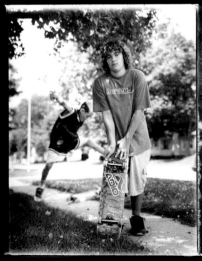
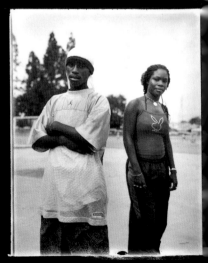

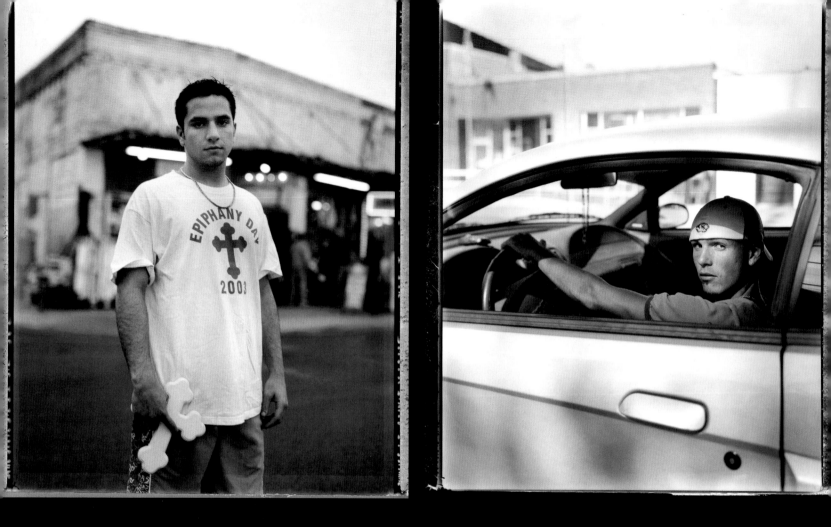

Retrieving the Cross is a celebration of the baptism of Christ in the River Jordan. Here we have one of the biggest celebrations in the world. It's a religious event and whoever retrieves the cross is said to have a year of blessing. When you grow up in this town, it's something that you look forward to doing. I caught it on my third year, my final year.

I don't know if retrieving the cross really changed me. I was very happy…. It's probably changed my life a little bit.

You can never go wrong with a college education. It's just that college isn't for everybody. Right now I'm selling real estate. I just got a job, I just got my license…. I'm gonna try this out for a bit. Maybe I would go back to school; who knows what I'm gonna do.

I was Amish until I moved up here. I didn't agree with a lot of their ways. In church they preach one thing and then, I mean I seen it every day, they don't live up to what they preach. After I left there, I live a whole different lifestyle. Back there I rode around in a horse and buggy, and here I ride around in a car. Everything's just completely different. I think I like it better, but I'm not doing what my parents want me to do. That part doesn't make me feel so good.

It'd be really hard to change from what I am now, to come back to religion like my parents are. I wouldn't have any TV or radio. I couldn't date, or go out with the girls; they don't do that.

I spend a lot on my car…it's a Ford Mustang GT. It's kind of a bad boy car.

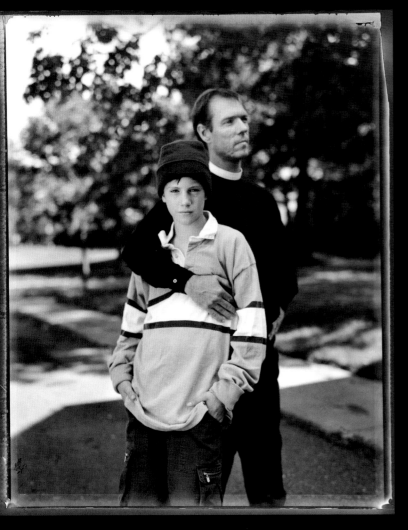

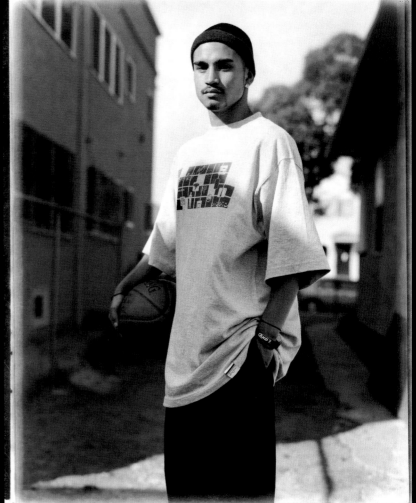

I believe in God…. I go to church every Sunday, and my dad's a priest. He's Episcopal. I'm not very into this whole religious shmiel. I don't really like going to church every Sunday.

I would say I respect my dad the most, 'cause he didn't join jobs just to get rich, he did what his heart wanted to do.

I want to become an ER doctor…. I'm not very scared of blood and I think it's kind of cool. I will make a fair amount of money. I'll quit the doctoring at, like, age forty or something, and then I'm going to start a paintball chain….

I want to have a lot of kids. Like, twelve (laughs)! Because I think it would be a lot funner, and it would be like a play place by itself, you wouldn't have to invite friends over and stuff.

Sam Walsh, age 13
SHAKER HEIGHTS, OHIO

Photographed September 28, 2002

I feel like, kinda, killing myself once in a while. I get these weird thoughts, like I have nothing to live for anymore.

My parents separated six months ago…it changed my personality. I kinda just want to be the old Frankie. My attitude has changed since the divorce…things get to me. I like being lonely now. I'm usually in my room listening to music, watching movies. I hardly go out.

It's kinda hard walking around the neighborhood. You know, a lot of shooting, you know…. You get in fights, it's hard!

Who do I respect the most? There's this one staff member at the Boys and Girls Club, 'cause he tried his hardest to make the community better. His name's Ricki, and I respect him a lot…he likes kids a lot.

If I could be someone else I would be Bill Gates. He started off at the bottom and now he's at the top.

Frankie Velador, age 15
EAST L.A., CALIFORNIA

Photographed August 22, 2002

No, I've never had a boyfriend. We don't have boyfriends cause the boys and the girls don't mix. When we're old enough, you know, to get married—then our families find people. Or you find someone and they check out the boy (or the girl), and then they set up a date.

I want to have a lot of kids…maybe seven or eight. I will marry within the Hasidic community, 'cause I wouldn't marry out of my own religion.

I think I might go to college. I want to study cosmetology. Like facial stuff, makeup, nails and hair and stuff.

If I could fix one problem in the world, I'd like to fix the thing about Israel and the Arab countries and all the suicide bombers.

Menucha Lederman, age 15
POSTVILLE, IOWA

To be Hasidic means basically someone who does more than what is required from them. The whole religion is geared to keep yourself separate from non-Jews. Not in a bad way, but simply to protect, to keep yourself Jewish. You have requirements to fulfill, and you have things to do and you can't forget that. You have obligations….

So why is being a Hasidic Jew important to me? Because since I am a very logical person, and I like to have a meaning in what I am doing in life, and I need a reason.

Within that Hasidic community girls get married within the ages of eighteen to twenty-four. Am I ready to get married? I don't know. I have stuff, and time, and things I want to figure out…. What would I like to do? First figure that out myself!

Both my parents were not raised religious. They were young, in the 60s, and things were kind of different. But then they got married and they came back to Habad, which is to help other—help teach other Jews what the Torah has to offer them.

My fantasy is to get a degree in law, and then in hand-writing analysis and psychology. And to go on and to work in detective work, FBI work or something…. What will I really become? A mother. I think that is a very important job to take very seriously. I think I will also go to a community that doesn't have as much religious Jews and establish it there. Build it.

What bothers me the most about myself is that I'm sharp and observant and I can't keep my mouth shut sometimes. So I say it, and I shouldn't say it. I should just keep quiet, and just let the other person say what they want to say.

Perel Lederman, age 19
POSTVILLE, IOWA

I'm Jewish, Hasidic. My personal reaction to it is it's cool, 'cause it's very different. I like long skirts, personally. But you can't really wear anything above your knee. You can't show your elbows, and your neckline can't show. In the summer, you go to waterparks, you can't wear bathing suits. So I wear long clothes still, and I feel weird, but I do it anyways.

My belief in God is important to me personally, because I believe someday the redemption will come and I want it to come. We're waiting for it. I believe it will come soon. I just believe it; it comes naturally to me.

My religion isolates me because other people look at me differently. Being a Jewish blonde is very interesting….

My family is very fun. It's really cool, we have six kids. Five of us are girls, one's a boy. That's pretty interesting for him probably, but we have a lot of fun. I personally think my parents are really cool. My father plays guitar and drums. My mother plays harp, violin, and piano.

Henna Lederman, age 13
POSTVILLE, IOWA

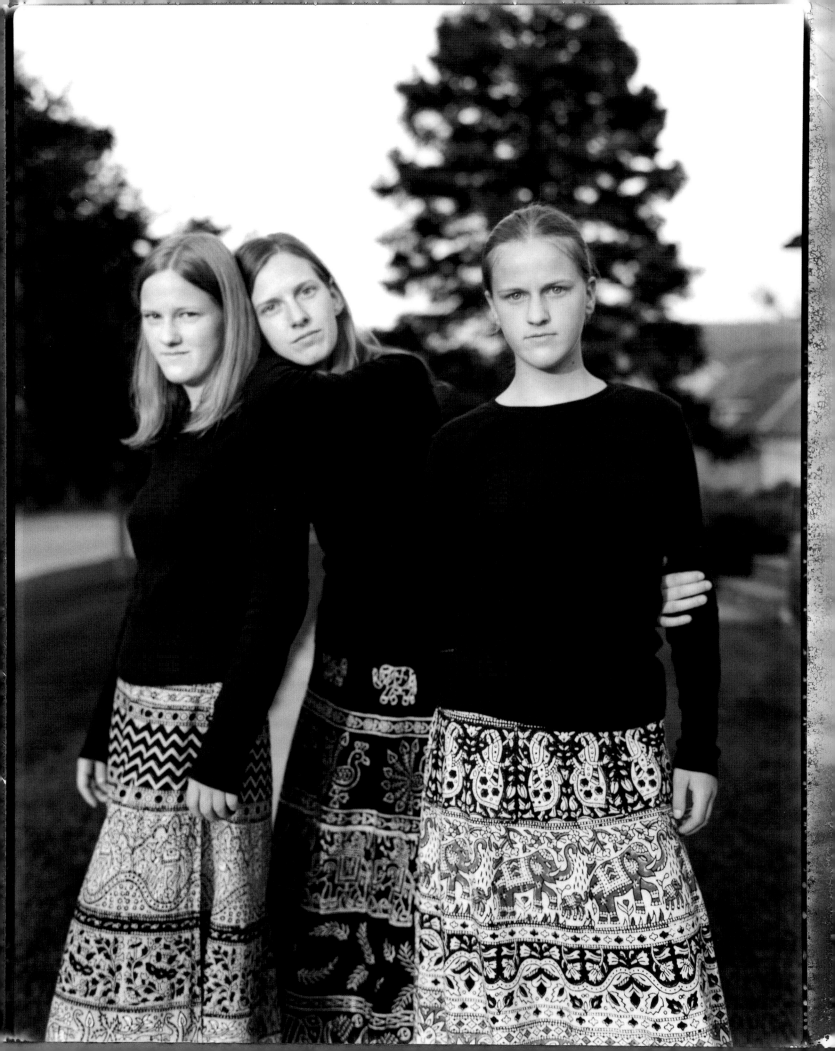

One thing in the world I would change would be social outcasts, because everybody should have a chance to do well and shouldn't be picked on because they're not rich enough to afford stuff.

Stewart McAdams, age 16
JOLO, WEST VIRGINIA

My mother, she used to be a runabout. She didn't like taking care of her young'uns. I was put in the welfare home and my grandmother found out and she came down.

My girlfriend makes me the happiest. I'm engaged to be married to her but do not know when we'll get married. She'll be turning eighteen this June, and we was hoping to get married on her birthday. She has something planned for me. A $32,000 car she wants for a wedding present. A Firebird.

My fantasy is I want to live like Nelly. He's a rapper, a black guy. He owns a million, probably a billion dollar home. He's got like twenty vehicles—eight or ten PT Cruisers, stretch limos, you know, everything. I would love to live like that.

I'd like to be President of the United States. I think I could if I really tried. I'd like to be George Bush right now so I can attack Afghanistan. For them bombing us.

In reality, I'll probably be a coal miner, marry my girlfriend, hopefully have two kids.

Ray Mowrer, age 18
JOLO, WEST VIRGINIA

I'm Gothic. I believe in being neutral—trying not to put myself in a place where I would influence anyone's belief in religion. I try to remain…more aloof from people.

Gothicism is something that I started believing in when I was fifteen. I met a lot of my friends at parties called raves. (There are very, very few Goths in West Virginia.)

The administrators at my school, they try to give me a hard time. Since I started wearing my Gothic attire to school. They've restricted me from wearing my collar. They weren't even going to allow me to wear this necklace. They're saying it was considered a weapon. The collars are a gift between Gothic lovers. I bought my girlfriend's, and she bought mine.

I have suffered from discrimination because of how much I weigh. People have made fun. I have some friends, if anybody says anything they'll defend me. It makes me feel good to know that there are people that would help me. I don't believe I discriminate against anybody. I definitely try my best not to because I know how it feels.

Jeremy Ball, age 17
BRADSHAW, WEST VIRGINIA

A big thing that changed my life was when I nearly got my fiancé pregnant, and basically when her mom and dad found out about it, it kind of PO'd them about me and her dad is trying to break us up. I don't want to lose my fiancée because I love her a lot and, if I lose her, it will be hard for me to live. We've been together for seven months.

My fiancée told me that if I don't get a job before she gets out of high school, the marriage is called off. It's kind of a big problem right now…. She's fifteen going on sixteen, and I'm seventeen and a half.

My dad passed away about four years ago. He wasn't my biological father—I'm adopted…. My adopted parents have raised me since I was a little baby. So they're my parents no matter what people tell me. I was closer to my mom, but I was really worried about my dad because he was in a hospital bed all his life. He was a coal miner. He was diagnosed with cancer, black lung.

Well, if I can have an impact on the world it would be because I'm quite fully intelligent, and if it was to impact something, I'd probably try to be the first to break the speed of light or something like that.

Matthew Phillips, age 17
PAYNESVILLE, WEST VIRGINIA

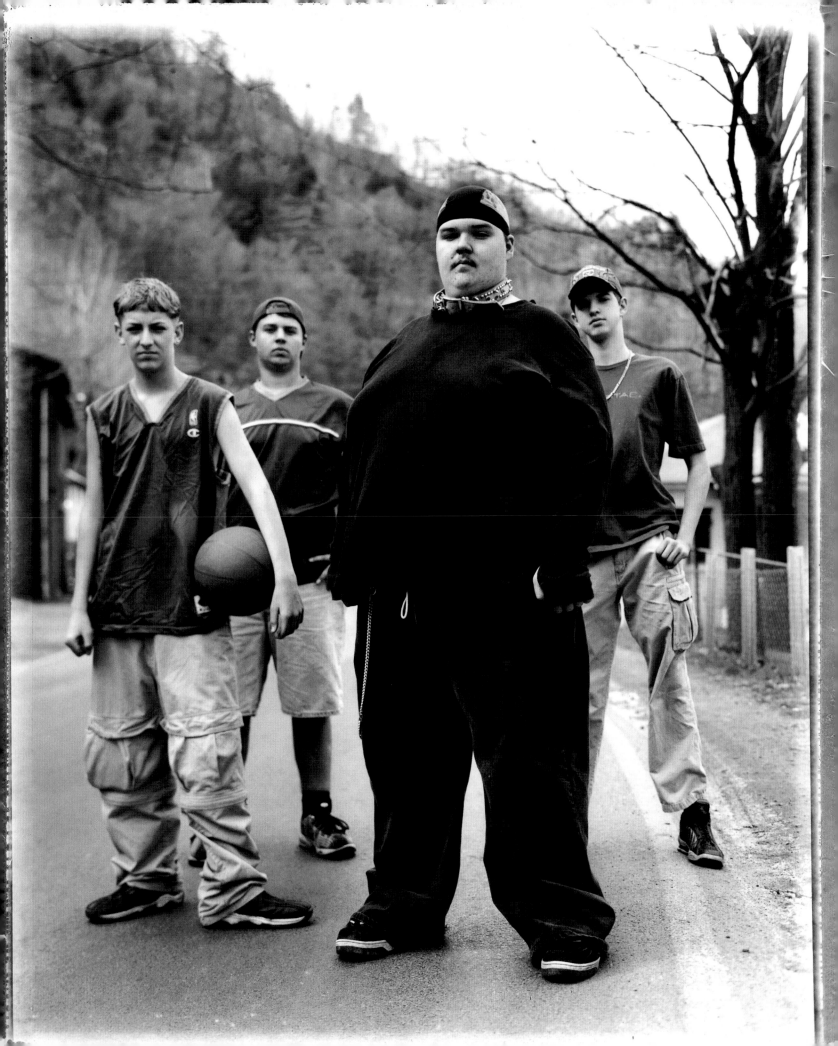

If I could be anybody else in the world, I'd have to be my mom, so I could know how pissed off I make her.

Money's important to me because it gets me stuff, but just having money and being able to say, "Oh I have money so I can go get me some 'ice'"—is just pointless. I'd say my family is upper-middle class…. I'd like to start off at the bottom and work my way up. Be able to earn my class.

A year ago today, on 9/11, I was laying in bed watching TV because my TV has a cool alarm-timer that turns on in the morning. It was showing when the TV came on…. I was frightened at first, but not for my own safety, but for the safety of the entire country, because I wasn't sure what Bush would do. Would he immediately say, "Hey it's this person, let's go bomb them," and then find out later that it wasn't them? Or if he wouldn't do anything for a while. Something like 9/11 could happen again; anything could happen. That's pretty much when my views of society and government started to completely change. When that happened it just went "Boom".

Michael Raskin, age 14
BERKELEY, CALIFORNIA

I'm completely atheist. I just don't believe in any of it. It seems like it's all a big story to me because someone was bored and decided to entertain people a really long time ago.

My biggest fear is being the only person left alive on Earth.

Rosie Fisher, age 14
SAN FRANCISCO, CALIFORNIA

Everyone has parents. Mine just happen to not live with me or speak to me often. I haven't seen my mom in a year or something…. My dad lives a couple blocks from me, so I see him often.

I might marry one day, but absolutely I would never breed. I'm getting surgically sterilized as soon as I possibly can…both for genetic and social reasons, I feel I'm most likely gonna turn into someone that would pose more of a threat to society. The way I would raise kids would be a harm to other human life. Based on the way my dad raises kids, that is. If I lived with him, I would probably be in jail right now. I just have views that should not be spread. I'm trying to change….

I've been discriminated against. A group of guys jumped me a couple years ago under the assumption I was racist…. I got beaten up. Because of my sexual orientation—I'm bisexual and tend to dress as such. I've had guns pulled on me. In one instance this guy just said, "Let's go beat up a fag."

The toughest thing about being a teenager is the overpowering ignorance of other people in society. If I could be someone else in the world? No one. I would never give this up. My life has gone too amusingly to trade it for anything.

Bill Gies-Smith, age 16
BERKELEY, CALIFORNIA

My mom is a neurotic Filipino woman; my dad a gay Filipino man. They were married for fourteen years…then my dad decided to come out. My mom didn't like that much. So I go to my dad's house one week, then I switch the next week to my mom's.

I have a little brother who is the smartest, most pure, beautiful kid that I have ever met. He can figure out things that I could never figure out when I was older than him. I think family's important, but not to the extent that you need to sit down with them all the time and freak out about stuff.

I was almost thirteen when I lost my virginity…it was like the scariest shit that's ever happened to me…. I think teenage sex is stupid, because it ruins relationships.

Jacob Medina, age 15
BERKELEY, CALIFORNIA

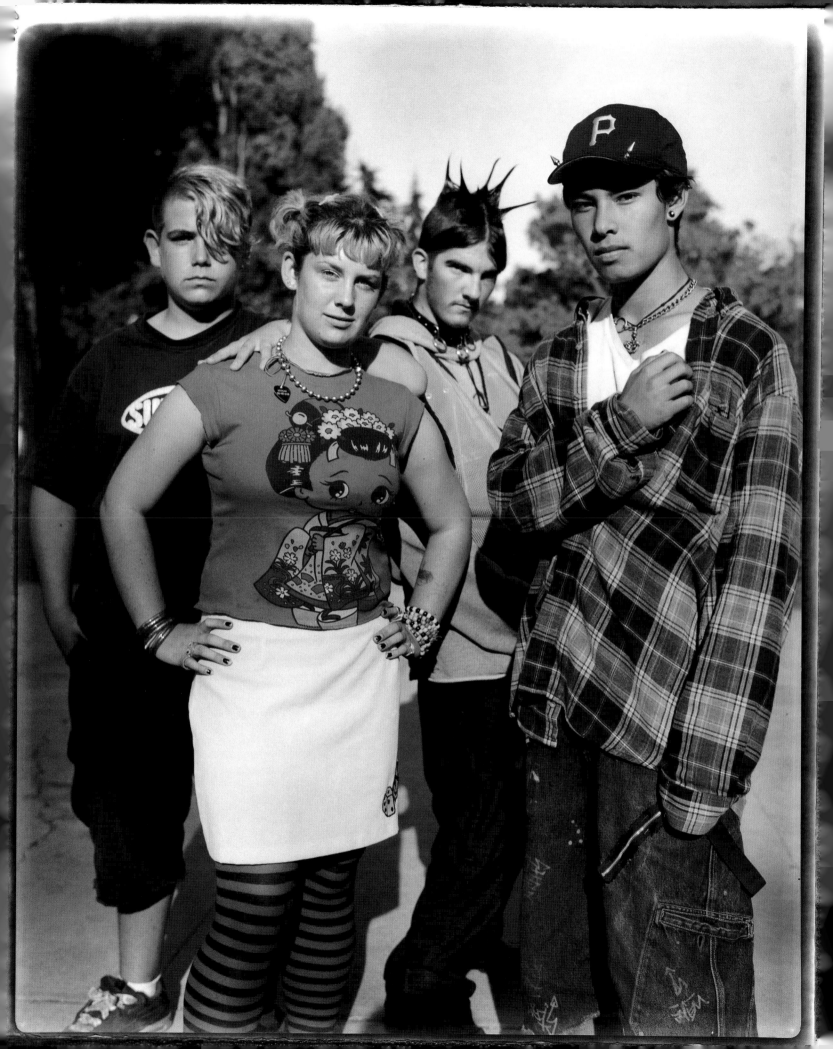

I go to Academy of the Sacred Heart. My grade is really catty and everyone is always in a fight. There's one group of girls that think they're so superior and better than everyone else…. Everyone is just really mean to each other and it's just clique-y.

The first time I drank was the summer going into the ninth grade, so I was like fourteen… I didn't feel pressured, it was my choice. It's my choice if I want to do it now. There is too much drinking in New Orleans, just 'cause it's so easily there. Everyone does it. I mean, I don't do it just because everyone does it. It's just, kind of, you do it.

Leighton Kohlmann, age 15
New Orleans, Louisiana

A lot of kids in my school are really, really wealthy and just have so much money. Their parents don't even need to work. My family—we're not like that. We don't come from family money, trust funds…you know, debutantes and all that…. My parents wanted me to go to a good school so they worked really hard to put me in Sacred Heart. My dad works really hard, too, you know, so that I can keep up with everyone. I know it's really hard. My dad is never home and I feel bad. I feel really bad that he feels like he has to do all that to keep up with everyone. I respect my dad a lot.

My fantasy is that I marry this guy who's a senior (laughs) and who doesn't know who I am—he's kind of like my sister's friend. And so I marry him and we live in New Orleans and we live in a huge house. And I have really cute, nice clothes. We have really nice cars and we have the cutest kids ever, and they have the cutest clothes too, and they are so cute. He has a really good job. I do something really big in fashion and I'm really famous (laughs).

Kristen Tomeny, age 15
New Orleans, Louisiana

I moved from Fort Worth, Texas to New Orleans when I was younger. In Fort Worth I was more religious. All my friends were really religious and then when I came to New Orleans, everyone wasn't really like that.

I do believe in God…. You just have to have faith, in order for Him to actually work in your life.

All of society, especially in New Orleans, is influenced in a way that would make teenagers—thirteen and fourteen year-olds—feel like they have to drink in order to fit in. Saying no is a really hard thing.

I've never had sex. I signed a contract at my camp. I know it kinda sounds weird.

Liz Sowa, age 15
New Orleans, Louisiana

What I like the most about myself is I think I am good. I shop well, I get good clothes; I dress well. What bothers me is my physical self. I hate my nose, I hate my thighs, my fingers, I can't deal with my fingers—they're so fat.

I kind of have two dreams but one of them is, like, the reality one. Okay…. There is this really, really pretty house that I love on St. Charles Avenue. Me and my husband are going to live there and right on the back, behind it, is another house and Kristin, my other friend, she's going to live there. We're both always going to wear really cool stuff and we're going to have the cutest kids and really good husbands. We are going to live on St. Charles and we're going to go shopping all the time. Our husbands will have really good jobs too, so we don't have to work that much, you know…. That's the more reality one!

Hannah Kitziger, age 15
New Orleans, Louisiana

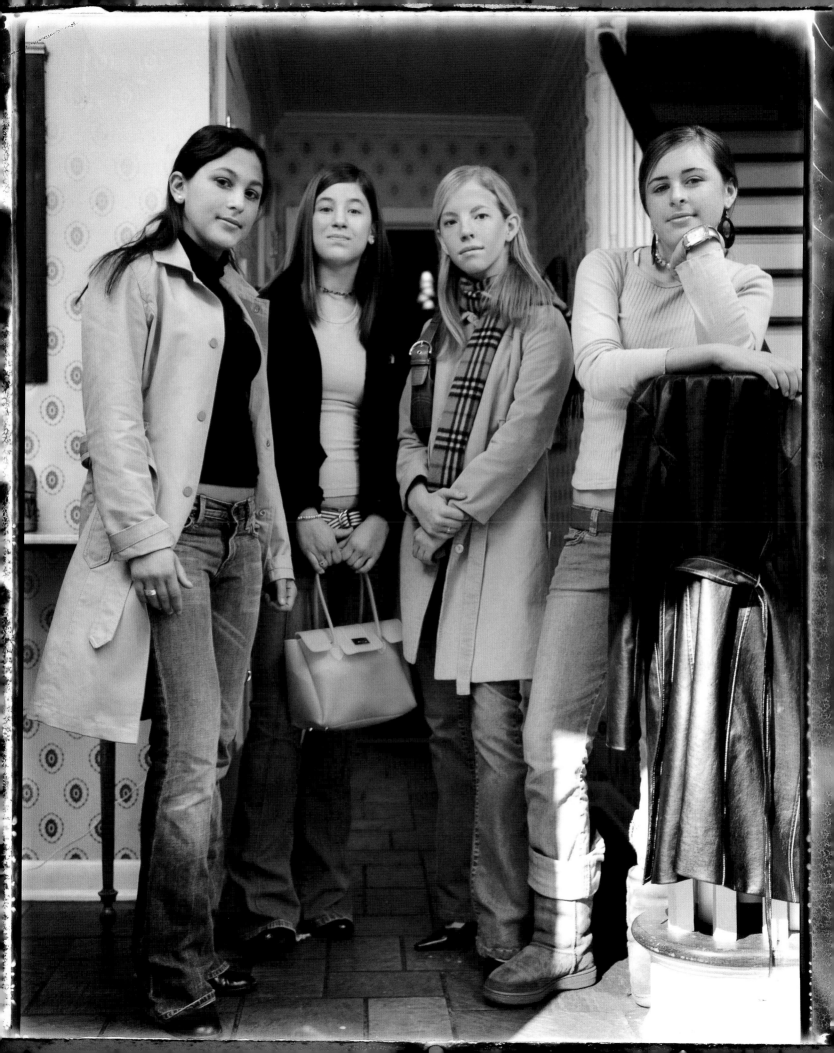

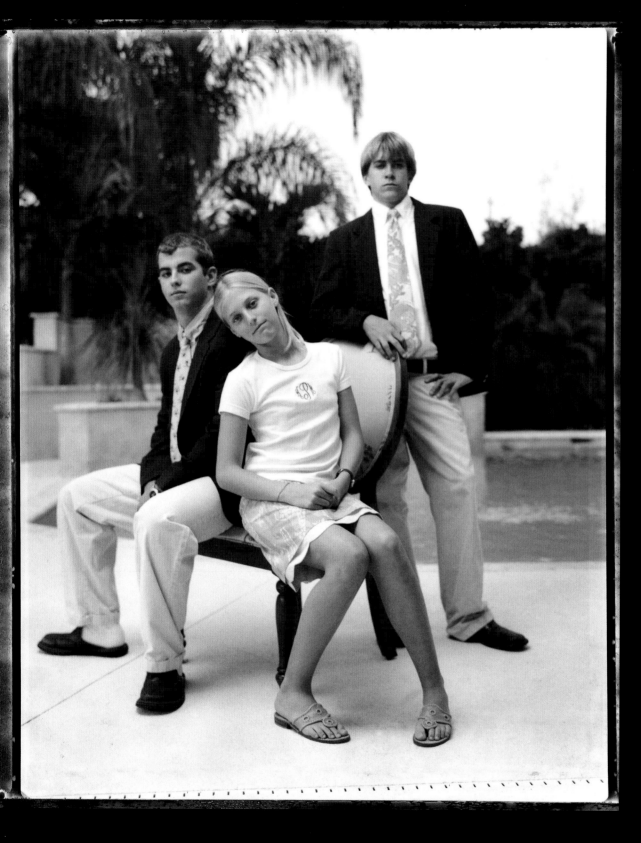

If I could be somebody else, I would be someone who I really respected, and I wouldn't have to do anything.

How do I feel about discrimination? It's pretty much the way you are brought up. The views you were taught about certain types of people and whatever, by your parents, that's how you will think of them

Chip Miner, age 17
VERO BEACH, FLORIDA

My parents got divorced about seven or eight years ago. I was really sad when it happened, but then when my dad got remarried it got a lot better….because I had another mom with my dad, and I had more siblings.

If I could be somebody else I would be my older stepsister, 'cause she's my role model…. She's just really nice and good and doesn't do drugs or alcohol or smoke or any of that.

Kate Perry, age 13
VERO BEACH, FLORIDA

My parents' divorce wasn't that bad for me…. I was probably nine or ten, so I didn't really realize what was happening. It was just different, 'cause we had to live in two different houses and they're, uh, yelling all the time, stuff like that…. I'm closer to my biological siblings than the other ones. Because I have been with them longer and know more about them.

9/11 scared me…because I thought it was going to happen again. Like closer, like, maybe near me here, I guess…. We talked about it at home, what we should do if anything happens. Who did it…like, who was behind all of it, Islam, I guess. I felt more impacted against them, because they were the ones behind it, bombing our country, hurting us. So I guess if I saw one I would think of him the same way as if he would have done it. That said, discrimination is not a good thing. People should not be judged by like what they look like or what color they are, I guess.

Spencer Miner, age 15
VERO BEACH, FLORIDA

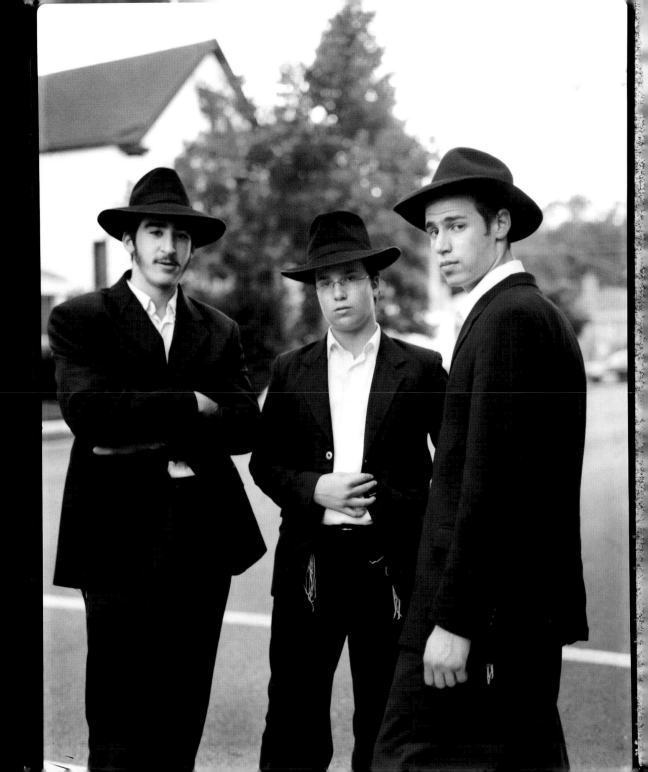

ertainly I want to have a family of my own one day…. In order to find a wife we all the "shatran"…there's a whole system m not quite familiar with.

How will I know if the girl is right for he? From what I gather, I guess, when the me comes, you'll feel it…. We hold that he soul of each person, it's kinda, split in alf, so there's the man and the woman. So here's like two halves of a soul, and when hey come together, it becomes one soul.

We Jewish people have been in exile or two thousand years now, so I don't think could personally "fix" that…. But very good deed could tip the scale, so…if could, I'd like to bring the Messiah, as oon as possible.

Mendy Wolf, age 16
CHICAGO, ILLINOIS

was taught that God is constantly reating the world.

If I could be someone else, I'd probably e the Prime Minister of Israel. Because the rime Ministers who are in Israel usually on't do the best moves, and they usually do hings that harm the country, What would do? Basically I would try and protect the ountry a little more, because, you know, here are constantly guys getting killed in rael from Arabs and everything.

Of course, in my fantasies, I dream f someday becoming the world's greatest aseball player.

Menachem Moskowitz, age 15
CHICAGO, ILLINOIS

go to school at the Lubovitch Boys High chool of Chicago. I enjoy it immensely. ou're part of just one force. You get an nderstanding of who you really are. It's ust a very, very enjoyable and meaningful xperience.

What's it like to be a Hassidic Jew? Hassidim means that every single part of our life is for the purpose of better serving God, which could be done through many ifferent ways.

My wish is basically to become a Rabbi—you have a magnificent, unbeliev- bly huge, humongous, magnificent syna- ogue, with thousands of people constantly oming to Jewish programs….

Yosef Denburg, age 16

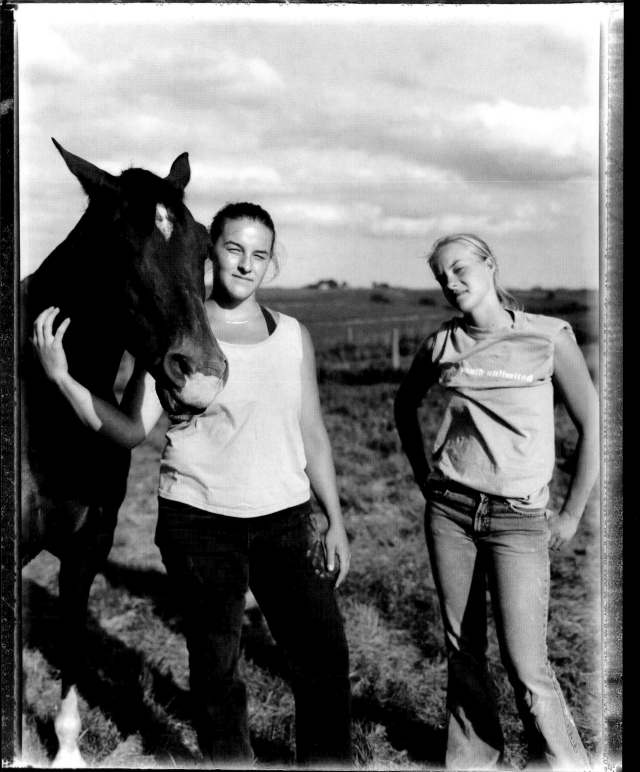

I have suffered discrimination. It's probably not very serious, but being a farm kid and also being Christian, a lot of times at college people won't include you in things. I've had people bad mouth me to my face because of what I believe, as a Christian farm girl that has conservative and traditional values.

My religion is important to me because it gives me hope…. God will forgive me if I do things wrong. To not be looking for people for acceptance, to ultimately know that even if somebody doesn't like me, God still loves me, and I don't have to worry about what other people think, necessarily…. I know that what I'm doing is right according to something bigger.

My dream would be to become a horse trainer. I would have my own big ranch, and kids would come and take horse lessons, kids with disabilities could come and do rehab and stuff, 'cause that's really a neat thing I'd like to do.

My horses are what make me happiest (laughs)!

Jacie Vos, age 19
SULLY, IOWA

I do believe in God. I don't know what I would do without Him. My parents raised me to be a good strong Christian and to love God. At first, you know, when you're younger you don't understand it, so it's kind of almost forced upon you, but now that I'm older I'm really glad that they did it. Now I have my own love that I belt out for Him.

Because I believe so strongly in my religion, I don't understand how somebody else could believe in theirs. I wish I had more understanding….

I think, for instance, Jews, they believe in God, and the same God I believe in, but because they don't believe in Christ I don't believe that they have salvation.

Sure, these differences are why there're wars all over the world, but…I mean, every religion thinks that they're the only religion that gets you to heaven, you know.

Jentri Vos, age 16
SULLY, IOWA

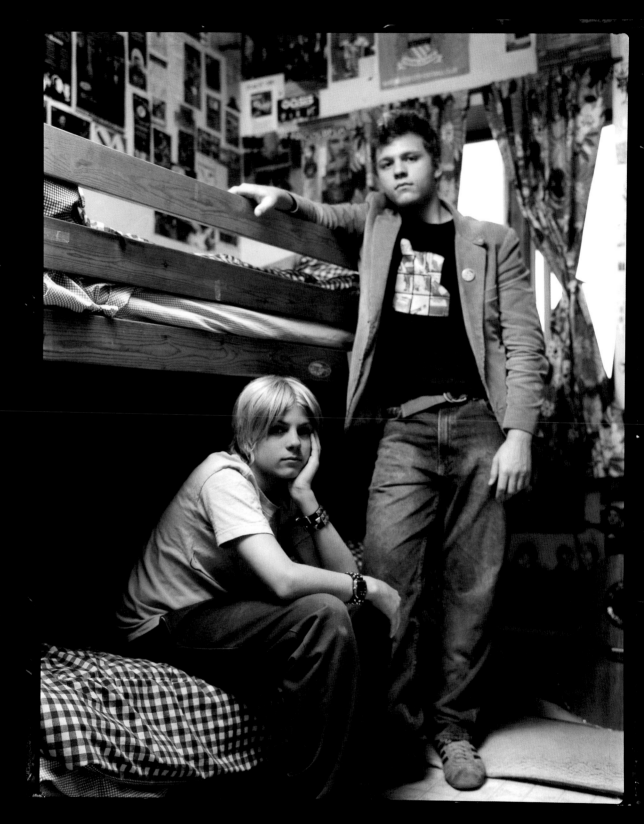

Based on science, no, I don't believe in God. But it's good to have beliefs because you feel that there is someone there for you. I have a mom and a dad and a dog and a brother. Family is important because people who don't have families might feel lonely.

I am sometimes close to my brother, but he sometimes pisses me off and I kind of get mad at him.

Who do I respect the most?... Probably my parents because I think they're really intelligent.

Me and my friends, we talk about girls, but we don't talk about sex. I will probably wait until I'm older to have sex because I think you have to have a reason to have sex.

My fantasy would be to be a scientist because I like science but they are really smart. I'm not stupid, but they are geniuses, and I wish I could be like that.

Jackson Pollis, age 13
BROOKLYN, NEW YORK

One of the biggest things that ever happened to me was getting into LaGuardia High School for instrumental guitar. I was really excited because I knew it would change my way of life. I also got into the Young Writers Workshop at the University of Virginia and I went for songwriting. I've been writing songs since I was eight or nine.

I respect so many people. John Lennon, obviously because he started a whole genre of music. A lot of jazz. Dave Brubeck because it's totally outrageous. People who take chances, that's who I respect.

I want to be a musician and a composer so maybe once the world hears my music I could have an impact.

We were totally freaked out by 9/11. It went away after a while but I wasn't asking why or anything. The World Trade Center was a big part of my life, I'm a New Yorker. I felt horrible about what happened because I think life is precious.

James Pollis, age 15
BROOKLYN, NEW YORK

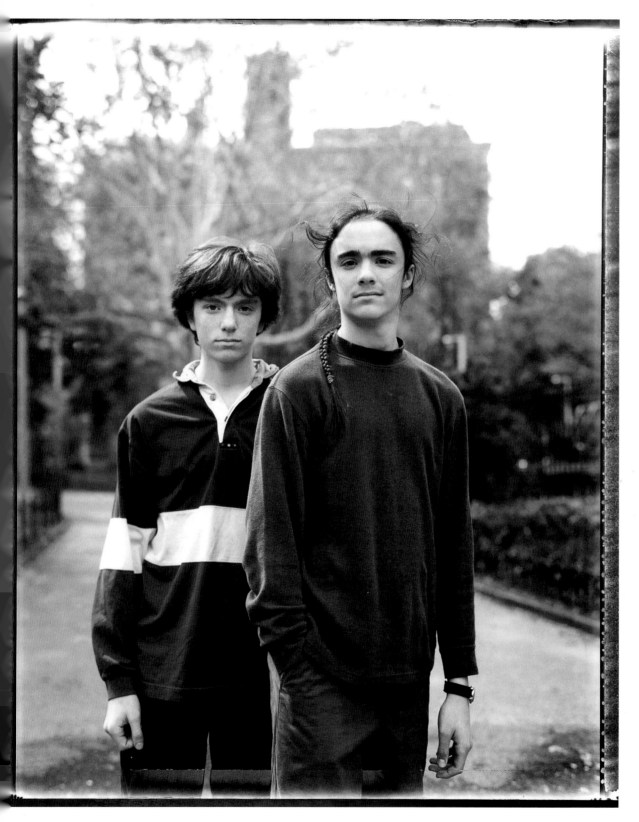

I get tense very easily about stuff. It just feels so good to get it done with. That's the best feeling I have.

I like that I'm not into the "teen culture" kinda thing. I try to be what I think of as where I want society to go, not where everyone else is.

Honestly, I haven't thought about girls that much. I don't know why I'm not into that right now. Maybe it's just because I haven't had it. Maybe it's because I'm shy, maybe it's 'cuz I don't like other kids that much. Sam will tell you all about "Oh, I hate other kids" blah, blah, blah. But he's had some more people he could consider real friends maybe.

I wanna be a politician maybe, maybe a writer. Maybe a lawyer who turns into a politician who likes to write short stories.

Gabriel Lord Kalcheim, age 15
NEW YORK, NEW YORK

The toughest thing about being a teen first of all is all the work you have to do from school…the whole social thing is kind of annoying. I'm way different from anyone else.

I have a twin brother, and we're very close because it's like a built-in best friend you have.

I respect my parents a lot because of how they've gone forth in their own careers, and had a great family at the same time and they are both very happy.

Fantasy—it's not like huge, I would want to become maybe a songwriter, composer-type thing, and maybe even a playwright. My father's a playwright. I don't want to be really rich, I'd rather do something what I want to do and make a living off of it. But of course money is important because you have to be able to live your life.

Samuel Lord Kalcheim, age 15
NEW YORK, NEW YORK

It's kind of crazy when you're a teenager 'cause your hormones are raging and then everyone around you is trying to find themselves. It's just a cluster of confused young people.

I think education is really important… it's really good to have something to occupy my time, so I'm not just doing brain dead shit, you know. And it's kind of good to have responsibilities….

My biggest fear is that this world is totally going to go to crap. People have lost their morals; their values are kind of corrupt now…it just doesn't look good. People can't respect each other anymore. They're just really selfish and narrow-minded.

I kind of saw 9/11 coming. I mean, the fucked-up shit that America does to all the other countries, it's like, bound to happen. We just think we're so invincible and shit, you know?

It makes me happy when I see people interact and love each other.

Leila Seraphin, age 17
BERKELEY, CALIFORNIA

The first time that I took LSD changed my life a lot. I realized so many things. 'Cause at that time I was really depressed and I just thought that school and the world was just really hard. Afterwards, I realized that there's more to life. That I could have such a deeper purpose in the world…. The next day, whether or not the experience was the best, I woke up and I was happy to be alive.

I believe that there is a higher source…this whole existence did not just come up out of nowhere. You know, this is amazing, we're walking, talking, thinking beings and we're the only one in this galaxy. So there has to be something special to that.

The TV is all lies. Like, most of it. It's like a made-up world that tries to make you believe that this is what real life is like, but it's not…. I hate money a lot. Why should I have that attachment to something that's so artificial and fake?

Hannah Ryan, age 16
BERKELEY, CALIFORNIA

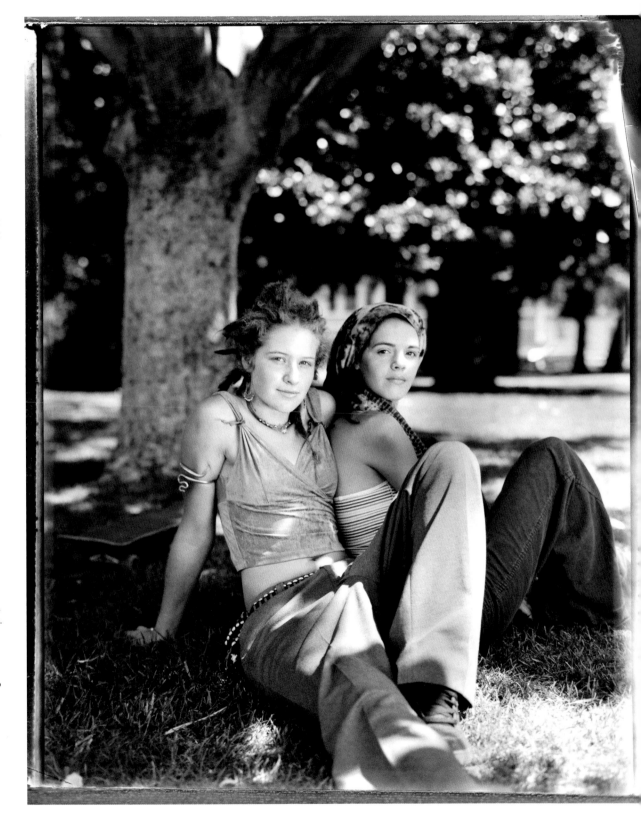

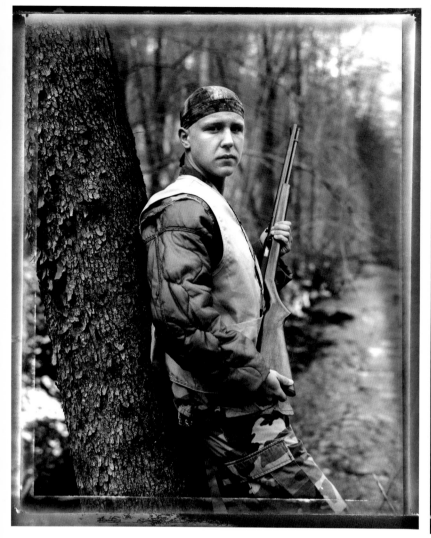

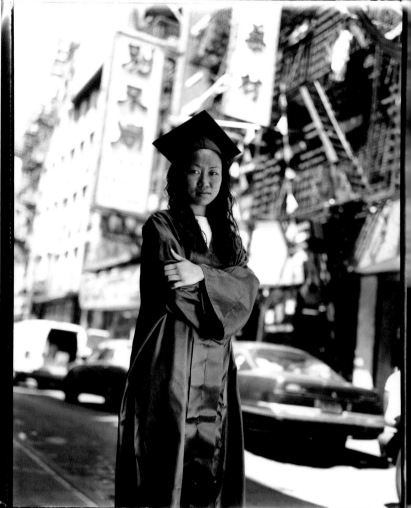

I'd like to be a movie star one day is my fantasy. Like Sylvester Stallone, ya know, action movies. In reality, I would say I'll be some type of a truck driver…maybe a cross country truck driver or a coal truck driver. Around here you haul coal or you haul logs, what they call timber. There's pretty good money in it; it's a living. Ya know it ain't gonna get you rich or nothing.

When 9/11 first happened I said that, uh, I think they shouldn't never let no one in here, not from other countries. But then it made me realize that some point in time my ethnic group came over here, 'cause, ya know, everybody came from somewhere. I'm not sure exactly where I come from, but there are just good and bad people in all of 'em.

Stevie Chaffin, age 19
GILBERT, WEST VIRGINIA

Photographed March 22, 2002

In ninth grade and I was hanging out at a park with my friends, and the truancy police picked us up. A cut card got sent home and my parents found out and they lectured me. From then on I changed. I brought my grades back up; they used to be pretty bad. I hung out with the wrong crowd (laughs).

I like learning but it really depends on the teacher. If I don't like the teacher it really gives me a bad insight on school in general. If I like all my teachers I'll have a great year; if not it really drags on.

We play basketball at this school in Chinatown. There are these black and hispanic people there and they look down on us. It's like why are you here if you're gonna look down on us, you're gonna make stereotypes about us…. Why are you in Chinatown if you're gonna make those stereotypes?

Josephine Tom, age 18
NEW YORK, NEW YORK

Photographed June 7, 2002

72

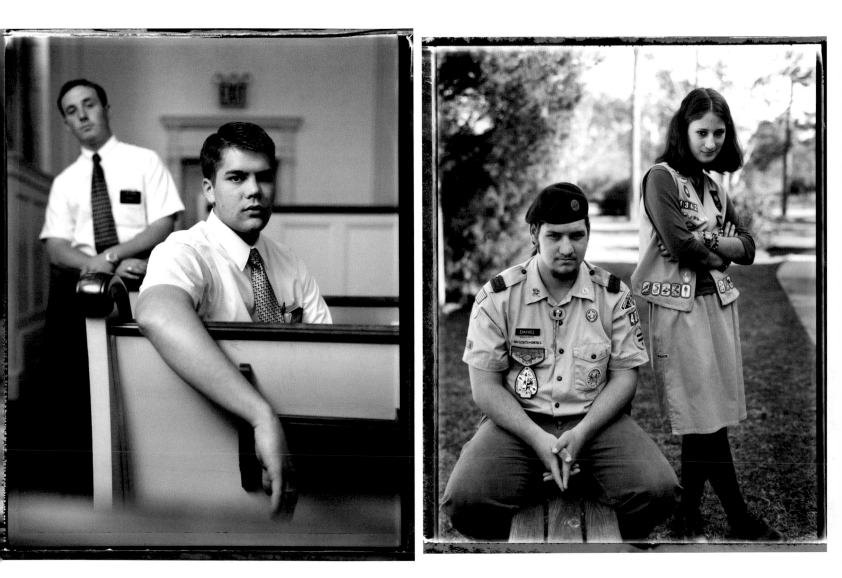

I'm a missionary for the Church of Jesus Christ of Latter Day Saints…. I learned Chinese, for my missionary work, here in Flushing…. I talk to people about Jesus Christ and try to get them to see that it's true.

I hope my work has an impact. If I don't have an impact then I'm doing something wrong.

Elder Andrew Metcalf Archer, age 19

LITTLETON, COLORADO

When I was three years old my father passed away from cancer…it definitely changed my life. My mom got breast cancer and passed away about two years ago. It was hard. They didn't tell me a lot of stuff, it was pretty fast, just very hard to… to figure out why. But, I know that everything's going to be okay.

I've been in New York for seven days…. I was very excited to share the Gospel and help people's lives. I see more people every day here than I've ever seen in my whole life….

Elder Jeremy John Martin, age 19

CEDAR CITY, UTAH

Photographed May 21, 2002

My parents got divorced last year. I'm sick of hearing about it. That's all they talk about. And dad's over here just about every weekend. My mom hates it (laughs). My dad thinks he can get her back.

We all clash. My dad just has to yell about everything. If me and mom say more than fifty words to each other, it's a fight in a day.

My sister thinks she's the best thing since pop-top beer cans. We're about as close as from here to California.

I guess family is somewhat important. That's the only thing you get free in life—your last name.

Daniel Murray, age 17

CALLAHAN, FLORIDA

Growing up and going to high school in a small town is tough; everybody knows everybody. There's the popular cliques…they get all the special treatment and all that crap. It's like if you are just the slightest bit different from them, they just hate you, just 'cause you're not like them.

Emily Murray, age 14

CALLAHAN, FLORIDA

Photographed January 24, 2004

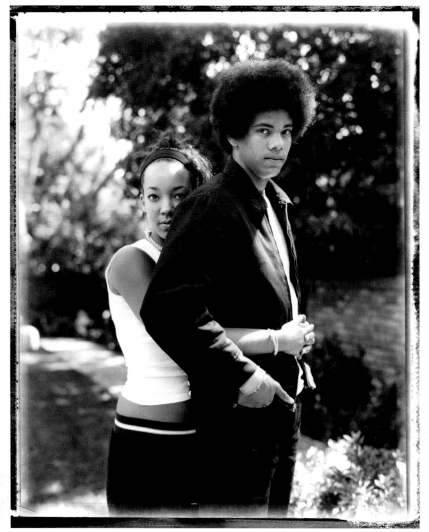

To me, having a white parent and a black parent is so normal, but to other people, they're like, "Well, are you white or are you black?" And I'm like, "I'm both." They're like "Well, how do you act?" Some people are like, "You act white," and I'm like, "Well, what's acting white?" Or they're like, "Well, you don't act black enough." Like, what? Am I supposed to go, like, run around the 'hood with a gun in my pocket?

Diana Norton, age 15
SANTA MONICA, CALIFORNIA

Because I'm upper-class people think I'm a rich, snotty bastard…. A lot of times I'm sort of embarrassed by my family's wealth. I just don't like being different from everybody else. In some ways it's good to be different…I don't like when attention's drawn to me. I like being tall, I like having my funky afro. But then it stands out. I like the look, but I don't like the attention…. It's one of those things.

Michael Norton, age 14
SANTA MONICA, CALIFORNIA

Photographed August 29, 2002

74

I think that if you have money you have a much less complicated life. I also think that it would be very hard for me to go from what I have to having no money.

From June 2001 'til I'd say, now, has been the most life-changing year. That was when I learned that my parents didn't know the answers to everything. I grew up a lot because when my friend died there was nothing my mom could do. September 11th was the same. It was like I'd never gone through that pain. It's something that was different than when my friend died because there was a real sense of unity…. You knew that every single person in the country was feeling the same pain as you were. I know people that it didn't affect, but for me, it was the hardest thing.

Caitlin Oyler, age 17
PACIFIC PALISADES, CALIFORNIA

Photographed August 26, 2002

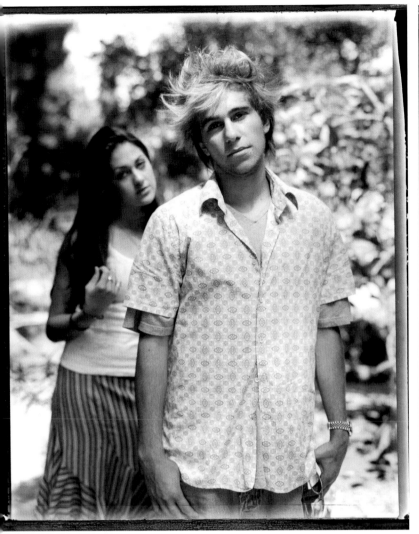

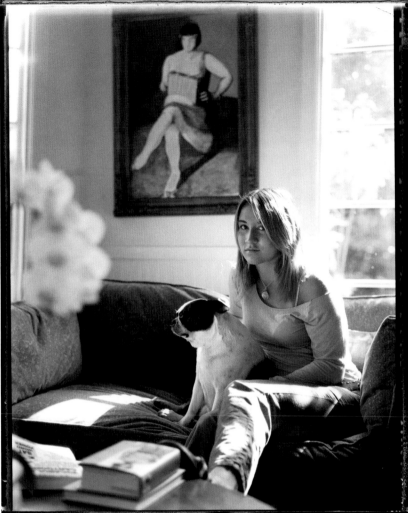

I live in LA and I've been given a lot of things that I've needed and stuff. In certain ways I've been spoiled. But, with my family, we try to keep it so that I'm not spoiled to the point where I think that people are less than me in any way. Everybody from my school will drive BMWs when they're sixteen as their first car. I guess money is very important in LA.

I have a lot of respect for my brother, because he's very much his own person—one hundred percent.

Roxy Olin, age 16
SANTA MONICA, CALIFORNIA

I've always been, like, real—almost too—sensitive, like sensitive to a flaw, where I'm so observant that it almost hurts.

I went to Princeton University for the first semester…four days after I was there the whole 9/11 thing went down. I could hear helicopters, I could smell the debris…. It just made me put things in perspective. I realized I shouldn't think so egotistically and narcissistic.

Cliff Olin, age 19
SANTA MONICA, CALIFORNIA

Photographed August 27, 2002

My parents are very close. They're like best friends, so I think it was a good environment for me to be raised in, because I can see marriages can work out, and a husband and wife can still be best friends after eighteen years.

LA is this little island where everybody's good-looking, and everybody's wealthy, and everybody's involved in the entertainment industry. You go outside the USA and it's nothing like that. Many people think that in Los Angeles, you'll have more opportunities and you'll get to see the world as it is because there's so much going on, but in a sense, you're actually more secluded from everybody, and sheltered.

I'm very self-critical, and I don't have very high self-esteem, just because growing up in LA, there's so many beautiful people and so many riches and everything…. You're constantly criticizing yourself on what you don't have, instead of commending yourself on what you do have.

Maggie Mull, age 16
SANTA MONICA, CALIFORNIA

Photographed August 27,2002

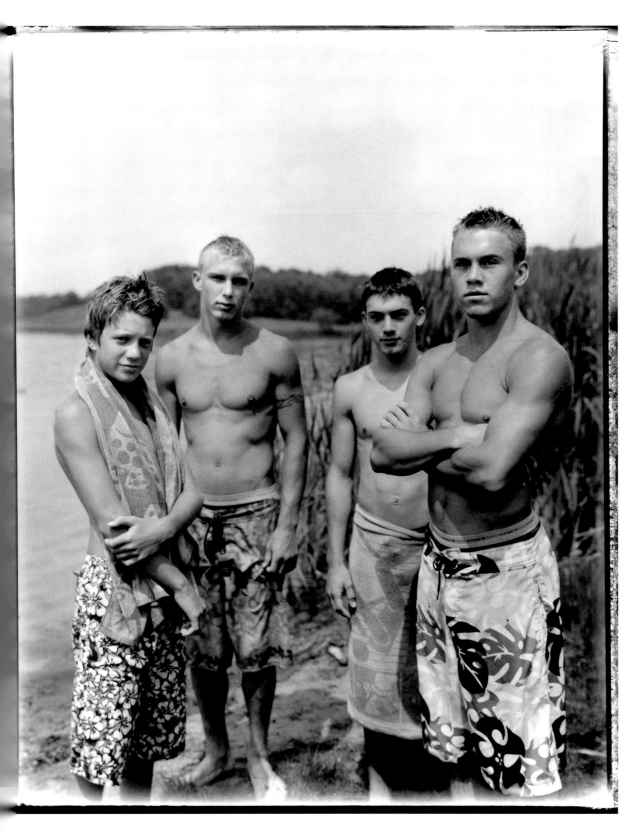

I have had a girlfriend before, I just haven't had one for the past couple of months. I haven't had, like, sex, but oral, yes. I didn't do anything until I was fourteen, but then other people do it in seventh grade, when they're twelve and thirteen. I think I was ready. They educate you young enough. They start educating you in fourth grade.

My dream is to become a really rich guy with a good-looking wife, two children (one boy and one girl, the boy first), living probably somewhere in Wisconsin out in the middle of the woods in a log cabin with a lake view.

Matthew Fink, age 15
PLATTEVILLE, WISCONSIN

I guess the most important thing in life is who you know.

I guess discrimination is gonna happen wherever you go. It's inevitable; I have discriminated against a few people. But my best friend is Korean and I've had some black friends, so I'm not judgmental about anything. I do not like gays, no. Well, I don't mind gay girls but gay guys, I don't like that.

The biggest problem I'd probably want to fix is the Middle East 'cause I just think them people over there are crazy.

What do I admire about myself? I'm good-looking.

Jake Carter, age 18
PLATTEVILLE, WISCONSIN

The toughest thing of being a teenager for me is probably staying away from drugs and alcohol. I got caught drinking New Year's night and I got a ticket. I haven't drank since then. My parents were pretty upset, disappointed…. They don't trust me as much anymore. So I'm kind of working that back.

I think most of my friends are sexually active. I haven't gotten pregnant with anybody. If I did, my life would be screwed over.

Adam Fink, age 16
PLATTEVILLE, WISCONSIN

I was probably twelve when I started working for my dad. I build fences for Fink Fencing. I'd like my job to be bigger and better.

I just graduated from high school and I don't think it's really hit me yet. I liked school. I didn't like classes but I liked sports.

Stephen Fink, age 18
PLATTEVILLE, WISCONSIN

In the sixth grade I made a suicide attempt. My grades were dropping, parents were getting really aggravated with me, and I felt I failed them and failed myself.

Killing myself was my intent. I thought I would be able to see people missing me. That's what motivated me the most. Then I realized, after it was all said and done that there would have been no tomorrow. Life has its ups and downs but there's no reason to go home and kill yourself over it.

I don't have a girlfriend, not an official one. I became a drum major this year and that's the coveted position. You know, all the glory and glamour that comes with it; the girls are all excited about it. Like I'm the star quarterback or something, but this is even more coveted because we're the best of the best. The best band in Louisiana. Sometimes we're referred to as the best band in the country.

David McCrea, age 17
Gretna, Louisiana

I respect my mother the most. She's a single parent, she works two jobs to take care of her two children, and she barely gets to see us that often, but she tries.

I have no idea where my father is and I don't really miss him. 'Cause he's a perfect example of how I should not be as a father figure for my son or daughter.

Justin Hughes, age 15
New Orleans, Louisiana

I have fun at my age, but I know it's not gonna last that much longer.

David Gaspard, age 15
New Orleans, Louisiana

I've never tried drugs, alcohol, or cigarettes and I don't want anything that would hinder my life right now. I look at myself and see that I'm in a positive school, and I have positive friends.

The biggest problems I would like to fix is crime. It starts with hatred, hatred for fellow man. Shooting people for no reason. Teens shooting each other for sneakers or shoes or something like that. I mean, it's no big deal…it's shoes.

I just want to have a positive note through music.

Edward Lee Jr., age 17
New Orleans, Louisiana

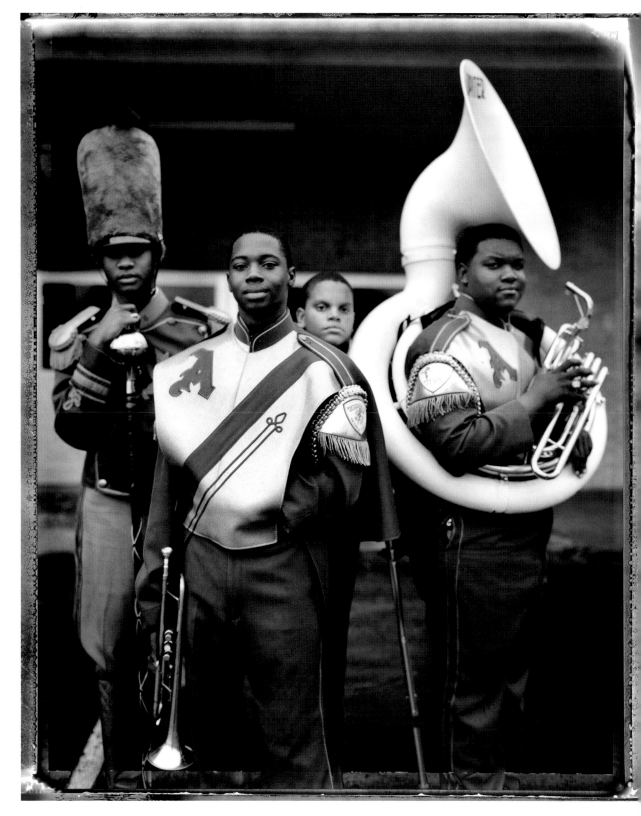

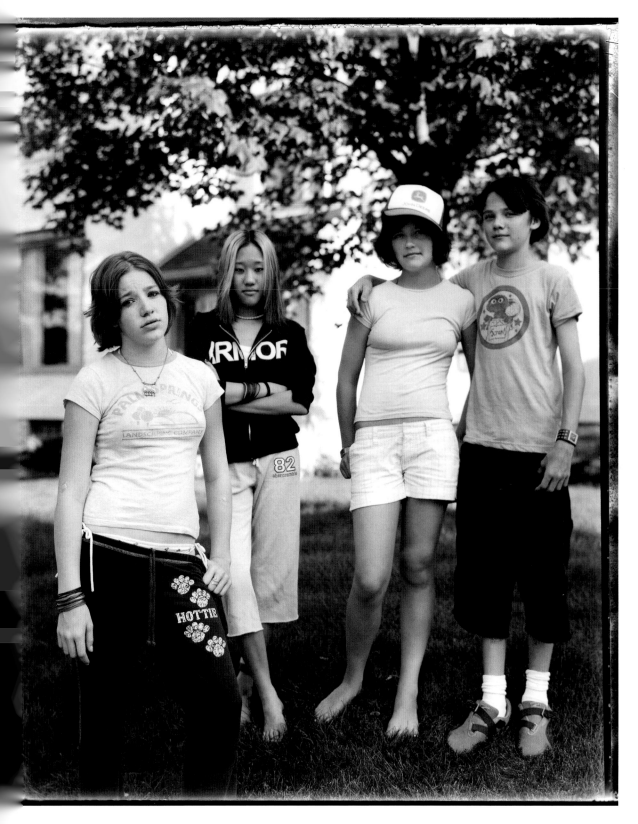

When my parents finally got divorced...it just changed my life, 'cause then I had two houses. Everything was like in doubles.... I think I was six. I really didn't know what marriage and divorce was. So I wasn't really sure what was going on, but I knew things were going to be different.... Well, it's like I feel like I have more of a responsibility now to be with my parents and to help them if something is wrong, and not go out and party all the time.

Yeah, I think I will go to college. Um, I'm actually trying to get my parents to let me go to college in England.... I want to be an ornithologist. A person who studies birds. My friend's mom told me that everybody in England studies birds (laughs).

Shannon Lagenfeld, age 14
MINNEAPOLIS, MINNESOTA

I was closer to my parents when I was younger, but I'm not that really close with them anymore.... I want just so much more freedom that they give me, and so, 'cause of that we have to do family counseling every week....

I consider my friends kind of more important than my family.

Selena Wilke, age 14
MINNEAPOLIS, MINNESOTA

My parents got divorced a few years ago.... They fought a lot and, yeah, you could tell they just weren't happy together. It's better since the divorce.... There were more good effects than bad.

Do I think I'm going to have a family of my own? Yeah... I don't know about marriage or kids, but, I mean, well, you can be a family and not get married.

Heda Hokschirr, age 14
MINNEAPOLIS, MINNESOTA

I don't believe in God. I've thought about it, but I don't see what's in it...it just seems like a story....

I don't really like school. Classes go too slow for me.... I get it in the first day, and then we spend another month on it.

Heda and I have been going out five months.... Yeah, she's my first girlfriend. It's great. I mean, yeah—yeah, it's great.

Iz Pollack, age 13
MINNEAPOLIS, MINNESOTA

A big thing that is happening to me is my cousin's wedding…. I'm gonna be very happy because I'm glad for them. I'm gonna be a bridesmaid.

The easiest part of being a teenager is you get away with something from your parents. Like stay up late and party…. Actually, that's my fantasy. But my real thing about getting away with something, is they go somewhere else and I stay home, eating my dessert and food and watch TV.

I love school. I just love school because I like to go to school and learn and good education…. I'm part of the E.S.E. program. It's a department for students who have disabilities…. I hate to say this, but I don't like math! It's too much information. Sometimes confusing, like always confusing.

Ohh, for girls the hardest thing is periods. When I first started, it hurt a lot. And then I keep having it, it's less hurting.

I have to say I respect my mom because girls need their moms to talk about, like, girl talks…. Like, what is happening. If you have a boyfriend and stuff like that. I have a boyfriend. Two of them. One of them is Madison and also my bestest friend is also my boyfriend, Jared…. Actually I'm not into a boyfriend and girlfriend relationship. I'm just more like a special friend…. I asked Jared to kiss me and he kissed me!

Family is important 'cause you have to appreciate them and you talk to them and eat with them and all the stuff. I think I might have a family one day. Not now, but in the future I will. I hope I'll have kids…. We'll live in California, in Beverly Hills. Because I'm going to work there, be a cosmetologist for celebrities.

Cameron Northup, age 17
PENSACOLA, FLORIDA

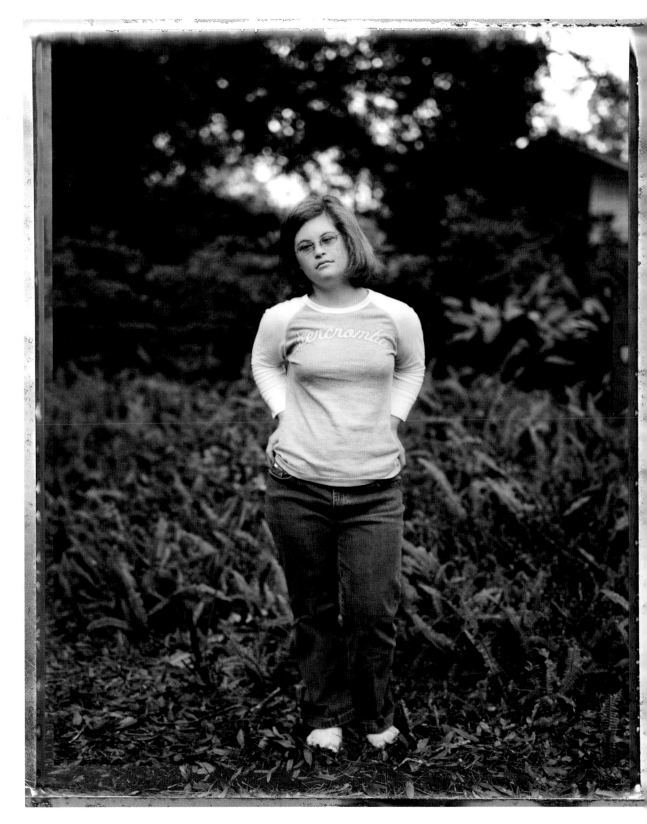

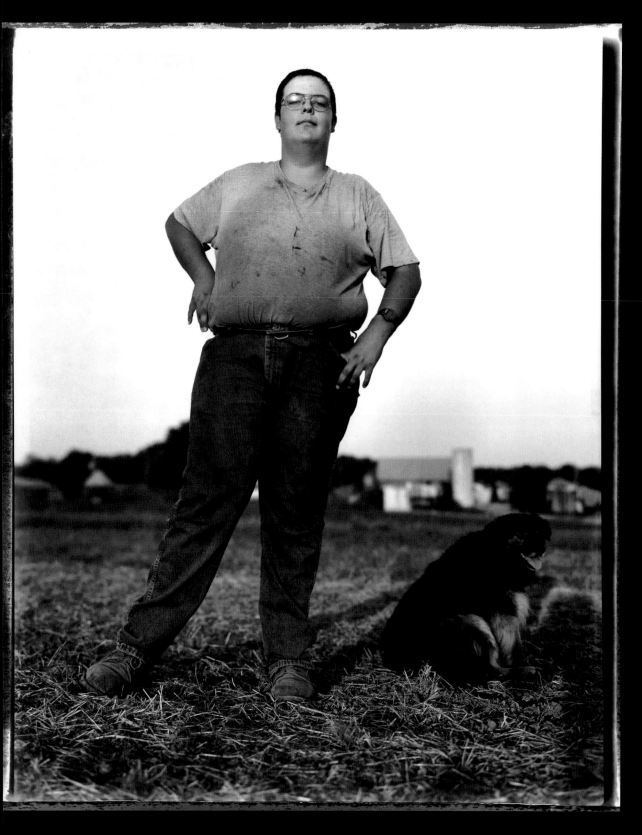

Biggest thing has happened to me was I had a teacher when I was in seventh grade. She had horses, and her hay suppliers, one of them got sick and the other one quit. And she sort of figured out that I was a farm boy, and she asked me one day if we had hay and I said, "Yeah," and she said, "Do you know if you would sell it to us?" And I said, "You could call my dad," and there's been many doors opened up to us and lot of work. We have around forty acres of hay and hope to grow every year. It made a bigger business for my family.

I'm happiest being out here with my animals, and working with the hay, and mudding with my four-wheeler. My biggest fear is losing the farm.

I like being an only child at times, because I get all the attention. But I miss times having a brother or a sister who we can go out with or go four-wheel riding. It's pretty boring doing stuff alone.

The toughest thing about being a teenager is mainly going to school and making the grades. And who can be the popularest and nicest and everything.

Family is important. You have to stick together to get stuff done. A perfect family is one that believes in Christ, and that works together, and that can make a living on the farm.

Scott Grote, age 15
CENTRALIA, ILLINOIS

I first became a naturist when I was born. I came out of my mom a naturist, so why not?

The toughest thing about being a teenager is just having to be around all the chaos of people liking each other, not liking each other, and they're always fighting with each other…. "Oh, I hate you!" and then the next day, "Oh, I like you!" Most teenagers are very moody.

I can talk freely. Sometimes I'm a little shy though, but I'm graduating to being more open. It bothers me that sometimes I used to put myself down…. I'm in choir at my school and my dad always bugs me about not trying out for solos…. I want to but I get all freaked out…. I'm hard on myself.

I'm very close to my parents. They've been married for almost twenty-four years. They have a really good marriage…. I think family's very important 'cause they're always there to tell you what you should do and what you shouldn't do and they help you throughout your life learning things and teaching you new things.

I used to go to a private Christian school for quite a few years. At home we pray, at breakfast, dinner and a night prayer.

I think teenage sex is really stupid and ridiculous. I mean, it's their own preference, but I'd rather just wait until I get married.

I like coming to a naturist club because you don't get any tan lines. Plus at a beach, you always get sand in your bathing suit…very uncomfortable. Being a naturist, you don't have to worry about what you're wearing. But being in clothes all the time you have to worry, "Oh am I going to look nice?" and "What should I wear today?" Being a naturist hasn't really changed me. Though it seems maybe I'm more open with my body than most teenagers probably are.

Jessica Harpin, age 16
NAPLES, FLORIDA

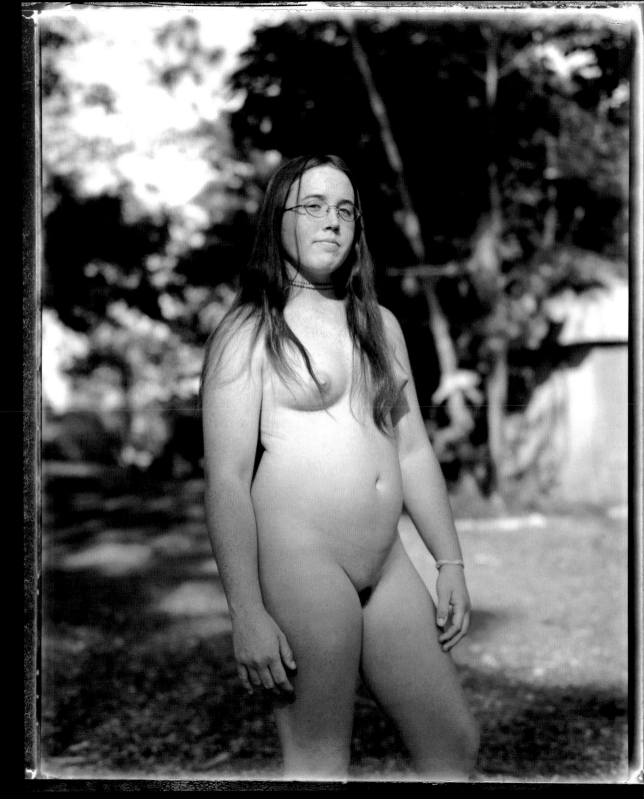

Well, the weirdest thing that happened to me, that changed my life, was that I went to rehab after using drugs for long period of time and I've been clean and sober after about a year and a half now.

My mother was an addict.... My earliest memory was when I was five and my mother stuck the meth needle in my arm. She wanted me to clean the house. That's all she would tell me.... It hurt. It felt like a big rush of adrenaline going through my body. When I got older I started using everyday.... I started getting into other stuff like crack and heroin and pot.... I started drinking when I was old enough to hold the bottle, I was about two.... I got it from my mother.

I gave it up because there's got to be something better out there than drugs and alcohol.... Pat, from The Rare Breed youth outreach center, she found me upstairs in The Missouri Hotel lying on my bathroom floor unconscious with a needle in my arm. I was told either give it up or die, so I gave it up. I feel healthier, I feel better....

The toughest thing for me about being a teenager is, well, for me personally, I am a recovering addict and most kids my age drink or use and it's hard to find friends my age who don't. I guess you can say it's very upsetting because I don't get to hangout with kids my age.

I've been raped many times, by babysitters, and neighbors. I guess I was just a target for it. I know it wasn't my fault; the person who did it is a very sick and twisted person. It has taken years of counseling to get me to say it that way, though. I don't really feel angry at them... the way I think about it, though, yes, they may have hurt me, but at least it was me and not someone who couldn't handle it.

I have a little brother.... We're very close to each other; we grew up together. In foster care he wouldn't listen to the foster parents, he would only listen to me.... Whenever they would split us up we would always run away and meet up with each other and take off.

I'm going to be a new mom, it's kind of scary. It confuses me and I'm afraid I might mess up.... I'm due tomorrow.... The father found out I was pregnant and said, "That's your problem," and took off.... He wasn't ready for a kid. Everything happens for a reason....

The baby is a girl. I'm going to name her Serenity Rose. I'm keeping my baby because I'm clean and I'm sober and I'm finally doing good for myself.

I want a better life for my family, not necessarily more money, but a better life. I don't want to live like I used to, dirty house, dirty clothes, never having enough to eat.

I'm most afraid that I will end up like my mother. She's probably dead in a gutter somewhere for all I know. I haven't seen her since I was seven, and I don't want to end up like that.

Just say no, seriously, just say no to drugs. My biggest dream is to go around high schools around the USA—schools, not just high schools—and tell them the true story behind the story about drugs and alcohol.

April Collins, age 19
SPRINGFIELD, MISSOURI

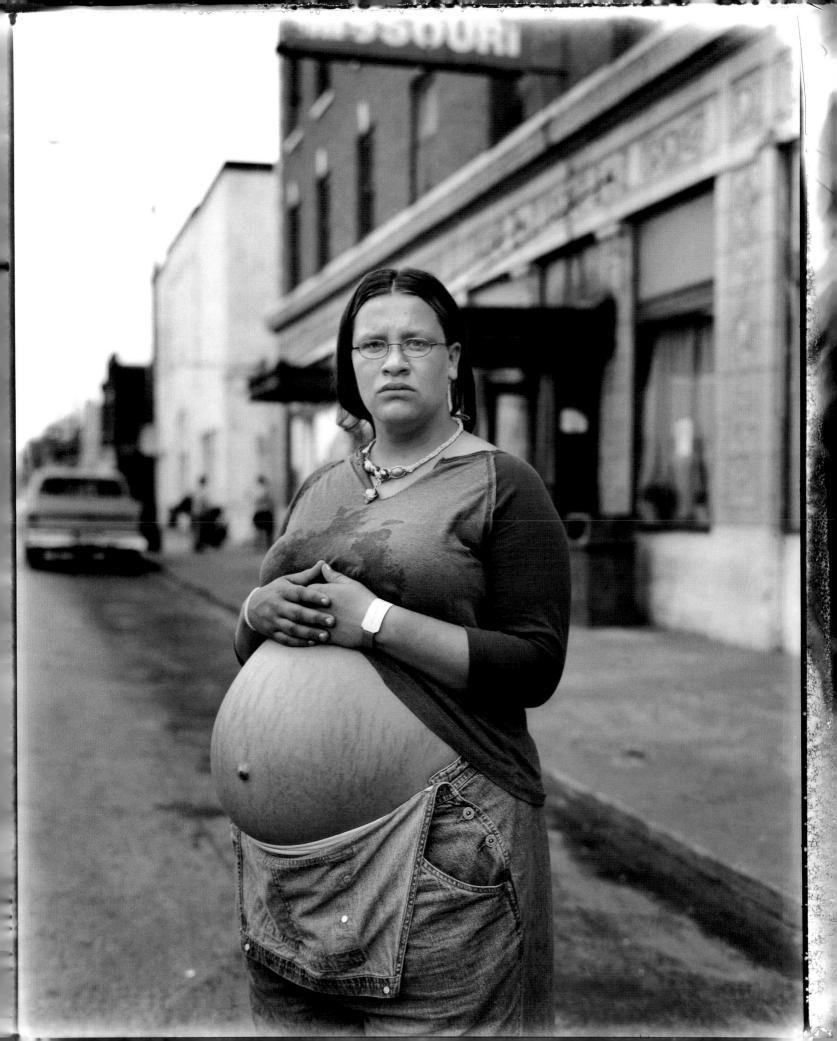

Leaving home gave me freedom, and I also had to grow up a lot faster…. I've matured in shit-loads. I mean, I'm a lot more responsible, even though I'm on the streets and people think I'm not responsible because I don't have a home. I can't have a home 'cuz I'm seventeen, I can't sign for it. I can't have rent because I can't sign for it. I can't have a job 'cuz I'm seventeen, I don't have an ID and I can't get an ID without a home….

I assume that my parents know I'm homeless. But I haven't talked to them. I just left. I think they do care, but they didn't change anything in their lives, they just went on doing what they were doing.

I stopped using drugs on November 7, 2000. I was sick of getting busted, and overdosing, and people just not caring. People say, like, "Whatever, I don't give a shit about this guy."

One day some guy gave me some pills, I don't know what pills they were. I took them and in some way it gave me a bad reaction. I don't remember forty-eight hours. People that I was using with, they were like, "Oh yeah, you passed out. You didn't do anything for forty-eight hours. You weren't awake at all. You wouldn't respond to anything." Why don't they do something?… I made a choice then to quit. I haven't had any drugs since. I feel very good. I'm proud of myself for it.

Just talking with people makes me happy. I mean, if I ask someone for spare change and they take the time just two minutes, even if they don't give me change, just like, "Hey, how're you doing, taking care of yourself?" "Are you doing good, is there anything other than money that I might be able to give you that will help you out?" I just like talking to people, and giving what I can and them giving what they can. It's never very much either way, but I mean, that's how the world works.

My dream is running a small organic farm that's completely sustainable and off-grid electrically and plumbing-wise and all that good stuff. Realistically, I can probably get that.

Tup, age 17
PHILADELPHIA, PENNSYLVANIA

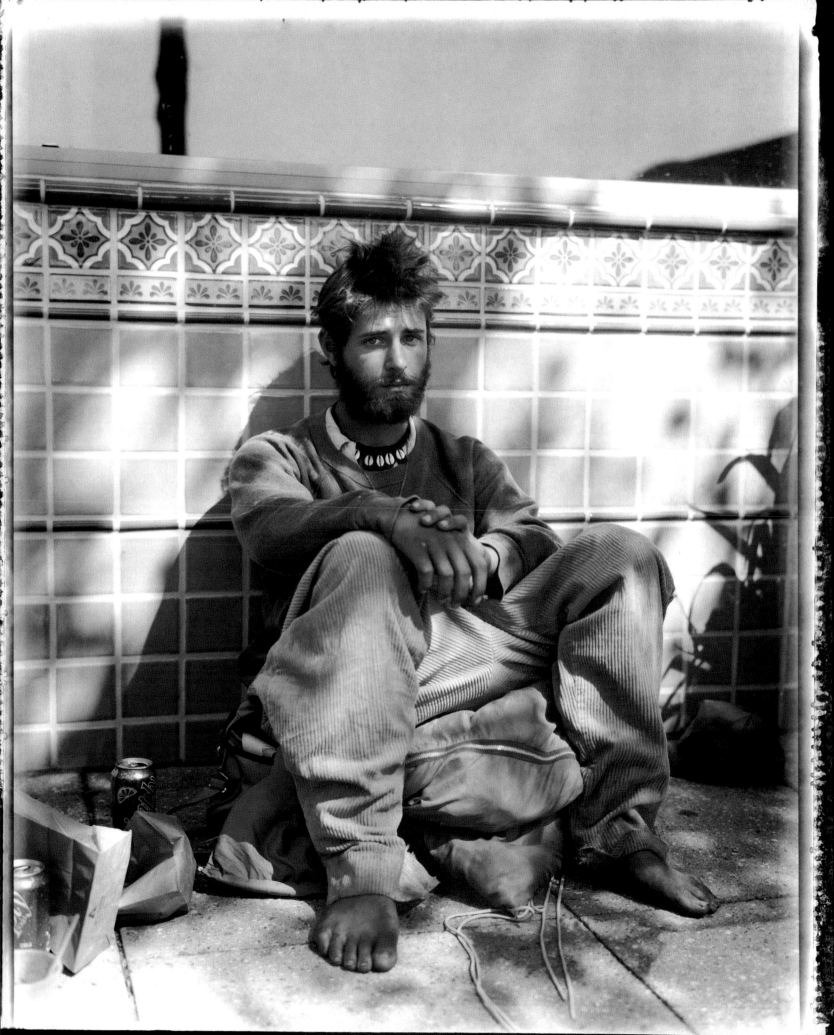

I'm on the streets 'cuz I chose not to live with my mom, and my mom chose me not to live with her. The thing is, I can't get an ID, I can't get a real job, you know? There are a lot of tough things about being a teenager. If I was older it'd be so much easier because I would have a job already, you know what I'm saying?

When I was raped that was the biggest thing that happened to me. But it made me stronger. I was fourteen. It was a someone that my friend knew, and I went with him 'cuz I thought he was cute, and he ended up raping me. How did it make me feel? I didn't sit and dwell over it, you know what I'm saying. It just made me stronger, it made me a lot stronger.

Who do I respect the most? Myself. If I could be anyone else, I wouldn't be no one else. I'm happy with myself.

I support my own self. There was a time when I was going to start prostituting, but a lot of people told me that I don't need to do that. I could use my mouth, and with my mouth I could get anything I want just by talking. 'Cuz I'm very manipulative too, when it comes to getting money. I get dressed up, you know, short dresses, stilettos, then I go to bars and dances. And I just sit there and when I see a guy who looks like he has money I stare and stare and stare until I get eye contact. When he looks at me, I laugh and I turn away and act like I'm all interested 'n shit and I start talking to him. I may make him buy me some drinks. Then I say, "Oh, you have money, I love money da, da, da." One night I go into a bar, I get $50 or sometimes $400, it depends. Or if they drop their wallet, hmmm, more.

With the money I get, I pay the landlord of the guesthouse money, buy my clothes, and I pay my grandma's hotel room and I save money.

That's kind of like my career.

Anastaizshzia (Tash) Rains, age 16
LOS ANGELES, CALIFORNIA

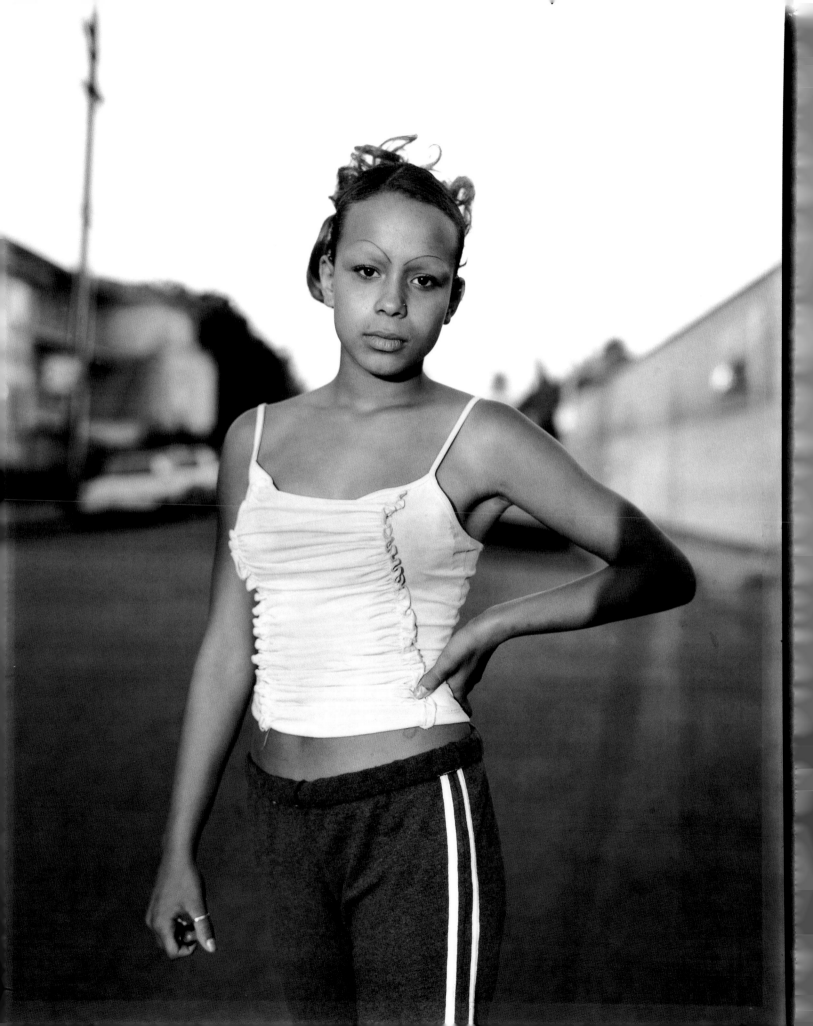

I was fifteen when I first had sex and that first time I got pregnant. I wish I woulda waited 'til I got older, but that's the only regret I have. I would never go back and change it because then I wouldn't have Christopher right now. I wouldn't go back and change it.

I did not even get to go to high school. I didn't go because I got pregnant. I was never really good in school and I guess I got bored sittin' at a desk for eight hours. I never liked it. About the only thing that I probably miss about school is that I never got to graduate. I never got to go to any prom or anything like that.

I live with my husband now. A month ago, we thought we was pregnant again, but the doctor told me that I was ovulating and I just wasn't having a period. It was caused by stress and depression so luckily I'm not. I want another one; I would like to have another one probably about three years from now. But I want a boy cause they…Harley, she's just…it's that much easier with boys for me.

Before I had Christopher I didn't think I was gonna get married. I thought I was gonna wait 'til I was twenty-five. But after I had Christopher and me and Chris got back together while I was pregnant, everything was just going so great. We just decided to go ahead and get married instead of waiting. I was eighteen. He was twenty. It's been good. It was worse before. Before me and Chris got married they wanted "guy's night out" more often and they were goin' out like all the time. It was just getting to me because I was the one stayin' at home with the kid. But now that we got married it's all mellowed out and we just all go out together.

My husband, he's a mechanic. He works on vehicles. First thing we do with the paycheck is pay our bills and then if there's anything left, we go get what the kids need, and then we get what we need.

If I could be someone else in this world I would probably be Jennifer Lopez because I love the way she looks. She's very pretty and she's famous. I would just love to be her.

Victoria Lee, age 19
JONES, ALABAMA

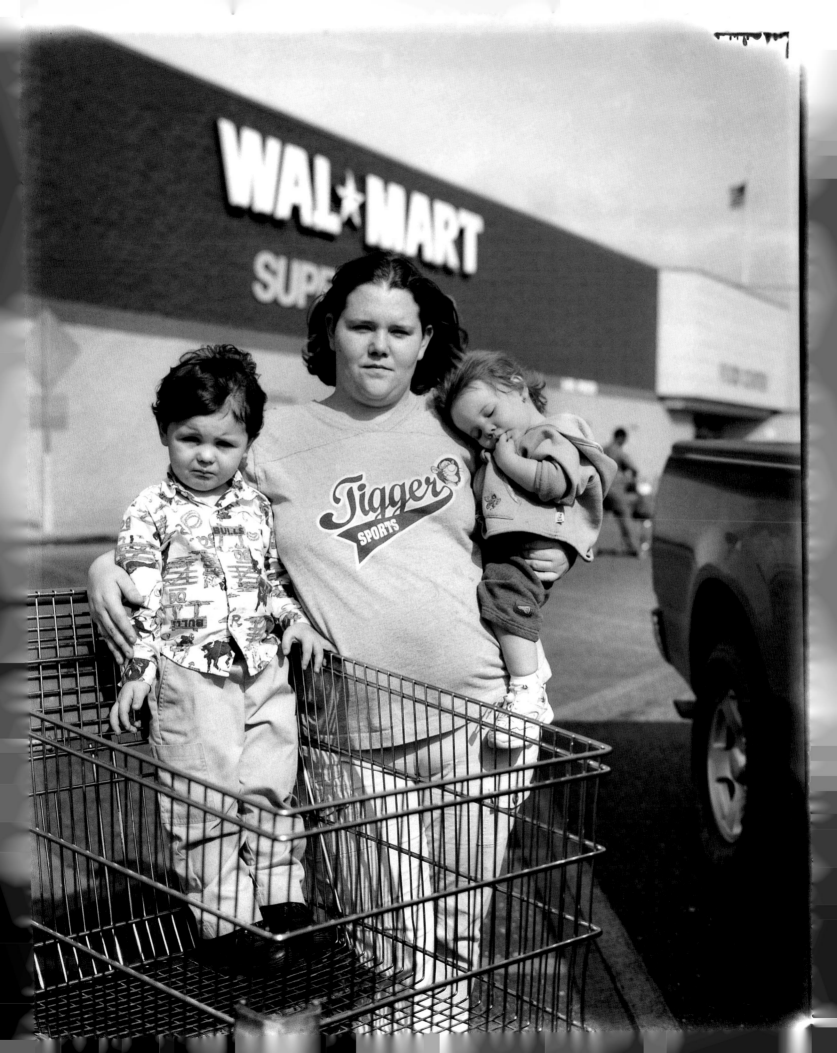

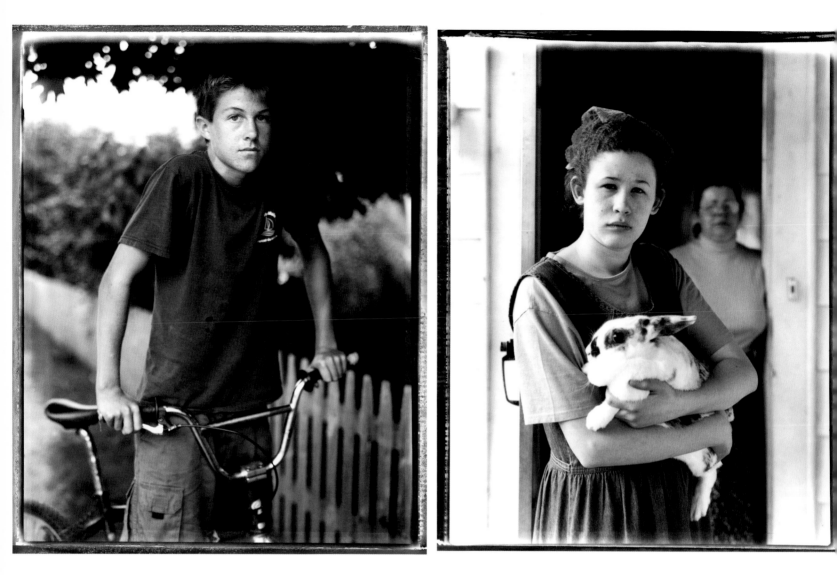

I'm at a private school, and it's a really academic school and it's really changed my outlook on society and on learning and on knowledge and all sorts of things. We do a lot of essay writing and we always have to connect the things we're writing about to ourselves and to our life and to just life as a whole.

Self-image is tough…when you're thirteen you start thinking more about what you look like and how you act around others so you can be accepted by everybody else.

I've never prayed, 'cause my parents never go to church. I've never felt that I needed to go. I guess since I've been so fortunate in my life—like we're the upper one percent of wealth in the world—I didn't feel I needed to rely on somebody else.

Jack Lindsay, age 14
IPSWICH, MASSACHUSETTS

Photographed August 7, 2001

The biggest thing that has ever happened to me was I changed churches. It changed my life, my walkway to God. I can hear God's voice clearer now, and I can know if it's God or not. I go to church three times a week. Jesus makes me the happiest. I could change the world by sharing the gospel.

I pray for sinners, I pray for the day, I just pray all around. I pray for my sisters…that they'll come back to the church.

I'm home-schooled. I stopped going to school because my sisters messed up in that school. I don't miss any of my friends from school. I don't have to be around all the cursing and stuff at regular schools.

If God wants me to I will have a husband and a family.

If I could be someone else in the world, I would be Jesus!

Laura Lyons, age 13
FEDERALSBURG, MARYLAND

Photographed March 16, 2002

90

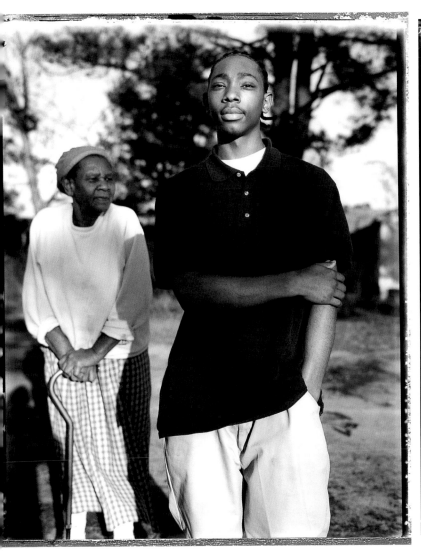

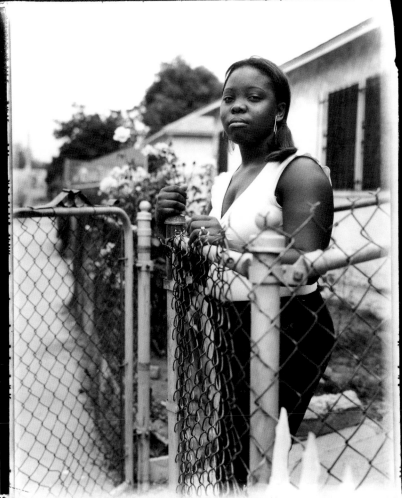

The hardest thing for me as a teen is having to do everything yo momma tell you and having to get up and go to school…to cook and stuff for yourself if mom don't be home.

I respect my mother the most…. She the oldest and if you respect your parents you'll live longer. Because God sees you respect them and you'll live long.

I'm not planning on going to college…. I'll probably take up a trade…drilling, or something like that.

If I could be someone else in this world I would be Kobe Bryant because I want to play basketball.

I dream about money. I wake up and look around but it's not there.

If I had a lot of money I'd have a big house and a car.

Richard Hoppins, 16
Gees Bend, Alabama

Photographed February 18, 2004

Watts is dangerous…because things are always happening in Watts. This is where all the bad people come and create dumb problems.

I have plenty of friends that are pregnant and have babies at sixteen, seventeen, fifteen, fourteen…. If you're sexually active, there's nothing I can do about it. Just be safe about it. Don't have no kids at no early age. You're just a baby!

The biggest thing that happened to me was when I got into the twelfth grade, because in my tenth-grade year, I had really bad grades and I didn't think I was going to graduate. But now it's like, Wow, I'm graduatin', so now I'm happy. With all the summer school and night school, it all came to place. I am going to college. I have a scholarship…. I want to study business and law.

I don't want to be anyone else in the world. I want to be myself.

Jassmond Johnson, age 17
Watts, California

Photographed August 31, 2002

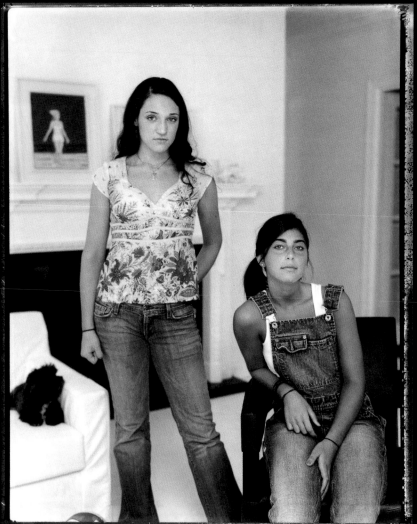

I'm Jewish so I was bat mitzvahed, and that was a choice.

I respect people who stand up for others, and I respect people who have a voice and aren't afraid to speak their mind....

Dance is a place where I can go and forget about everything else, and I can be myself, and I can express myself, and it just takes me to a new place.

Kiley Taslitz, age 17
GLENCOE, ILLINOIS

I think I'm a kind person and I try to go out of my way to do good things for other people. What bothers me the most about myself is I can be a pushover. I try to please everyone too much.

My parents got divorced, but they live a block away, they're best friends, they call each other all the time, they eat dinner once in a while together. It's a one-in-a-million circumstance, but I'm so thankful for it.

Lindsay Small, age 17
GLENVIEW, ILLINOIS

Photographed July 23, 2004

Most of the time I feel happy and excited, and weird, kinda. Just because going to an all-girls school you're never trying to impress people, like boys or anything, so you just do whatever.

I think discrimination is so common in the world, that little things will be thrown every now and then. Katie even told me when she was on the float they would yell at her, like, "Stupid white girl," or something. It makes me upset and something might come out of my mouth, but I wouldn't say it to their face.

Jamie Rittiner, age 18
METAIRIE, LOUISIANA

Being Queen of the Endymion Mardi Gras parade was probably, honestly, the biggest thing that ever happened to me.... I used to be a very shy person.... I would get anxiety attacks if I was in front of a lot of people. And after the first event it just helped me so much to be open and be myself in front of people.

Katie Rittiner, age 18
METAIRIE, LOUISIANA

Photographed February 7, 2004

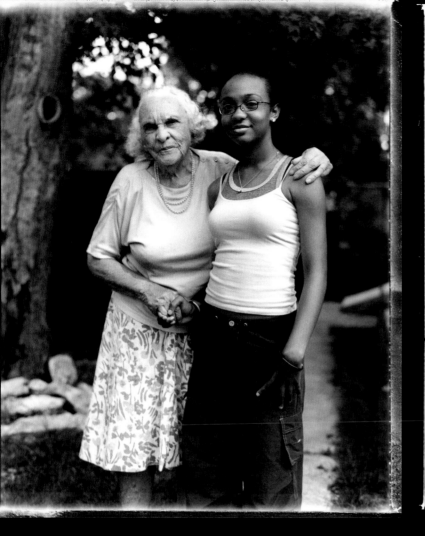

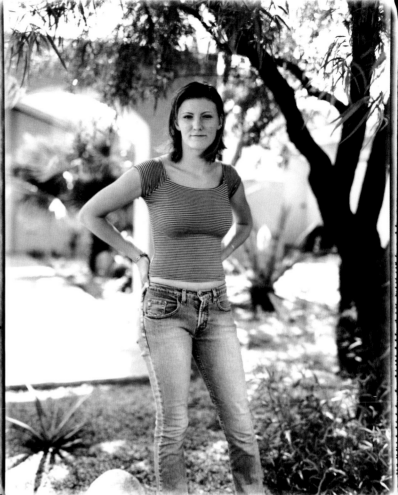

I practice all different religions, not just one. But I go to a Catholic school so I have a lot of belief in the Catholic religion. It's a very powerful school and I feel I need that to survive in life. I plan on going to college to study design or law.

I would like to adopt a child instead of going through childbirth. Maybe adopt a child from Russia or Africa, just to see how they feel about life…. Just to show that you don't have to be connected physically with that child, but you connect with their brain and it can all be the same.

If I could be someone else I would be my Aunt Elizabeth. Just looking at her, being born in 1911…so much has gone on since 1911…. She's still strong today… doing so much for other people. I just feel if I could be that kind of person then I'll be okay.

Jade Beason, age 15
Madisonville, Ohio

Photographed June 25, 2004

I lived with my biological mom until I was thirteen and my step-dad and my half-brother. And um, my mom was diagnosed with bipolar, here in Tucson, so she wasn't capable of taking care of me or my brother so then I got into CPS (Child Protective Services). I moved in with this woman, Melanie, and things have been great. She loves me as if I were her own daughter. She's taught me how to trust people and how to put myself on the line and she really built up my self-esteem and just a lot of different things.

I've read up on different types of religion. The one that makes the most sense to me is Taoism. It's about just going with the flow of things and not trying to control it all the time. Because I don't think that I can control my life and control what happens to me.

Stephanie Carl, age 19
Tucson, Arizona

Photographed August 15, 2002

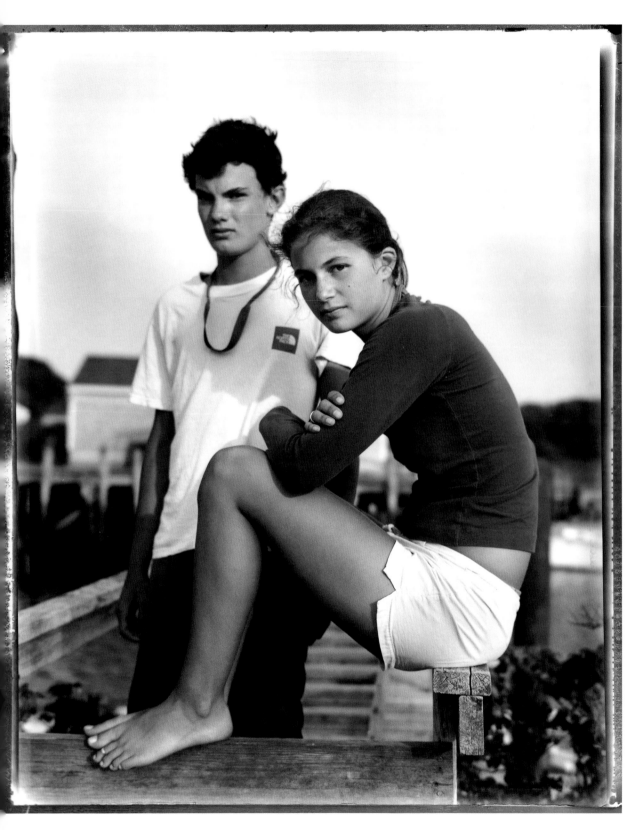

I respect my dad because he's brought me up to like the outdoors, and I think that's a good way to go: being outside and not into video games and computers and TVs and needing to live off of those.

I believe in Mother Nature…someone that watches over things; that tries to keep things running smoothly. But I don't believe in a God that's watching over you all the time, and getting mad at you if you do something wrong.

Pollution and cutting down rainforests is one of the biggest problems in the world—I don't see why people do that. It's just hurting themselves in the long run. And pollution—why do people litter when there's trash cans—like, take the trash and put it in the trashcans!

Alex Buck, age 14
TOPSFIELD, MASSACHUSETTS

The girls at my old school definitely didn't like me 'cause I didn't shop at the right stores, and I wasn't loud enough and I wasn't on every varsity sport, and I wasn't—I just wasn't what they wanted. It made me feel awful. I hated it, but…. I thought it was normal for a while. I thought it was me against them and it would never happen any other way. But then I went somewhere else and it was like, Whoa! People are nice and it's not always like that.

My most frequent emotion is frustration because I feel like a lot of the time my parents don't see me, because they think that they're listening to me, but they're not. And so I have this like little lump of frustration that grows…. I do think family is important because I love my family…. if they weren't there I wouldn't know what to do with myself. But if they weren't there I also would be able to do a lot more.

Sarah Buck, age 17
TOPSFIELD, MASSACHUSETTS

I don't get mad very easily…. I guess I get frustrated a lot, because I have four younger siblings, and I get frustrated with them a lot.

Marriage didn't work out for my parents, so I couldn't say that a perfect family wouldn't ever get divorced, because we still have a really good family relationship. I guess a perfect family would be a husband that would stick by you forever and help you, and help with the kids, and just love you unconditionally. And the kids don't have to be perfect, they don't have to be "A" students, like scholar-athletes and stuff, but just love their parents and be good to everyone.

I have no idea, honestly, what I want to be. Well, a mother—definitely a mother. That's like my number one.

Ellie LeBlond, age 14
BETHESDA, MARYLAND

My earliest memory is from when I was four, in the White House. In the bowling alley…. I really respect Grandfather Bush because he has done so much in his life, and he can still walk around like a regular person. He can still find time to go fishing with me, call me up and ask me how I'm doing during the year. I think that is just unbelievable how he can still do that.

There are so many people that are split in views, and nothing ever gets done. I'm kind of into getting things done, and having things go smoothly, and there are so many people out there that disrupt, and so many people that don't believe and aren't agreeing…. There is really no way to get everybody to think that one way is the right way, but I think if everybody could unite under one idea or belief, things could get done. The world would be a better place. I sound like a politician and that is exactly what I don't want to be!

Sam LeBlond, age 17
BETHESDA, MARYLAND

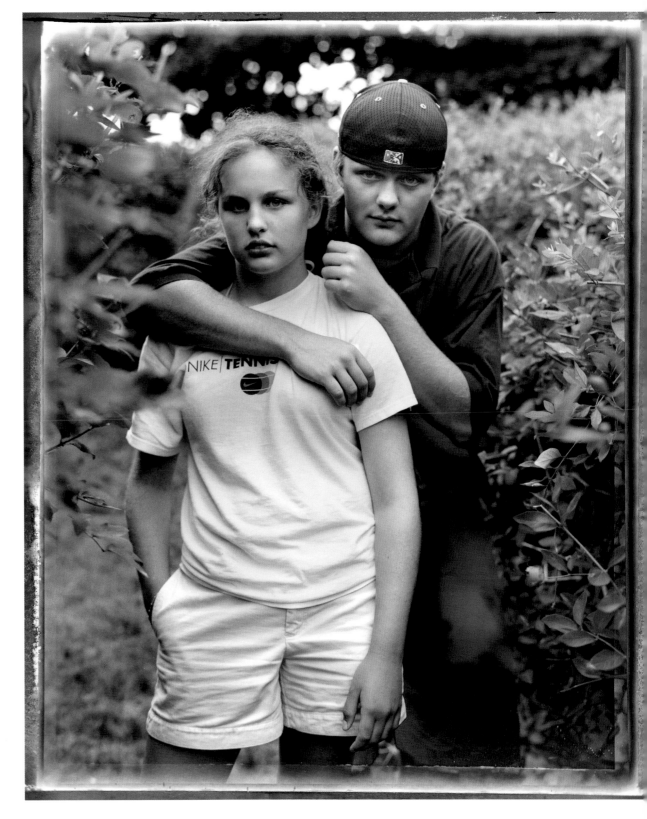

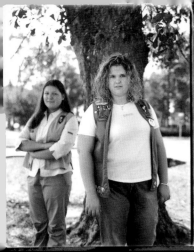 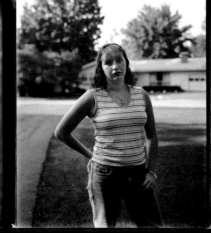 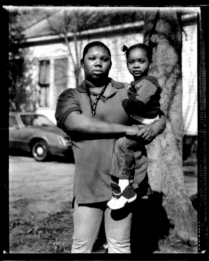 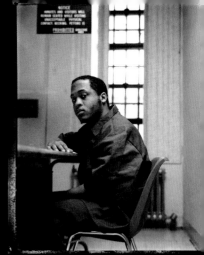

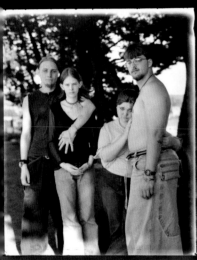 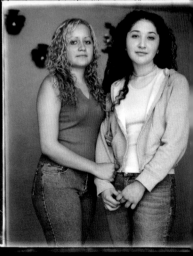 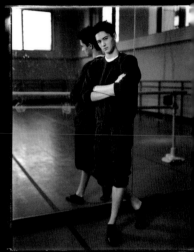

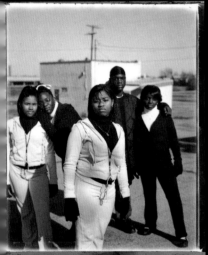 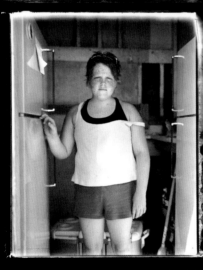 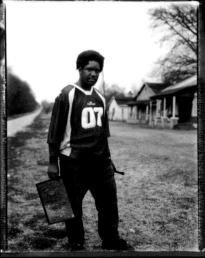 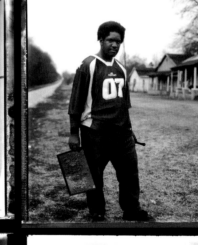

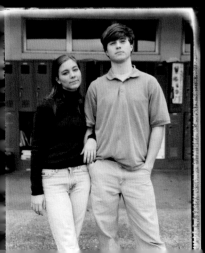 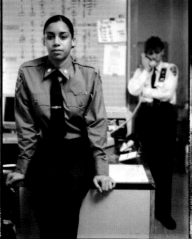 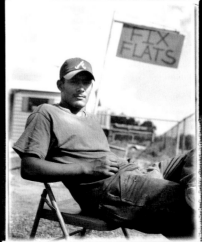 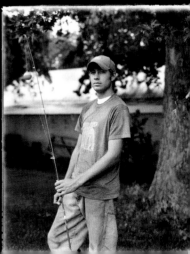

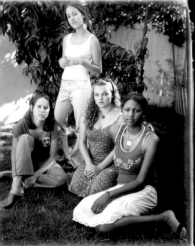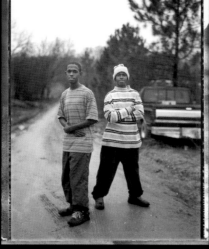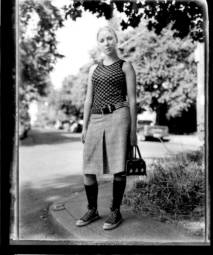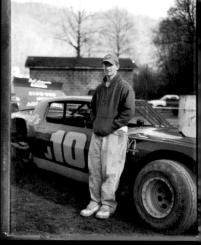
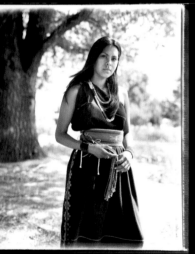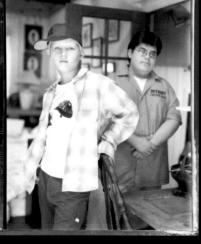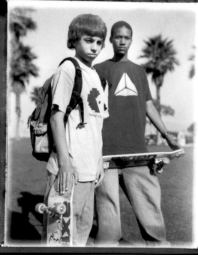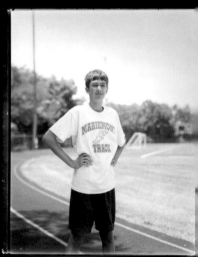
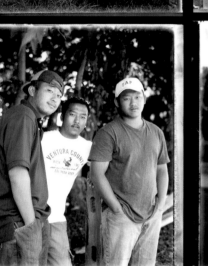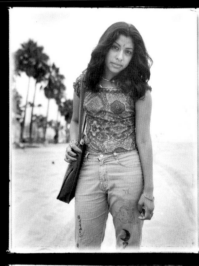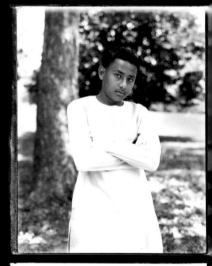
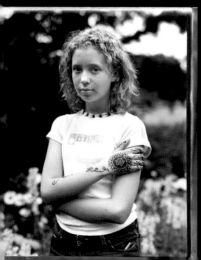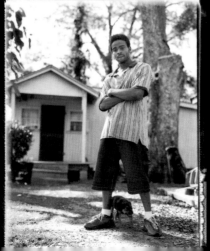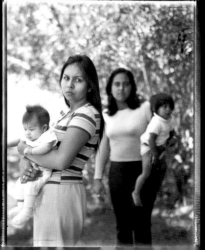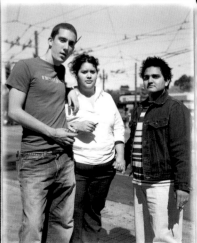

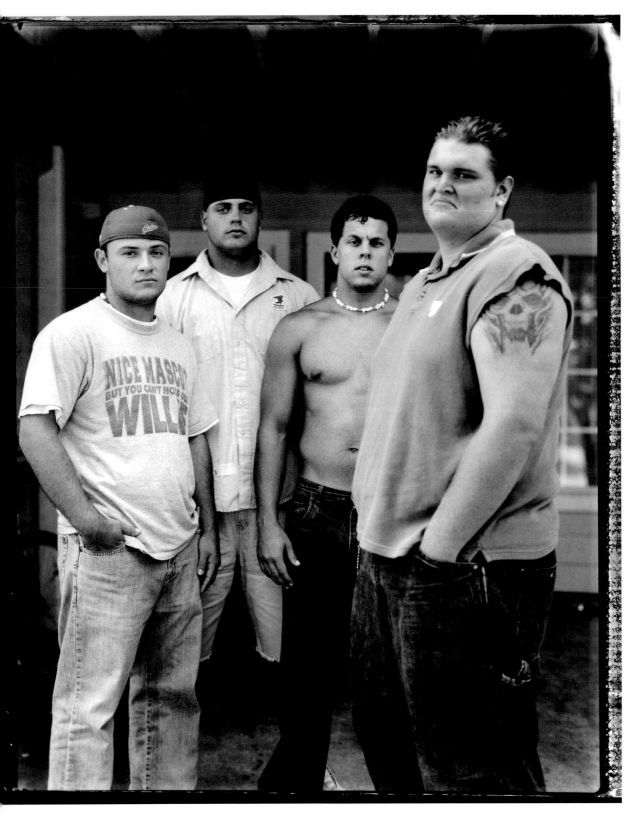

Getting into school and living on my own kind of gave me a little more responsibility, as much as I don't wish I had it. Everythin is on you now. Paying bills and stuff like that, it's not something you look forward t but, yeah, it makes you do things different

I have a job as a Certified Nurses Assistant in a Retirement Village.

I drink once, twice a week. Yeah, we drink to get drunk. I think you got to live it up. If you're not living like you're dying, you're not living at all.

Jake Gawith, 19
MINNEAPOLIS, KANSAS

I don't really like school…. I'm here 'cause it's expected of me by my parents. My parents are paying for school.

I was fifteen when I started drinking. I drink now, probably four times a week. Probably about twelve to fifteen beers a night. The only reason I drink is to get drunk…. 'Cause it's fun. I like it.

My biggest fear is getting old. Gettin out of college. Getting into the real world.

Zac Bishop, age 19
SALINA, KANSAS

I would say my family is lower class. When I'm an adult, I want more than we had growing up. My family has a really small farm. I work for my dad on his farm. I've worked for him since I was eight. I work between thirty and fifty hours a week. Wh my older sister was nineteen she had a kid and [having a nephew] changed me a lot. I'm a very big part of his life. Every day I'r playing with him.

Jared Shoemaker, age 19
MINNEAPOLIS, KANSAS

This sounds so gay, but my biggest fear is probably not ever finding a girl that I'd lik to be with.

A good fantasy future would probabl be…maybe an artist. That would be really cool to do for a living.

If I could fix one problem in the world…maybe the high divorce rate. I'm not really sure why people get married any more because over half of them get divorced.

Matt Davidson, age 19
MINNEAPOLIS, KANSAS

Skateboarding is the most fun thing I do.

I never tried drugs. No. Not drugs. I want to keep myself healthy. 'Cause if you take drugs while you're skating you're going to get tired quick.

Angel Garcia, age 14
East L.A., California

I used to be all gangster and stuff… when I was little, but not any more. When I was like nine or ten. I got out of it. It was a little crew. We didn't do nothing wrong, but just hang around and stuff…. I used to dress all baggy. My shirt was out all the way to my knees and stuff. Skateboarding with my friends and stuff makes me happy now.

I have a job. I help my dad…. He works with my uncle, so I help him fix the cars…. I've done it since I was thirteen. I make $50.00 a week. I spend the money on new clothes, a new skateboard.

My dream, in the future, would be to be rich…to live in a two-story house or something. In reality, I'll be a mechanic.

Jimmy Vazquez, age 14
East L.A., California

Getting into drugs changed my life. I messed up in school and then I didn't know what to do…. I was fifteen. I did drugs like weed, everything…. I got in trouble. They sent me to some place so I can learn about life. Like a jail…and I gotta go for a class to learn about my life…. I stopped, and I'm doing good right now.

My mother is in Mexico. She was not good to us… I came over here 'cause she hit us a lot. With cables and everything. All she had in her hands. So me and my brother and my sister and my dad came to America.

My dream is to be a drawing person. An artist…like, not painting, like regular pencils.

I'm most scared to be in jail.

Marcos Norberto, age 16
East L.A., California

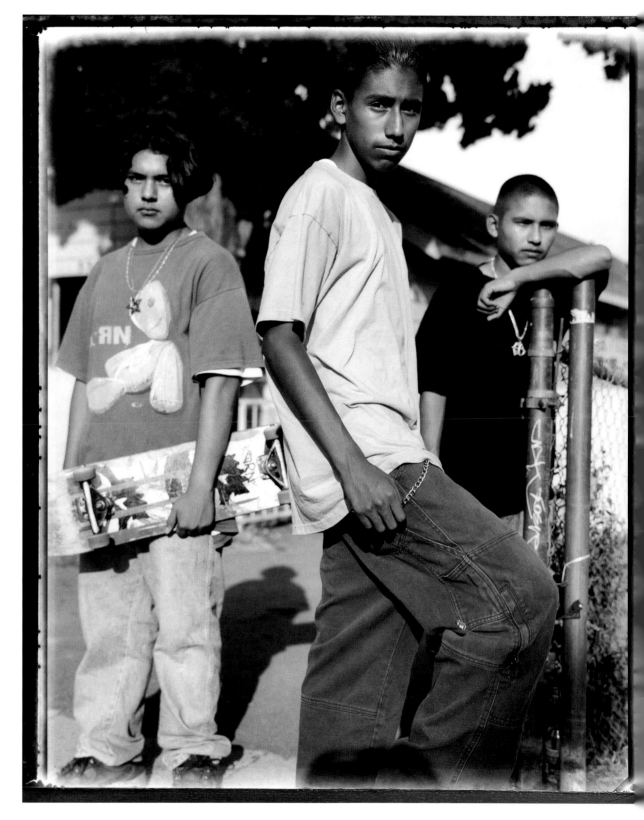

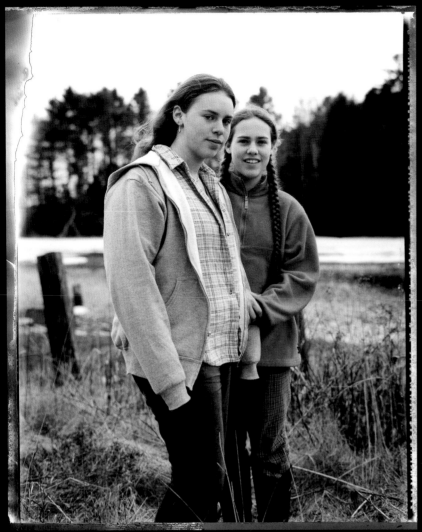

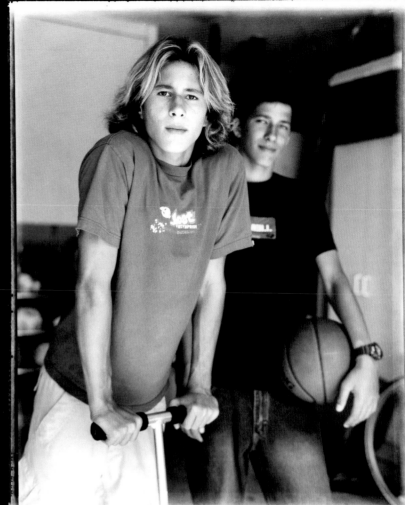

I started playing music when I was in fourth grade. I started playing violin. In sixth grade I joined a bluegrass group. It's made me more confident. I think about my music, and now, whenever we play out, I'm really excited and I'm like oh yay!

In my school dating isn't like a big thing, so it's not like you have to have a boyfriend to be cool or to go to parties or anything.

Hannah Espy, age 15
FREEPORT, MAINE

I do believe in God 'cause my friends do. I think that God is a spirit maybe.

I think [teenagers having sex] is gross because they're not old enough…. It's bad to smoke, you can die. To drink, 'cause you can die.

What's the other one? Oh yeah, drugs. Bleh!

Adele Espy, age 13
FREEPORT, MAINE

Photographed March 11, 2004

Every year that I've been on this earth that I can remember, I've been at school at least nine months of it. And it takes up way too much time and I don't think I'm going to learn anything that I'm ever going to use when I grow up.

I respect probably my mom. Because she does so much and she gets so little. She does so much for the whole family and everyone but she gets so little.

Jesse Rambis, age 16
MANHATTAN BEACH, CALIFORNIA

Respect the most?… probably my dad. Even though he was picked on in school he didn't rub it in. He is very successful, but he doesn't show it. Just look at the cars we're driving. He doesn't show it off. He doesn't go around wearing Gucci or anything like that. He just wants to be subtle, I think. And I respect him for that.

Jordan Rambis, age 15
MANHATTAN BEACH, CALIFORNIA

Photographed August 30, 2002

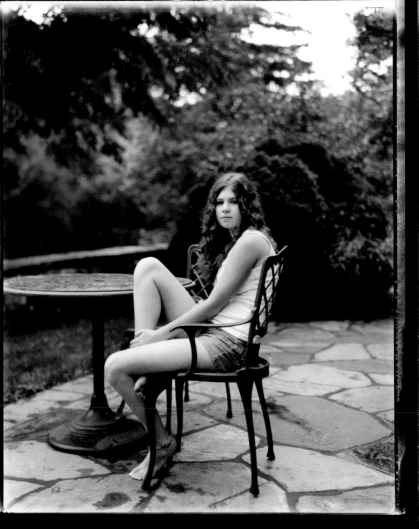

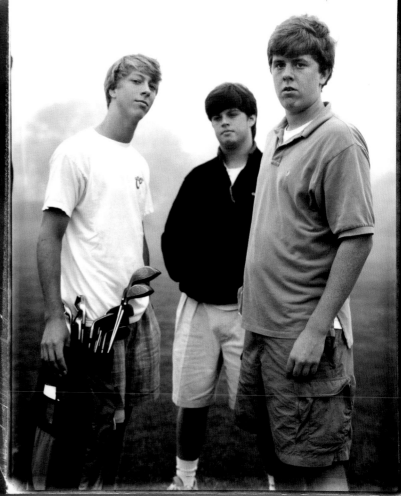

A tough thing about being a teenager…. I think cliques are pretty hard. Like, I have a group of friends, but its kind of, like, annoying to see how, like, I'm not one of the most popular. But I'm not a dork either, and it's tough to see all the popular girls getting all the boyfriends and stuff.

I love to write, and I guess I was a really, really bookish kid, and really dreamy.

I don't really believe that there's the whole "God from the Bible" sort of thing…. But I heard somewhere that people who are religious and believe in God tend to live like ten to fifteen years (laughs) longer than people who don't.

Ronald Reagan was my role model when I was younger. He's my dad's favorite person. I was growing up hearing how cool he was. So all the reports I did on famous people, I always picked him.

Meg Fry, age 13
WYOMISSING, PENNSYLVANIA

Photographed June 22, 2004

You have to pursue knowledge. I want to have more time each day to try and keep learning new and interesting stuff….

Paul McClure, age 19
MEMPHIS, TENNESSEE

Five years ago my father passed away of cancer. It showed me that life is very short. To me my father was Superman, you know? I loved him dearly; I never thought he'd ever die…. And then two years ago my brother died. He was twenty-one when he died and he was off at college. It humbled me very much and showed me that I should really grab life. It means a lot to me that I'm able to live on this Earth and be who I am. Being a teenager was the most fun I've ever had.

Marshall Stratton, age 19
MEMPHIS, TENNESSEE

I think I'd be a really good lawyer or politician simply because me and my parents used to get in these arguments and I would not give up—even when I knew I was wrong.

Bond Hopkins, age 19
MEMPHIS, TENNESSEE

Photographed August 9, 2001

The biggest thing that ever happened to me would probably have to be my father passing away. I was ten years old. Just growing up without a dad since the age of ten was just not normal. I think I could've used some more discipline. I'm just wondering if that's what I need, 'cause I don't know, I'm not really great at school or anything.

I was somewhat close to my dad but honestly, I can't really have that many memories of him actually sober.

I think I'm closest to my siblings. Each one of my siblings has a part like a parent or something, but they all have to be together for it to work. My sister Cassandra's the one like, "Oh, you have to be home at this time. Here's your curfew, where are you going, what're you doing?" And my sister Nita's the one like, "Are you hungry? Do you want dinner? Want me to make something?"

I'm thinking about starting my family in my late 20s, early 30s, so I can get the living that I want to live—like skydiving and whatever else I want to do—out of my system so I won't have to be that middle-aged man who goes and buys a Harley. I want to live my life before I have to worry about kids and all that.

If there could be a world without money, I'd choose that world, 'cause there's just way better things out there. I don't think a lot of people realize that.

Zechariah Messing, age 15
TUCSON, ARIZONA

I was scared to tell my mom I was pregnant but I knew I had to tell her…. She was mad. She was real mad. Then she said she was sorry for getting mad and telling me all the stuff she told me…. She went with me to my first couple appointments but then she started working again. She just seems like she wants to be closer now. My biggest fear in life now is losing my mom.

I didn't want to be a teen mom. It doesn't upset me, not really. Like, I know that other people are, like, gonna look down on me, but it happened and I have my little baby boy now. If I could do it all over again, and choose when I had my first child, it would be when I was already out of college.

Juanita Messing, age 16
TUCSON, ARIZONA

My mom and dad got divorced just about a year before my dad died, but he was still around all the time, and we were a just really close family for a long time and it just changed a lot of things. They got divorced because my mom was really tired of the way things were, and him not changing and giving up the alcohol for us and for her.

Do I have a boyfriend? Kind of, kind of not…. He's so different from me, he's not so goal-oriented. He's kind of just liking hanging out and being a teenager. The toughest thing for me is probably just not being able to do teenager stuff…. I take on a lot and I make sure that everybody else is taken care of before me, before I do things for myself.

There's some stuff that I might have missed out on, just because we haven't had the most money growing up. When I have my own family and my own kids I don't want there to be anything that they can't have just because we can't afford it. I don't want them to be spoiled brats or anything either, but I don't want them to feel like they can't have something new just because the bills are due, or just because other things are more important than their needs.

Cassandra Messing, age 18
TUCSON, ARIZONA

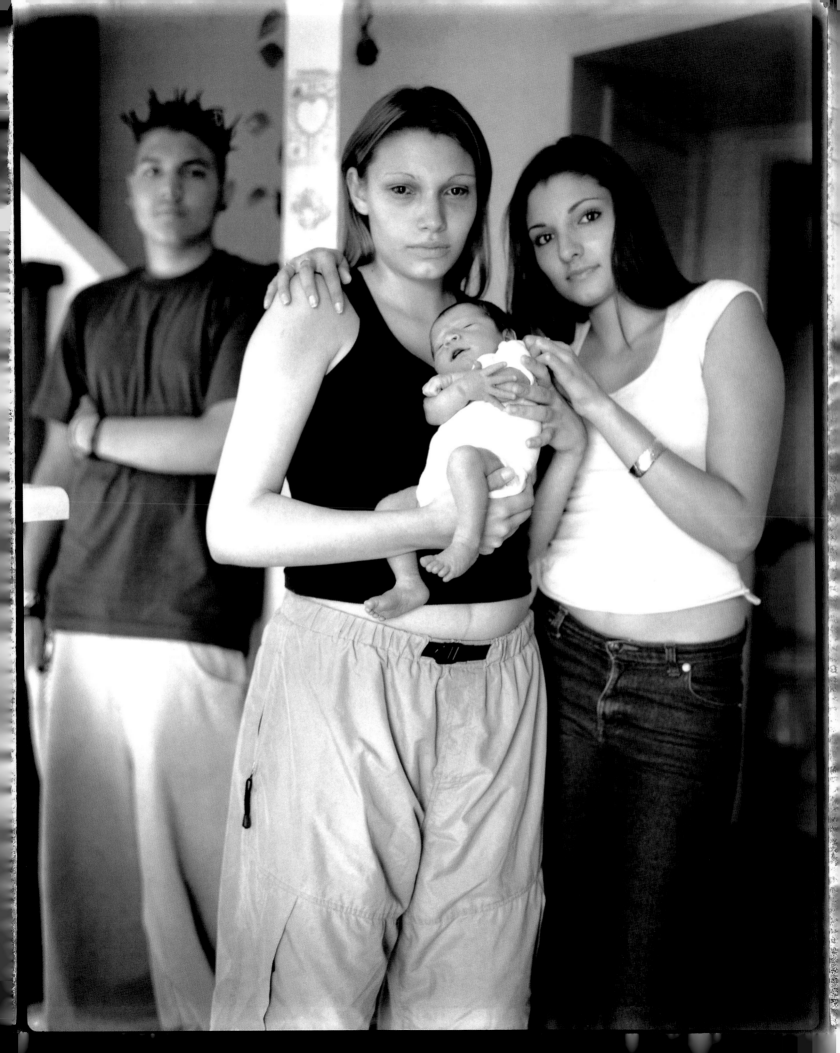

I live with my parents. This year in September it's their twenty-fifth anniversary. My mom came from a family of fourteen. There are seven kids in our family, I'm third. There's two brothers older than me. The one that's twenty-one, he drives a truck and he's not Amish any more…. He's just always been kind of a rebellious kid. He used to drink a lot, but he doesn't any more, but he's still not Amish…. I know my mom, well, we all pray for him, you know, that he will come back.

I think sometimes I'm ready to have a boyfriend. I have a crush on someone…but he's not Amish anymore, and I know he doesn't want to be Amish, so I don't know where that's gonna end.

I have friends that aren't Amish any more, and if I hang out with them and then come back to being at home all week, sometimes I get kind of confused 'n stuff.

There's a lot of rules in the Amish culture. Like our dress, and we believe in our modesty. We believe, and go to church. We don't have electricity or cars, or anything like that. We drive the horse and buggies.

My parents don't know, but I have a little television. We have to run it by batteries. It's really a pain because you have to first carry a big battery up—I mean these are heavy—and then hook it up to an inverter and then we watch movies with that.

I finished school when I was thirteen. That's usually the normal age. After that we just work at home until we're a little older, then usually we get jobs. I do kind of miss learning.

No, we don't vote. Amish don't vote. We believe in keeping away from the world, the Amish. See, so, no I don't really believe I could make a big impact on the world, but I do believe I can be a light to the world by living the way we do.

Naomi Sue Kramer, age 18
JAMESPORT, MISSOURI

Being Amish is really important to me. I guess because I always grew up like this, and my parents taught me to live a simple life, and live it for Jesus. I hope to be Amish for the rest of my life. I'm gonna marry an Amish boy and have a family.

I really think it would be awesome to have a boyfriend. The Amish can't date 'til they're seventeen, so a week from now I'll be able to start dating, go to the movies and stuff. From seventeen to whenever you're ready to join the Church, we go hang out and do some stuff like that. They call it "Rumspringer." It means "running around."

I use the telephone probably every day. We have an outdoor phone. It's a little ways down the field in an old shed. Because we don't believe in having electricity and a phone in the house. That would be too much like the world, I guess….

There's times, you know, when people mock us because we're Amish, we're different. There's times we're driving along the road with our horse and buggy, people will yell mean stuff at us.

I think there's more in life than money. I think if I have enough money to get me through, then I think that's great…. I spend [my money] on dress material, shoes. When me and my friends go out, we go eat, go out to movies, or go to amusement parks.

The best thing I like about myself is my sense of humor. I'm kind of shy and insecure, so that's the worst about myself.

Marjorie Lynn Kramer, age 17
JAMESPORT, MISSOURI

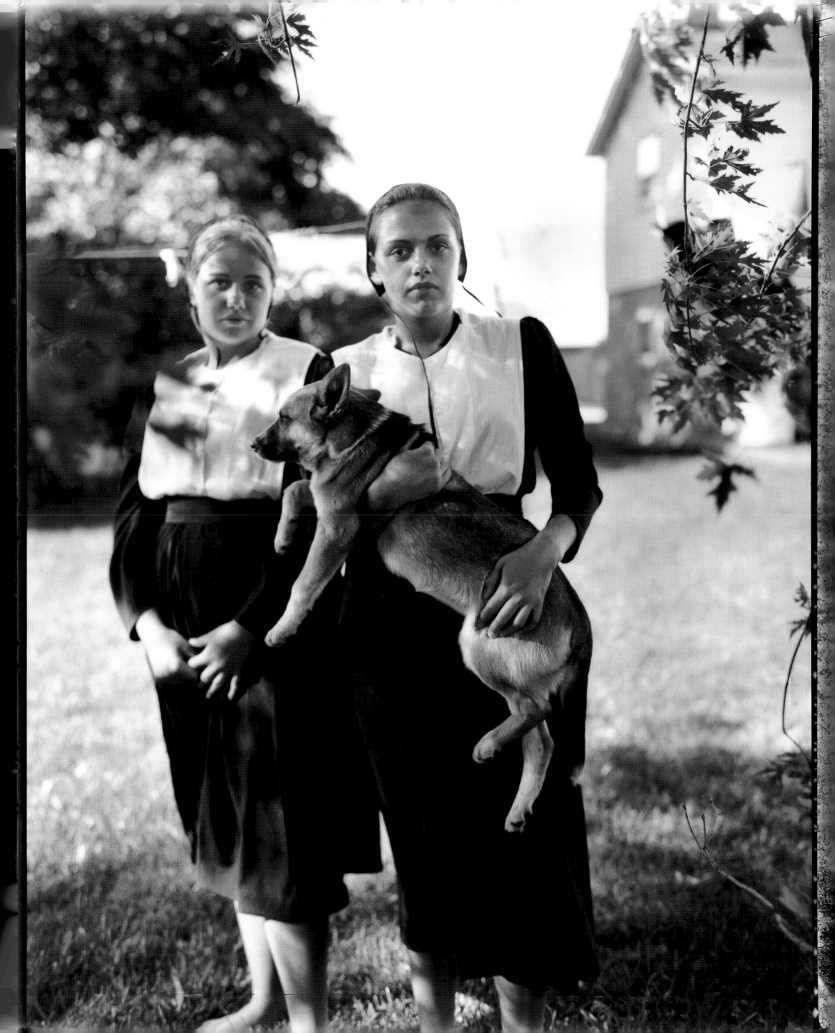

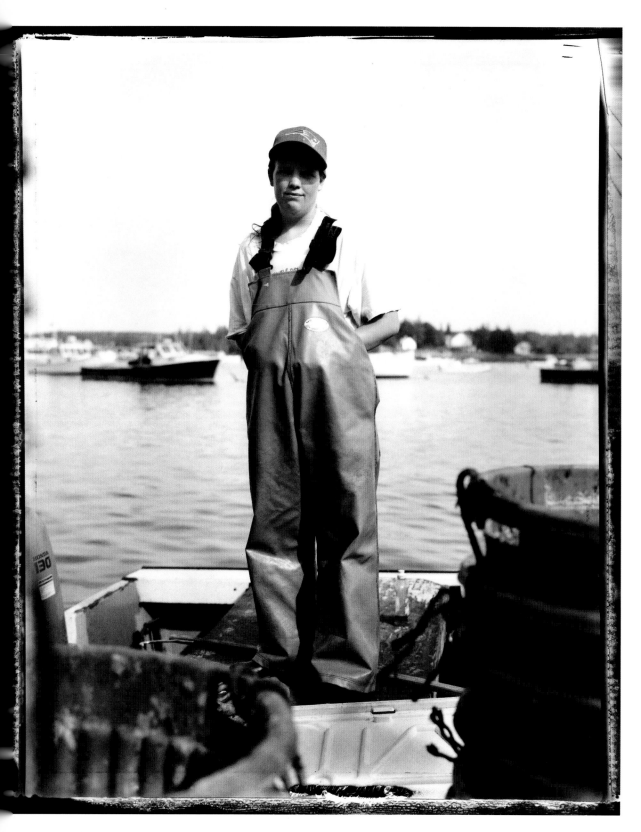

The biggest thing that's ever happened to me. Um, just, like, living on an island, it's not big but you're stuck here and you kinda gotta make do with what you have and come up with your own. In a social way it makes you so you're not good at meeting new people 'cuz you know everybody.

In my school, there's probably just fifty kids in high school. I am not going to college. I am going into lobster'in with my father. School's important, I mean, you should finish it and everything, but I don't think you have to go to college to be successful.

My biggest fear is not succeedin' or being successful, you know? I plan on going to lobsterin' after I get out of school—just goin' out with my dad, so I want to be able to be good at that and make lots of money.

For work I'm up at five and I'm usually going by five thirty, six o'clock. We're usually in by two or three. We have, like, six hundreds traps. I'm not really sure how many lobsters we catch in a day, but today we filled a tank…. I'm not really sure how much that holds. I usually make like, a hundred bucks a day. I've been doing this for probably ten years.

My fantasy would be…this sounds probably really bad, but to have a husband that has a lot of money and just be able to stay at home with my kids and just do the at-home-mom kind of deal. I'd probably live here just 'cuz it's a good place to live.

Elizabeth Davis, age 17
VINAL HAVEN, MAINE

I work at the rodeo, cattle roping. When I started working I was probably, like, nine years old…. I started liking it 'cause I got paid; they pay me $98 a day. I work one day every fifteen days. I try to save it up for clothes…mall clothes. And I spend my money on stuff that my brother wants to buy, and my little sister.

I watch TV almost the whole time when I don't have nothing to do. When I saw 9/11 on TV I felt, like, sad on the inside, and on the outside too. Really, really sad.

If we didn't have any school, everybody would probably…don't know anything. They wouldn't know how to count leopards, wouldn't know how to count cows, I don't know…wouldn't know to count your birthday!

If I could be someone else, I would probably be an angel 'cause you won't have to suffer anymore up there.

Edgar Estrada, age 13
ROUND MOUNTAIN, TEXAS

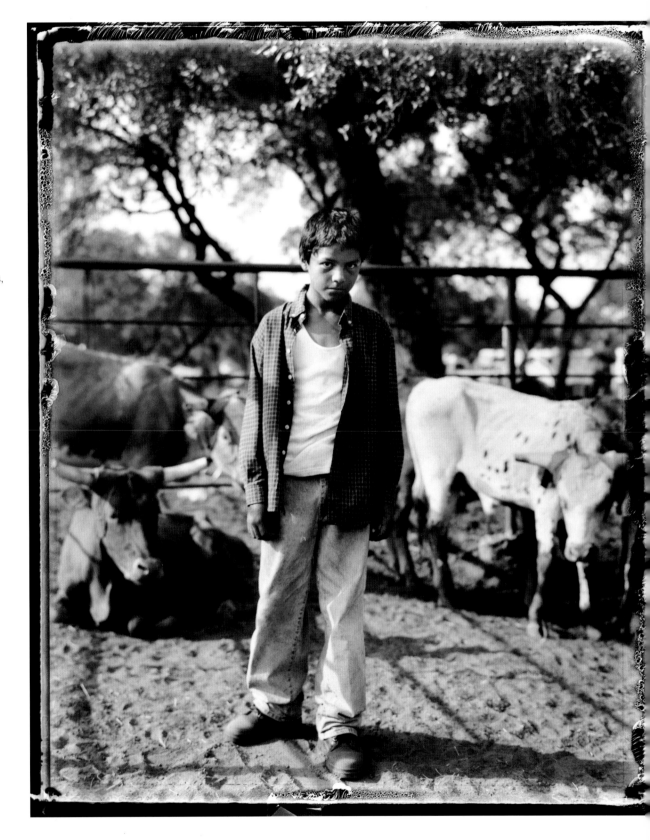

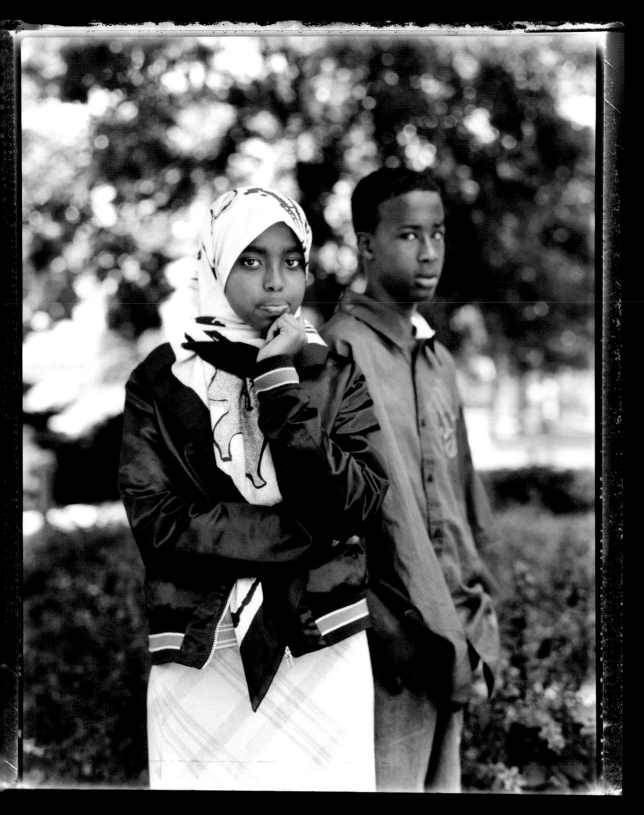

I believe in God. My religion is Islam. Religion is very important in my life. It helps me get through every day. I believe that if there is God, you can always trust, you can always ask anything. Your life will be easier…. I pray five times a day just to worship my God…so, I'm really happy.

I love the school here…. I really enjoy school since I was a kid. I'm really interested in math and biology. I love my teachers… they always there for me. I'm a good student. Yep…. Straight A's. I work really hard on it.

If I can be somebody else…. I don't know. A hero…. Ghandi. You know Ghandi? "You must be the change you most seek."…. Like, if you want to do a thing, you should not wait for someone to do it. You should do it….

Faduma Mohamed, age 16
MINNEAPOLIS, MINNESOTA

When I left Somalia, there was a war going on…. The war was happening around us… as soon as you get up you see bullets around. People killing people…. We went from Somalia to Kenya…. We walked. It took us like a couple of months, three, or two.

I remember my first day in America. It was winter. I had no jacket. All I had was shorts, sandals and a black t-shirt. It was so cold. I didn't even know what snow was. As soon as I step on it, my legs got colder.

I like living here…it's peaceful…. Back there people used to kill each other…. Here people respect each other. They show love, and your dreams come true. Here if you work hard, you get whatever you want.

But here, when I go school I see black kids cursing at Somalians. I see white people hating Native Americans. People hate you and then you have to hate them back…. I don't want to do that. I want to be friend with everybody. We all should get along.

Said Ahmed, age 15
MINNEAPOLIS, MINNESOTA

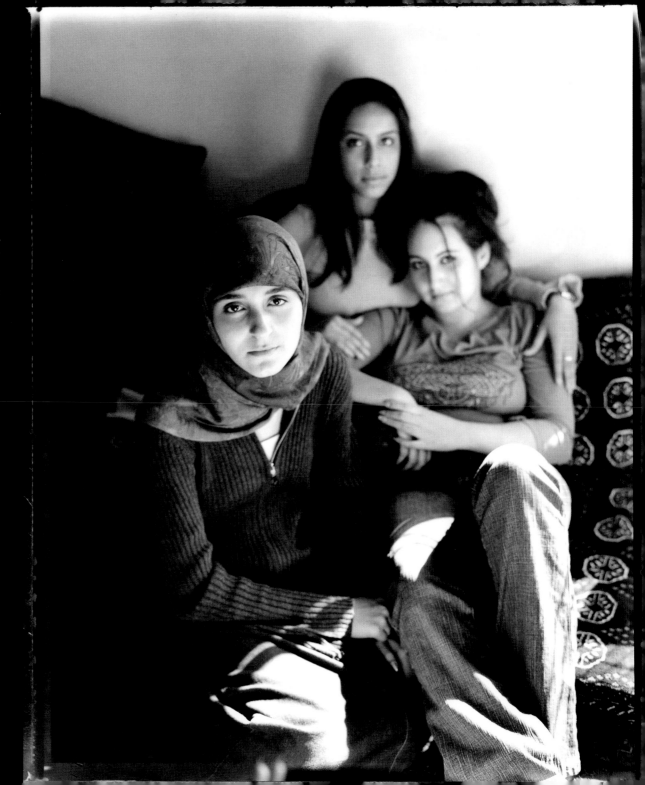

'm from Afghanistan, I have lived here
lmost three years.

I haven't changed that much since
oming to America, really. But my dad, he
tarts to talk to us all about Afghanistan and
ells us you can't act like you're American or
nything. You are Muslim and you have to
e Muslim.

I like the idea of staying in America
or a long time, 'cause if I go back to Af-
hanistan, I can't go to school or anything.
 don't think a woman has that much rights
here.... I want to work and make my own
ecisions.

In my religion, you marry someone
our parents bring to you. You have to marry
nd you have to have a family. I am not now
nterested in boys.... I don't want my own
hildren. If it happens I just have to face it.
eah, in America there is choice, but I don't
vant to make my parents sad just because
 came to America and I have freedom. I
on't want to do that.

Haseena Arsala, age 15
REMONT, CALIFORNIA

 work at an Indian restaurant here in
remont. I've been serving there for almost
ne year. Because when we was new here
ve need some money, so I have to do work.
 give the money I make to my parents. My
arents do not work, because they can't
peak English, not at all.

Oh, God is who I respect the most.
irst God, and then my parents.

Rohina Hamedi, age 17
REMONT, CALIFORNIA

My mom doesn't want me to have many
riends.... She says like, "You don't know
vhat's out there," and "They might change
our personality".

I do believe in God. I'm Muslim. Al-
ah is important to me because he is telling
he truth.... I think being covered is for
our own good so guys don't bother you
nd stuff.

The Afghan people were very, very
adly treated because of the Taliban hitting
hem and treating them bad—raping the
oung girls. I think it was a good thing that
hey're gone now.

Dina Salemi, age 18
REMONT, CALIFORNIA

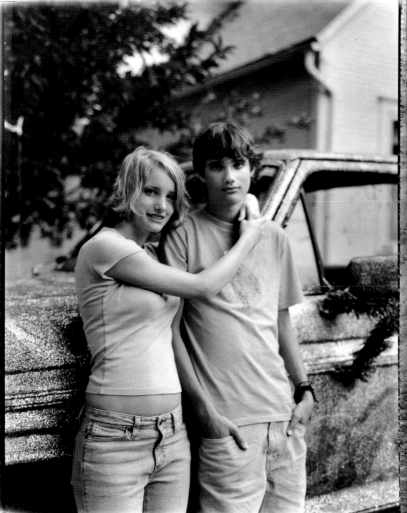

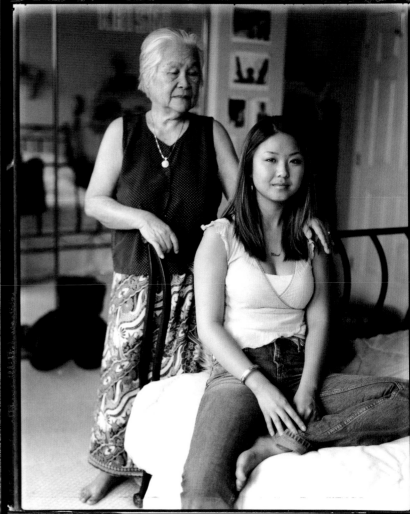

I don't like my father. He doesn't like me. He gets along with my brother, but he doesn't like me 'cause I speak up to him. He's an alcoholic…. I won't take him being inappropriate, saying mean things or whatever….

I have a lot of respect for my mom…. She has dealt with this alcoholism thing very nicely. She's made sure that things are good for us even if they are hard for her.

Adrian Bell, age 18
PELLA, IOWA

My dad could be a really nice guy, but I also know that he's a complete jerk to my mom and my sister, and seems to favor me unfairly, which gets rather confusing at times.

Where I live is a capital of Christian fundamentalism…. Most kids are uberly Christian…. I get treated differently because I'm not, but only if people find out about it and try and save my soul. I've gotten two letters telling me to go to Church.

Walker Bell, age 15
PELLA, IOWA

Photographed July 8, 2004

I don't really know why I'm not close to my parents. They just were really about control because they don't want anything bad to happen to me. They are very traditional.

My parents had an arranged marriage. I want to fall in love with the person I marry. I'm close with my grandmother. She's just a little more open-minded, and she raised me, basically.

I don't follow a lot of rules that my parents set for me…. I have a boyfriend. Is that gonna be in the interview, 'cause I'm not supposed to!

Oh God…if I got pregnant, I don't think my family would help me anymore.

Even though me and my parents don't get along, I really respect them cause they work really hard. They own a business. It's a liquor store. They've just done lots of things like restaurants and donut shops and stuff. Money is important, 'cause money is power (laughs). Money is everything.

Krisna Kay, age 17
TUCSON, ARIZONA

Photographed August 16, 2002

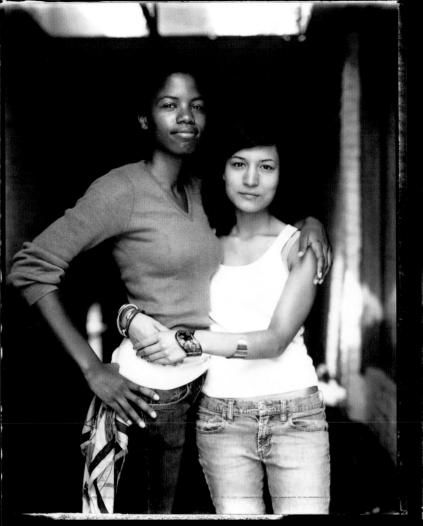

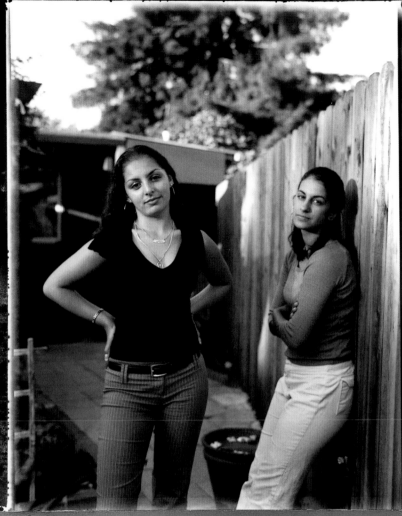

I think that everybody thinks about race, I think that is one of the first things people will identify you with so I'm sure, yes.

I've actually encountered white people who think about it more, because of the way my friends and me have been brought up has been pushing diversity and stuff like that. I think sometimes white people feel more guilted by it because they're white. I see a lot of influential people around me, so I'm not really scared for the world.

Stephanie Pottinger, age 18
BROOKLYN, NEW YORK

The toughest thing about being a teenager is probably realizing that adults are a lot like teenagers themselves.

I respect my dad the most because he has been making art for sixty years and he isn't a successful artist, he's not super famous, he's never given up.

I don't feel particularly white and I don't feel particularly Asian. So I guess I'm a chameleon. I guess I'm whoever people think I am.

Misa Kobayashi, age 17
NEW YORK, NEW YORK

Having a strong family can really help someone out. I didn't have those things— we didn't eat dinner together, we don't do those family things and I feel like I'm left out.

After the September 11 attacks people started saying all sorts of things. I was just blown away, cause I have Persian soccer jerseys I wear to school, you know, I'm not ashamed, I'm Persian. My mom's more like "Now we have to be really careful what we say, what you wear, don't wear your Perisan jerseys anymore." I flaunt it whenever I can. I'm very proud of it.

Natalie Nadimi, age 17
RICHMOND, CALIFORNIA

I want to do everything, I want to have everything, I want to enjoy everything, I want to experience everything.

I'm a Syrian-Iranian. My father and brother are atheist, and my mom believes in a greater being. I see the point in a lot of peoples' religions, but I don't feel like I need it for myself.

Anusheh Warda, age 17
EL SEBRANTE, CALIFORNIA

I was in the South Park Free Stone Gang. I've shot at people, but actually hit them? I don't know. See, I've done a couple of drive-bys and just ducked down and pulled the trigger. You don't even really know where you're shooting at. It scares me actually to think that I was that way, I was that brutal, that dangerous. It kind of gives me a rush but it kind of scares me.

I decided to leave the gang when I suddenly realized that they weren't behind me. They said, "Yeah I got your back, I'm there for you, whatever you need, blah blah blah." But when it came down to it, and I really needed them there by my side to help me get through something, they weren't there.

Being arrested was a big part of my life turning around. And when Lirio walked in to my life. When she walked in to my life, it changed a big part of me. I know she's "the one" because so far in my life she's the only thing that's truly made me happy. I have the bad tendency of not being able to smile. I can't smile for nothing. She brings a smile to my face every time I see her. I wanna get married to Lirio, and she wants to wait to have some kids, and I'll wait for her. And I want to have three kids. I wanna have two boys and a girl—my little princess, I'll call her. I just wanna have a nice home....

Twenty years now, my parents have been married. They have their little quarrels once in a while but right after that, "I love you" and they're happy as far as I can see. And I wish to have that, too.

Blas Valdez, age 18
TUCSON, ARIZONA

Family is your first teacher. Your family is your first school. Your family is your first Church. It's like they are the first people you see in the morning and the last you see at night. So they're gonna be the ones most involved in your early life, and in your early life is when you learn everything, you get all your habits and everything. So I think that family has the most impact on your life.

Probably the toughest thing about being a teenager is the fact that adults don't trust teenagers a lot. Not all of us are ruthless and disruptive or drug addicts and alcoholics or anything like that. A lot of us have a great potential that they just aren't able to see and we're not able to fulfill.

Me and my boyfriend Blas have talked about getting married and having three kids—two boys and a girl, so it's pretty set. We were together for about three or four months before we actually had sex. The first time it was weird, but was an "Oh my gosh" type of thing. But now it's like.... I'm not gonna say routine but I'm not surprised with it now (laughs)! You can say that I enjoy it! If I ever got pregnant, Blas said he would drop out of school and take care of the baby while I stay in school. I believe in the right to choose but I for one do not believe in abortion.

As a minority I think I would really take it to heart if someone would discriminate against me. And as a girl, again I would take it to heart because a lot of people, you know, are like, "Girls can't do that job...girls can't do that"—it's like, "Don't tell me I can't, cause I will!"

Lirio Meraz, age 16
TUCSON, ARIZONA

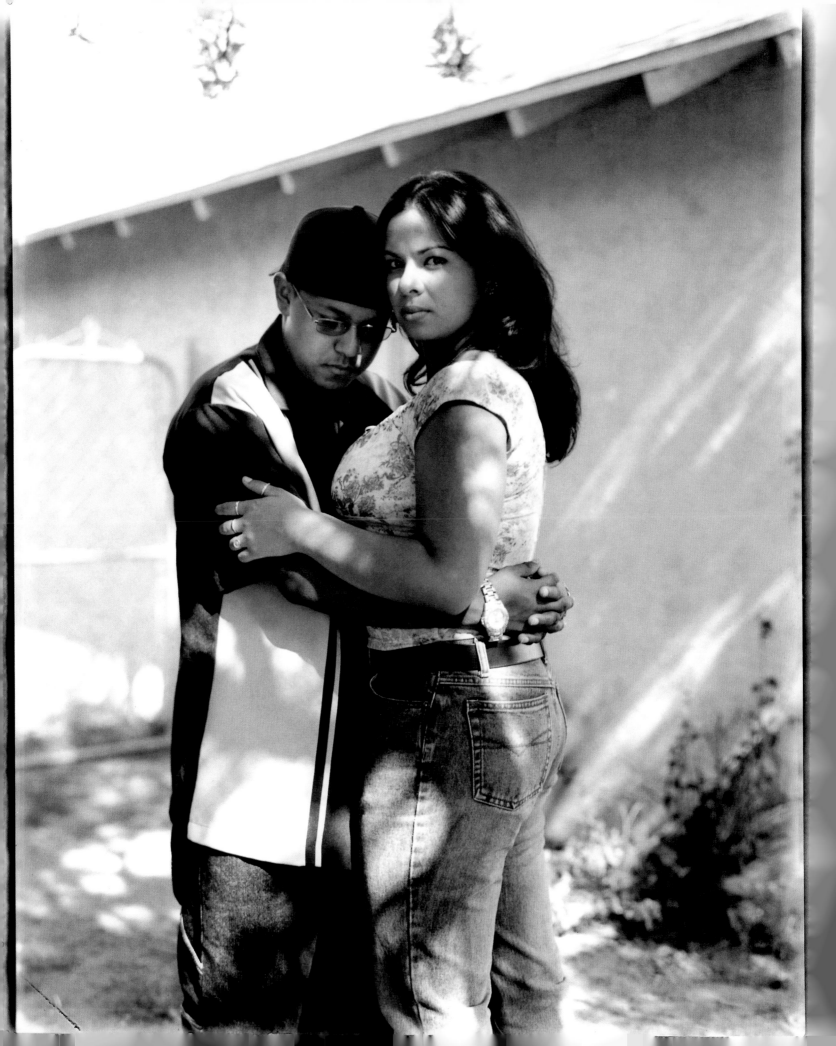

When I was four years old, they took me away from my mother because she was using drugs. I lived in a couple of foster homes, and then I went to my own grandmother's house and a family member raped me when I was like five. So that's why I'm attracted to girls, because I'm afraid of men.

I lost my virginity to a boy. The reason I had sex as a teenager was that there wasn't anybody there for me. My father wasn't there, and this boy was there for me and this boy told me he loved me, and I felt like I owed it to him. Maybe if parents were there more than what they are right now, the kids wouldn't go out and find somebody for them to love and have sex with them…. We shouldn't have to go out and find people to love us.

Before I had my girlfriend, Love, I was always depressed. I didn't know what to do, but now that I'm with her, I'm happy. I mean, we have our ups and downs and sometimes I'm sad, but I'm usually happy.

At times I believe in God. When people sit around and say that God doesn't accept gay people, I get upset. And I say that He is being selfish, and He should love us for who we are…. Because I do want to believe in Him. I'm confused, and I really don't know what I should do, if I should believe or if I shouldn't.

I want a house with my kids and Love's kids and my niece and her nephew. I guess I would be the mother who drops them off at school and cooks dinner and stuff like that.

Honestly, I'm not mad at my parents. I thank them, because this is the happiest I have ever been in my entire life.

Roxy Trevino, age 17
JAMAICA, QUEENS, NEW YORK

I started dating girls when I was thirteen. 'Cause I was in Spartan Juvenile Detention and everybody else was doing it and I just followed…. I ended up there because I had a fight with my brother…he was twelve and I was thirteen, and he was beating me up real bad. When he let me go, I ran in the kitchen, got a knife, and I stabbed him in the hand. My mother broke it up with a broomstick and then she called the police and they took me away.

I was in there for a year and a half. Juvenile detention was nice. I liked it better than here, so after I came home I got in trouble on purpose so I could go back. I was on probation and went to the store and stole a whole bunch of clothes, and so I went back because I had a lot of friends and stuff in there.

Roxy's not my first girlfriend, but she's my first love. My mother don't talk about me being gay but Roxy lives with me and my mom, but my mom never asked me and I never told her but I know she knows. My sister told me she said, "Your daughter's gay," and she said, "No, she's not, she's just going through a phase right now."

My fantasy is to be a famous dancer. I want to make money off of that and I'm going to have a big house in the Hamptons. My mother used to work out there. She be telling me about it. A perfect family to me is two people that love each other. And I want to have, like, four cars for my girlfriend Roxy, her two kids, my five kids, plus my three nieces and nephews, my little brother, and just a nice big house. That's it.

Love Kye, age 19
JAMAICA, QUEENS, NEW YORK

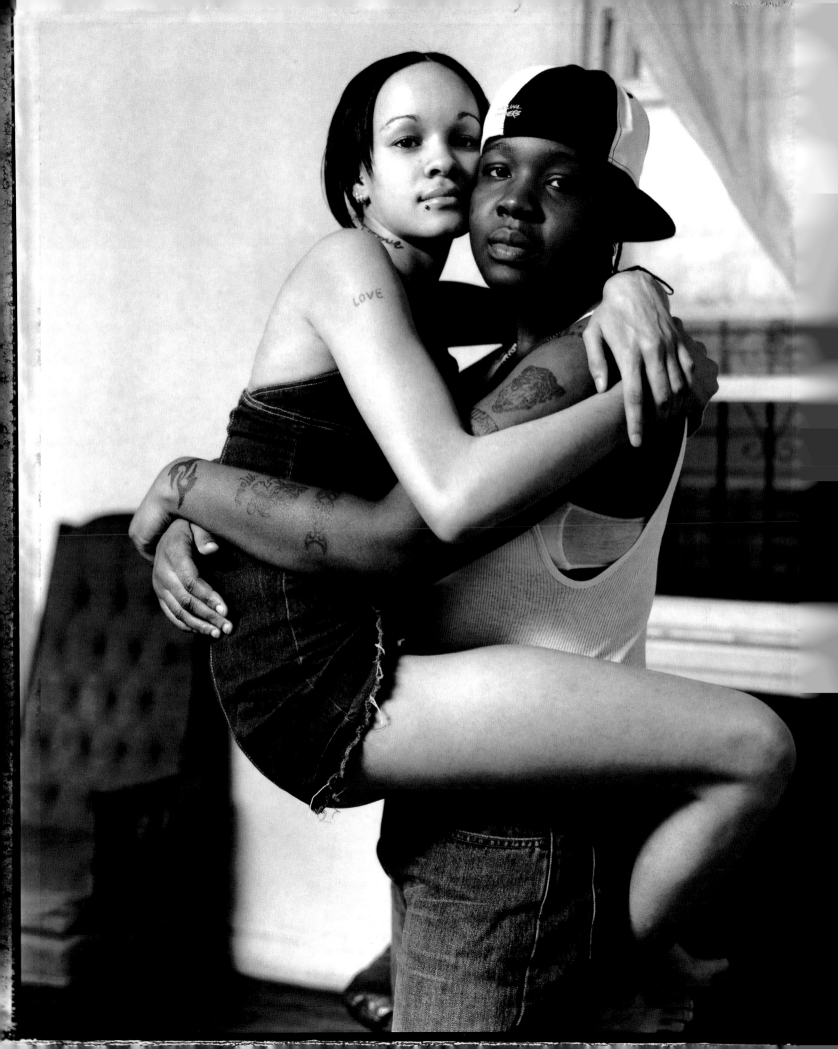

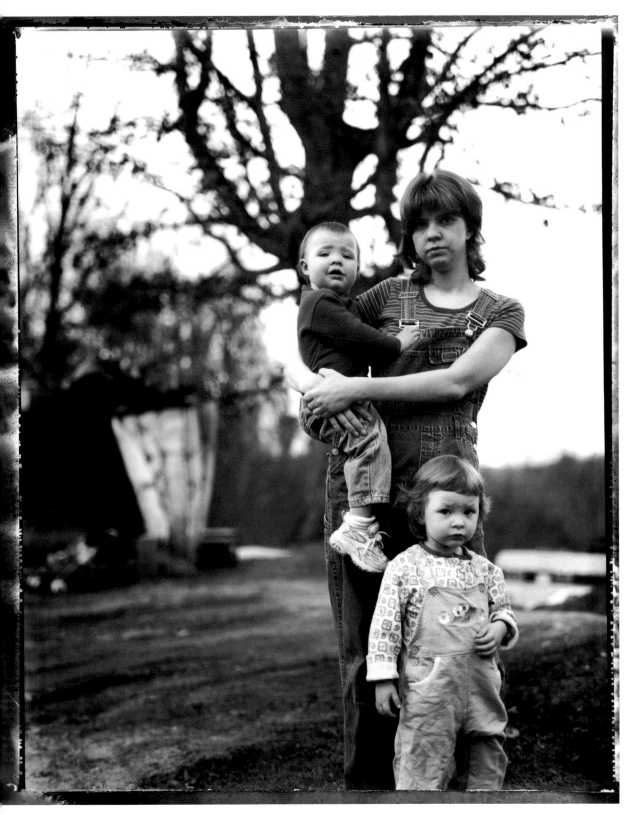

My mom, my adopted mother, owned a store and she would sell beer out of that store, and my real mom and my real dad used to come up there. And she said my dad beat on my real mother when she was pregnant. And then whenever I was born, my mom said that he came up here and said I was lying there starving and didn't have no food or doctors, and she told him to bring me up here and that she would take me in. And the next day they brought me up to her…. She adopted my oldest sister too, from my aunt…. She adopted all three of us.

I was sixteen when I got pregnant…. The father broke up with me when I was six months pregnant. He left me because he said the baby wasn't his. He left me for a fourteen-year-old girl; he was twenty-one.

I met my husband—I'd dated him before, and then he got with me and married me and has raised her since she was born….

God is real important. He helps me through everything. I pray for my husband to get a job when he's out of work and we're on welfare and can hardly make it. And I prayed for him to get a job and he went out that day and got a job. I prayed when we didn't have a vehicle for Him to help me there. He helped me. I was out of diapers one day and He helped me get diapers. My friend brought me a pack up here. She said her little girl got potty trained and she brought them up here and I didn't even expect it.

God gives me a whole lot for the kids and He makes sure I have food for them. We never go hungry. We don't never go without anything for them.

Ruby Joann Browning, age 19
PAYNESVILLE, WEST VIRGINIA

I quit school in tenth grade…. I was
going to quit before, but I had to wait until
I turned sixteen…. Probably after my baby's
born I'll get my GED and probably go to
college, maybe.

We stay with my parents for now.
Our trailer will be here next week. My
husband moved in right after we found
out that I was pregnant.

My parents have been married for
twenty-five years. My mom is thirty-six and
I think my dad is forty-six…. My mom was
twelve when she got married.

In my fantasies, I want just to move
away and be happy…to Florida. Somewhere
where it's pretty.

Tiffany Vance, age 16
WHARNCLIFFE, WEST VIRGINIA

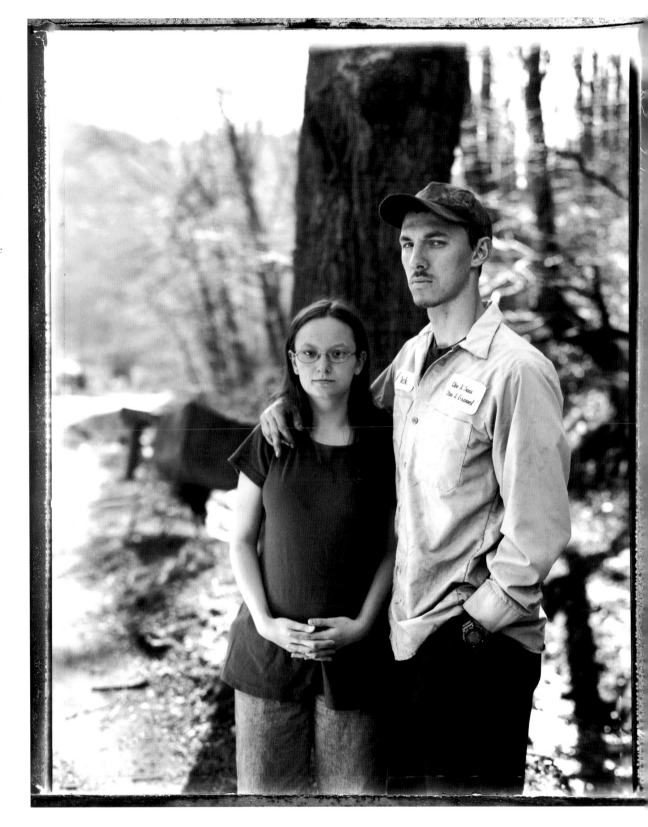

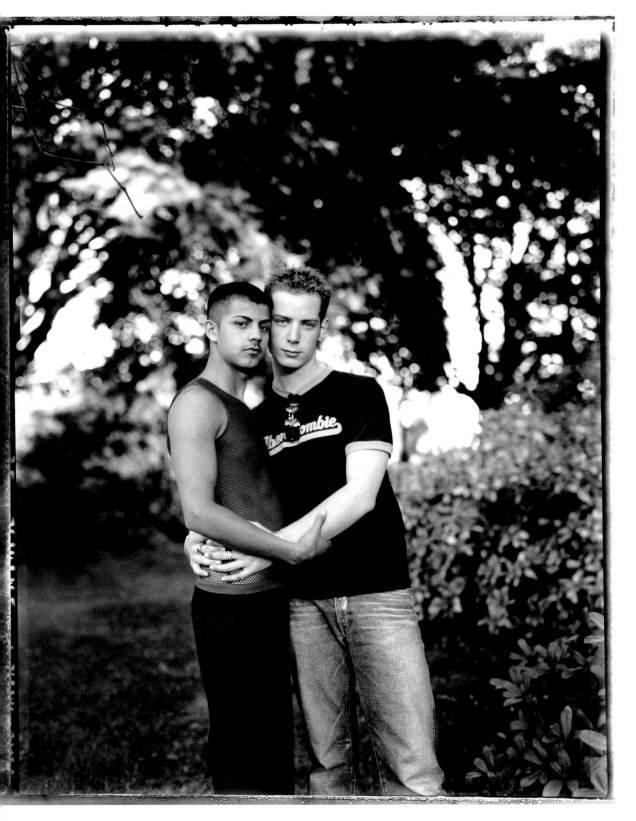

The biggest thing that happened to me was the day that I told my mother that I was gay. It was really hard but you know, you feel like a ton of rocks are off your back once you tell your family…. I feel like I'm wanted now. Because when I was straight I tried to act like someone I wasn't, and now that I came out I feel like I found myself.

I left Yakima because I came out; um, because my mom would hear people talking shit about me and it would hurt her, and I didn't want her to go through that anymore. Sometimes I would take her to lunch and stuff like that, and they would just look at me like, "My God, she has a faggot as a son," you know, and it would hurt me. I just told my mom it was better off if I just left Yakima and they'd just forget about me, like, old news.

Tony Rivera, age 17
YAKIMA, WASHINGTON

By the time I was thirteen I was a three-time convicted felon. I thought it would be fun to go out and vandalize a lot of cars. Me and all my friends, we had everything…. What money couldn't buy, we did.

Honestly, I can say money is one of the most important things besides friends in my life. I was influenced by it greatly. My family was very, very wealthy. They were just freakin' rich…my grandparents, if I wanted anything I saw they'd give it to me…. Like my next-door neighbor got a trampoline, and I was like, "I want one." Three hours later I had one. When I'm older I want to have even more. Everybody always says this about me. I'm very insatiable.

I want to get married, um, to a man… adopt children…. I plan on having the whole white picket fence, little dog, house on the prairie, you know.

Scott Brown, age 19
KENT, WASHINGTON

I'm poison free and I won't have sex 'til marriage. I won't drink or smoke…. People claim "straight edge", which means you won't drink, won't smoke for life. But I claim "poison free", because I can't make a life decision right now…. Some people think it's a religious thing, for me it isn't….

…I think I would love to become an artist. I don't care if I become famous, I just want some of my work to get out there….

Chelsea Corbin, age 18
SEATTLE, WASHINGTON

Have I had discrimination? Like, people making fun of you and stuff? Yeah. In school mostly. Because I'm fat. I used to be a lot bigger, so…. It made me feel like shit!

Music has been a big part of my life. I started listening to more emotional music like punk rock and stuff, and that's how I met the friends that I have…. I don't consider myself punk…. Well, see, I used to be big on labels, but now I think it's kind of pointless.

It would be really nice to be rich and have all these people looking up to you so I guess like, being like a rockstar or something would be my fantasy future. My future reality is probably working at a makeup counter in Nordstrom.

Tia Larson, age 18
VANCOUVER, WASHINGTON

I was raised Mormon…. Probably my life is not a normal Mormon life in other peoples' eyes…. But I still pray every night, and I still try to read my Scriptures, and I still keep the Commandments….

I think that teens jump into sex these days. If you don't love somebody, you shouldn't be having sex with them.

I have friends that have had abortions. I think it's really sad. But, that's the only way that those girls can correct those mistakes sometimes.

If you fall in love with somebody the same sex, that's the way God made you and you can't change that. I guess I'm a pretty open-minded Mormon!

Nichole Monson, age 18
SEATTLE, WASHINGTON

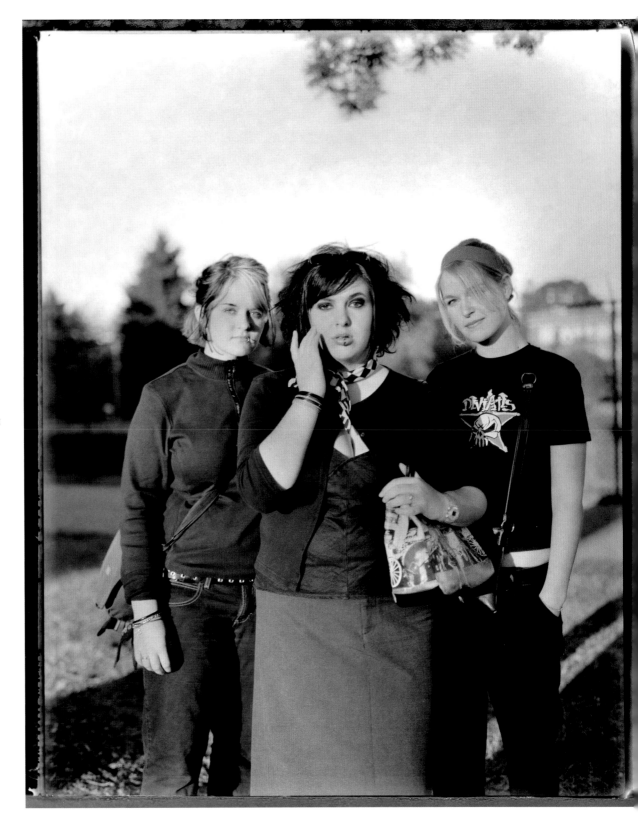

Two years ago when my parents got divorced I kinda didn't get both sides of the story. Right after the divorce [my dad] got married to a lady. I didn't want to live with my mom or him, so I moved into my camp house on the Alabama River. I was seventeen. Neither one of them could stop me. They didn't want to talk to each other so they were using me for interference and I got fed up with it.

You're gonna find this hard to believe, but the first time I took a puff off a cigarette (I didn't know what I was doing) I was in the third grade. I still smoke. I wake up every morning and I'm shaking because I want a cigarette.

I was probably nine or ten the first time I got drunk. On both sides, my mom and dad's, there's been alcoholism–real bad alcoholics. That's probably what everybody thinks I might become.

I got a lot of black friends 'cause I live out in the country and it's just blacks that live all around us. I go to their house and play cards with them. I mess with them and they mess with me. When I walk in the house, "Hey, white boy," or something, but they're just messing around. It matters on the circumstance. There's "blacks" and there's "whites"; and there's "niggers" and there's "white trash." That's four different categories.

Jake Brown, age 18
SARDIS, ALABAMA

Biggest thing that ever happened to me would probably be the day that I became a Christian…. It was a day I had been praying about and I finally just felt "This is something I need to do, a choice I have to make." It's changed me, it's made me feel like I've become a better person, developed a closer relationship to God.

Selma was the center of the Civil Rights Movement back in the '60s, and the blacks here have always been hated by the whites…. I can be racial at times too, because of just the blood, you know, that I have in me. It kind of runs in the family. We got family members that are real old-school. They discriminate a lot towards blacks and I think I inherited it because of the way I hear my family talking.

Like I was workin' this summer and a black man—he was from up in a little town outside of Selma—he was tellin' me, you know, "Do this, do that, do this." I told him, I said, "I'm white. You're black. You do it." Because that's just the way the family has always done it. He was kinda used to it because that's just the way he grew up, was being told mostly by white people, "You do this. You do that." I thought he was just trying to take advantage of the situation and he did a lot to tick me off that day. I think discrimination is wrong, but just like sexual relationships, I know the right and the wrong thing to do, but most of the time I just don't do the right thing (laughs)!

Whit Schroeder, age 18
SELMA, ALABAMA

I was probably around fifteen when my parents got divorced…I took it pretty hard. It made me sad for a while and then I just got angry at both of them. I thought it was one of their faults, but realized I couldn't do that. Then I started drinkin' and stuff, but that didn't change anything either so I just had to depend on God to do it. Yes ma'am, God is a large part of my life. He's the one that knows everything that's gonna happen before it happens, and if you depend on Him, you'll pretty much be in control of it.

Randall Huffman, age 17
SELMA, ALABAMA

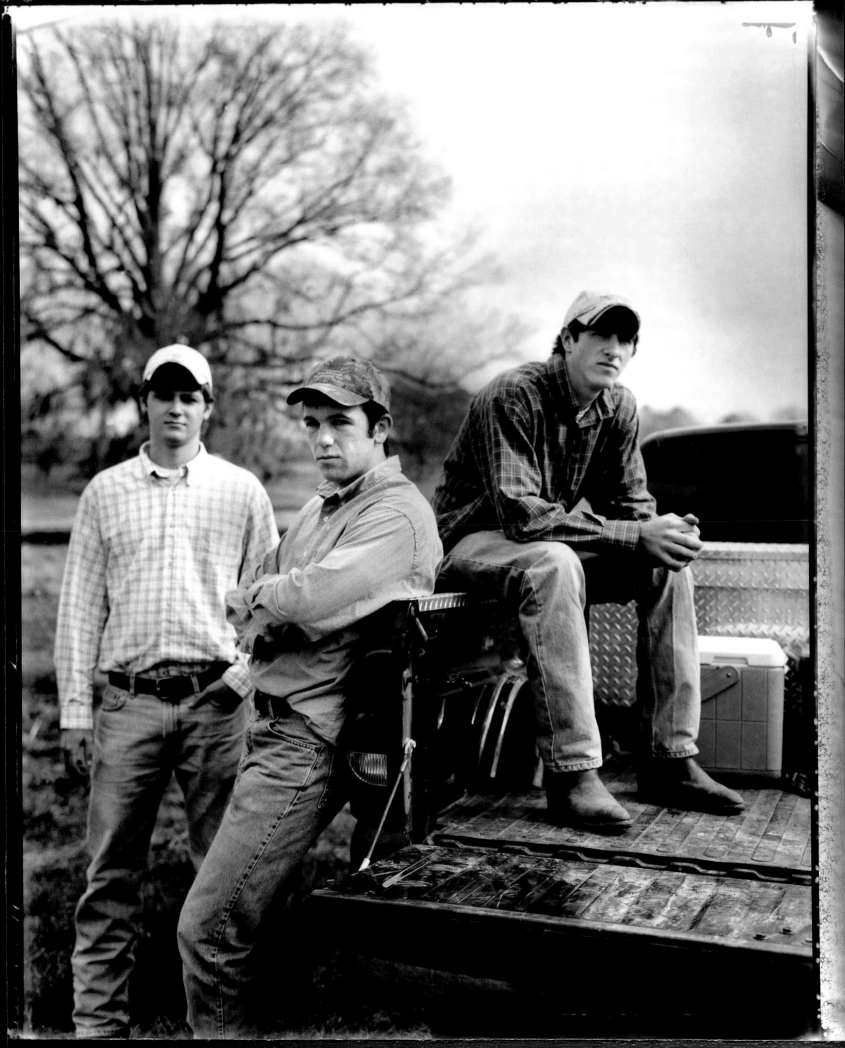

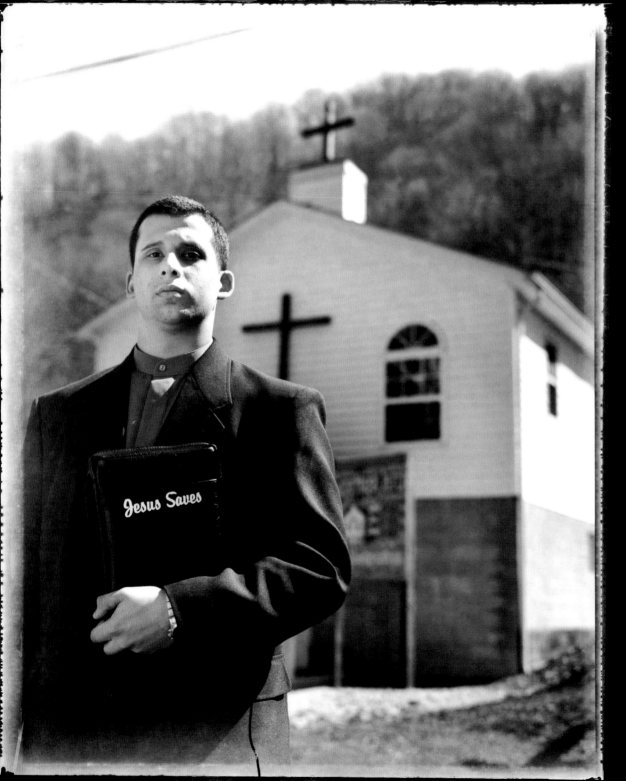

One of the biggest things that's ever happened to me is when I got saved and met God and it changed my life…. That was when I was nine years old. It was an experience like I've never felt before. It was like the Bible says it was…full of glory. And it's not something that you can really explain, it's just something down inside that you can feel and it's something that you know is real…. Before I went to Church I could feel the conviction. I could feel God knockin' on my heart's door. And when I went to Church I knowed what it took to be saved and I knowed what I had to do.

I attend The Church of God. They believe in being born again, being saved, being sanctified, filled with the Holy Ghost. With evidence, with speaking in tongues. I started speaking in tongues about a year after I got saved, when I was about ten…. You're aware of it, but it's not something that you really can control. You could stop it but you wouldn't want to, it's such a good feeling you wouldn't want to stop it. Some people calls our church Holy Roller, because we shout a lot.

I don't find very much hard about being a teen except there's just a lot of decisions you have to make about what's gonna happen in the future…like your career decisions and your school decisions and decisions that are gonna affect the rest of your life…I started preaching when I was thirteen…. I would like to have my own church someday…that's part of who I am.

I don't really know anything that really bothers me about myself because I stand the way God made me and that's about it…. I really wouldn't want to be nobody else.

Nathaniel Gibson, age 17
VARNEY, WEST VIRGINIA

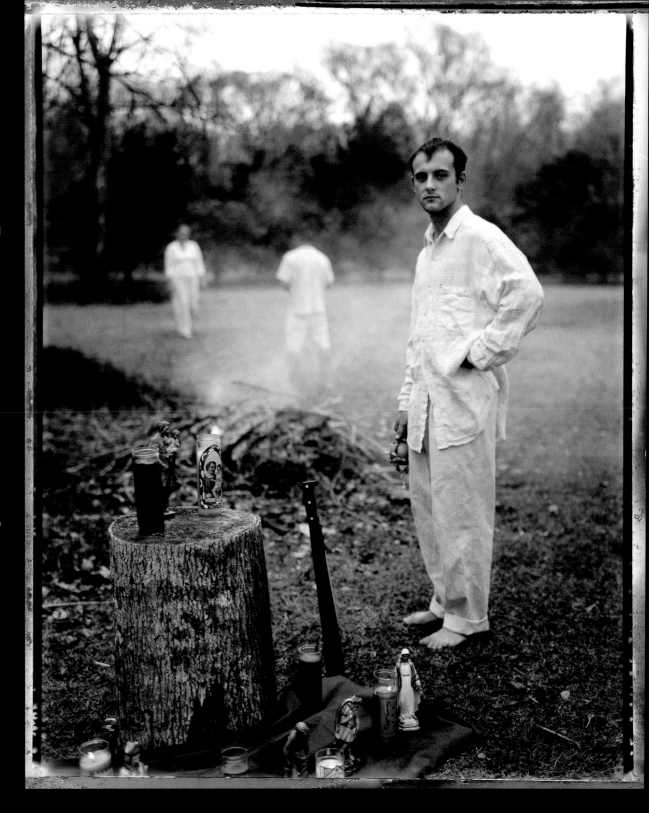

All my life I've had a spiritual sense, if you will. I've always studied world religion, but around the age of ten was when I stumbled upon voodoo and it hit me like a ton of bricks and I knew that's what I had to follow. I couldn't really even explain why. It's just something you know. I guess everyone has a similar type of experience in life, where you just know something. Be it religion, or love, or whatever it may be—something you just know and that's the way it's gonna be and that's it.

Being a voodoo priest I have a temple, and in my temple I have children. My children are the people that come to me and ask me to teach them. My students, if you will. I'm helping them in life—not just in religion, but in everyday situations. If they call me and ask me for advice, I'm there for them. I'll give them the best advice I can give them. That's the way that I see myself helping the world.

I didn't graduate high school, which is something I regret. I went to Catholic school all my life. Things happened, you know, and I had to drop out. I got someone pregnant, plain and simple. We ended up losing the baby. I think it's just the spirits planned it that way, 'cause it wasn't the right time.

Nearly having that baby is something that I'll never forget, because I was happy. I said, "I'll have to work for the rest of my life and come home dirty, but at least I know when I come home I'll have someone there waiting for me." You know, to call me "Daddy." But you know, things worked out differently. Nothing ever works out wrong in life.

Anybody who says money can't buy you happiness—they're shoppin' at the wrong store.

**Jesse Brunet
(Voodoo Name:
Houngan Ti Damballah),
age 19**
HOUMA, LOUISIANA

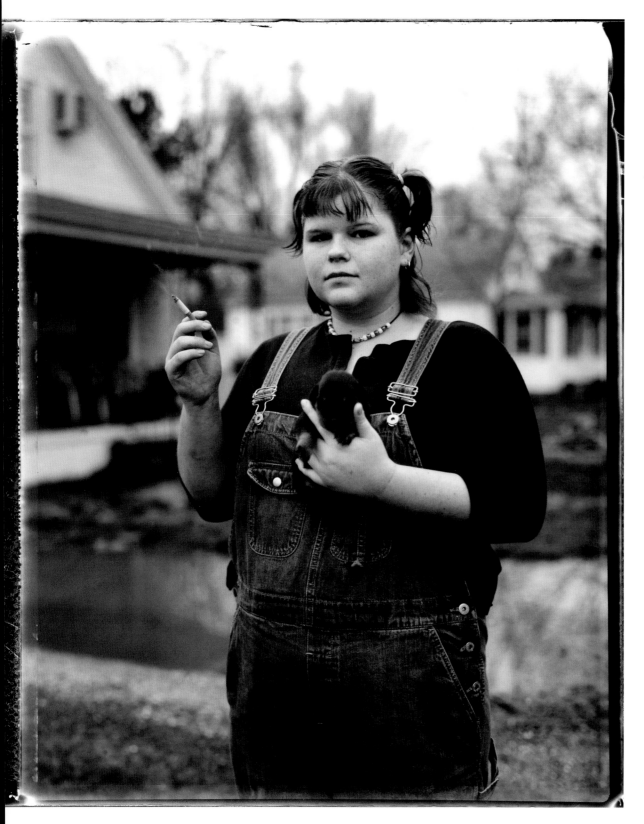

Peer pressure is the hardest thing about being a teenager, Some people might say that I'm the peer pressure one. When I was younger I was like, "Come on let's do this, let's go do this." Now that I've gotten older everybody's into more drugs and everything. And they're like, "Come on," and I'm like, why did I do that when I was younger, make people do something they didn't want to do?

Like with Ecstasy, I didn't want to do it at first 'cause I heard it could kill you and everything, but my friend she did 'em and she was like, "Come on, ya got to do 'em." So I did. I've snorted heroin (that made me feel really bad), snorted Ritalin, done coke for like three months nonstop. And then I realized I needed to stop—I made myself stop. There's one drug I will do again and that's acid. I love that drug.

I'd say my fantasy future life is like everybody else's. Have a big house, lots of cars, be able to just stop everything I'm doing and take a cruise for like a whole year, around the world or something.

In reality, in the future I'll probably have a steady job, probably have my own apartment but things will probably be very, very ghetto. Like, how we describe ghetto here is Oodles of Noodles. You have Oodles of Noodles and Kool Aid. That's it, that's about all. This is just how it sets in around here. If you stay here, you know for a fact, coming from where I grew up you will have a ghetto apartment.

The biggest thing that changed my life was when I dropped out of school in tenth grade…. If I was in school it would be so much easier to get into college and get the grants and the scholarships, so much easier than now.

Izi Schunick, age 18
CAMBRIDGE, MARYLAND

There ain't no perfect family. Just like there ain't no perfect relationship; you always gotta argue once in a while. Nothing can be perfect.

I was living with my mom but we kinda got in an argument and I just moved out…she kicked me out. I didn't talk to her for about a month. I guess I kinda made her feel bad. But now I talk to her and she invites me over for dinner. We just have a better relationship if I don't live there.

I've grown up with my mom drinkin' and stuff and she yells at me all the time. That's why I did drink for a while but I quit 'cause I didn't wanna turn out to be a drunk like my family. I just wish I could maybe help out people and tell 'em, "Hey, yeah it might be nice to try but don't stick to it."

When I was drinkin' I didn't think it was right if I drank and go to Church. I was drinkin' liquor. Seagram's gin. Almost every day…maybe three or four of them. I never got drunk…'cause I always made sure I knew what I was doin'. I stopped because I just realized there was no point in doin' it…too many people were dyin' of drinking and drivin' and stuff. I never drank and drove. I either sobered up, then drove or just stayed the night wherever I was.

I believe in God 'cause I mean there's a lot…angels come from God and I've had angels overtop of me so….

I got my first job when I was fifteen. I was a manager at McDonald's. I worked there for a while and then I worked at Pizza Hut and I've worked at Black & Decker. I've always wanted to work. I love workin'.

Carla Pritchett, age 19
CAMBRIDGE, MARYLAND

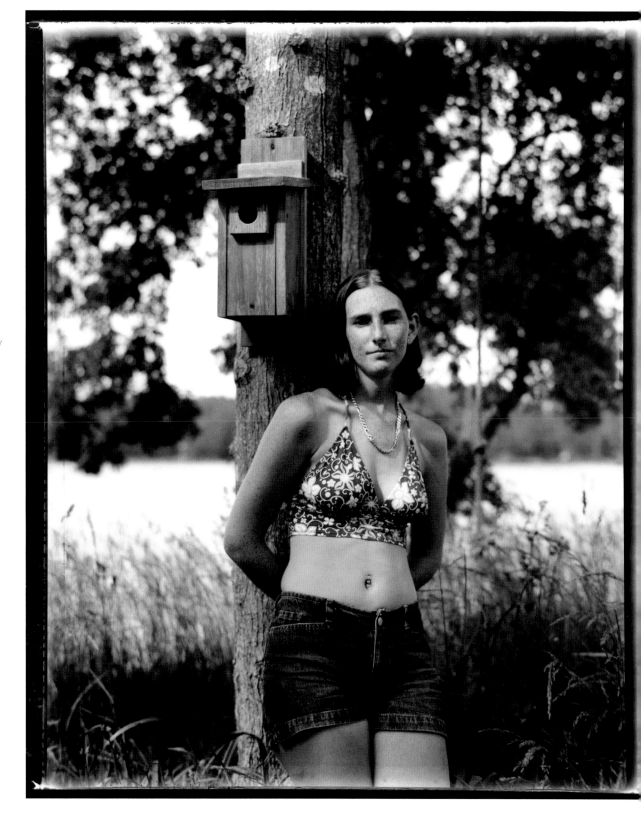

The most biggest thing that has ever happened to me is, really, going to school for hair. It has changed my life you know. I help other people by redoing their hair. It helps their self-esteem. It boosts them up. I just like doing hair just 'cause you know, we make people feel good. It's not really about the money.

My earliest memory is fighting with my twin sister. We were real young. We got a whooping everyday. So that's the main thing I remember, getting a whooping.

I cried when I found out my sister was pregnant, I was so disappointed. It hurt me, 'cause I told her I thought me and her were just going to go on, a couple more years. It would have just been me and her. I just wish she would have waited. It's good now that the baby's here. You know, you think about that once she was pregnant. But once she had it, you be happy and she fit in just fine.

Most people who don't go to school, seems like they don't do nothing. If you get used to staying at home everyday, then that's what you are going to do…. I'd rather go to school and do something and make something of myself then staying at home.

I can have an impact on the world, just like I said just by me doing hair. Helping people out. Boosting their self-esteem everyday. I'm satisfied with that.

Sharonda Rankin, age 19
PATTISON, MISSISSIPPI

The biggest thing that has happened to me was the day I gave birth to my child…and how its changed my life. Cause growing up now is a big responsibility…. Sometimes I thank God for what he has done for me, even though it's a big change, but I make it through.

I was depressed when I found out I was pregnant. I wanted to have a child, but I didn't want to have it, you know, at the age of seventeen. But things happen, and I had to take on the responsibility for having a child, of raising a child…. The father was there in the beginning, but things happened. He take care of her but, you know, we not close.

My parents were divorced when I was young. I don't see my father very often. I miss having a father around a lot. You have a child, you know, you should at least be spending some time with us, but he doesn't do that.

The toughest thing about being a teenager is taken on responsibilities like going shopping. It was easier when I was younger, 'cause I was spending my mama's money, but now it's my own…. I'd rather spend my mama's….

Well, for my future I see me having at least one more child. Not now…I plan to get married when I'm about thirty and start a family. But I'm being in school right now. My major is nursing. I plan to have a good education, job and to be able to take care of me and my family.

My earliest memory that I can think of was when I was about ten years old, and I stole a peach from my neighbor. My Aunt whoop us for it.

My twin sister and me are really close, if I go somewhere and ask her to go, she'd rather go, and if one of us don't go, we both don't go. It's fun being a twin.

Being with my family and spending time with my daughter makes me the happiest.

Louvonda Rankin, age 19
PATTISON, MISSISSIPPI

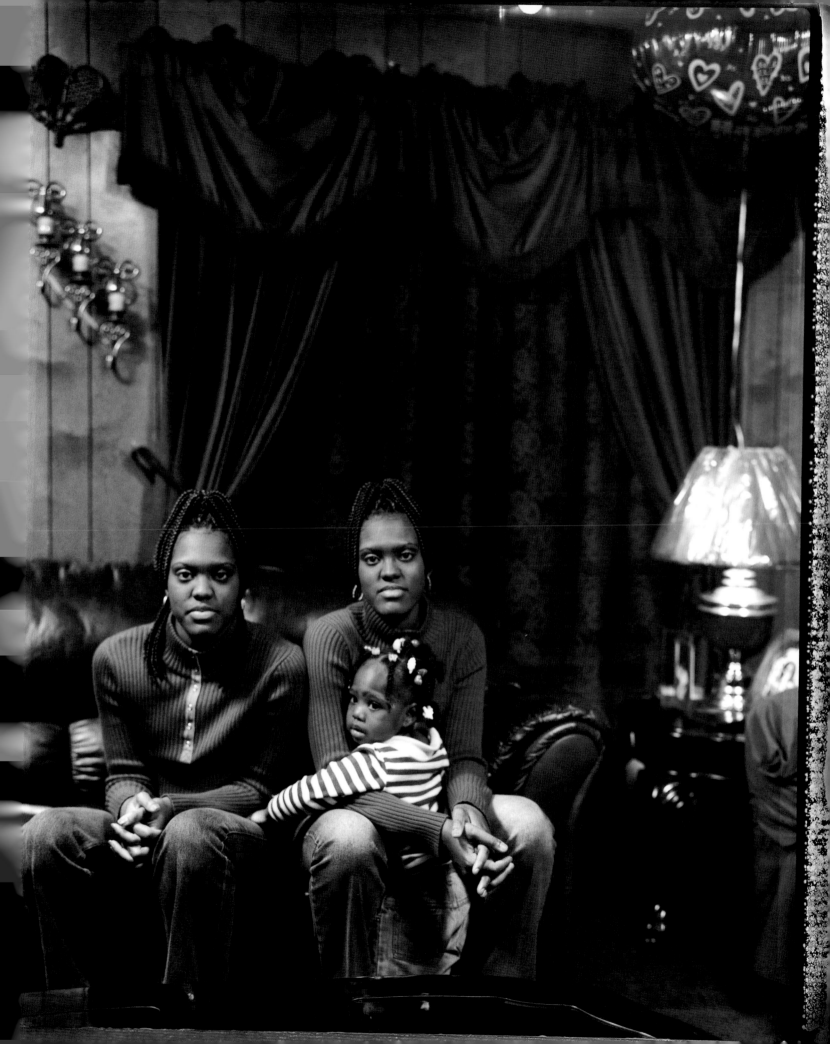

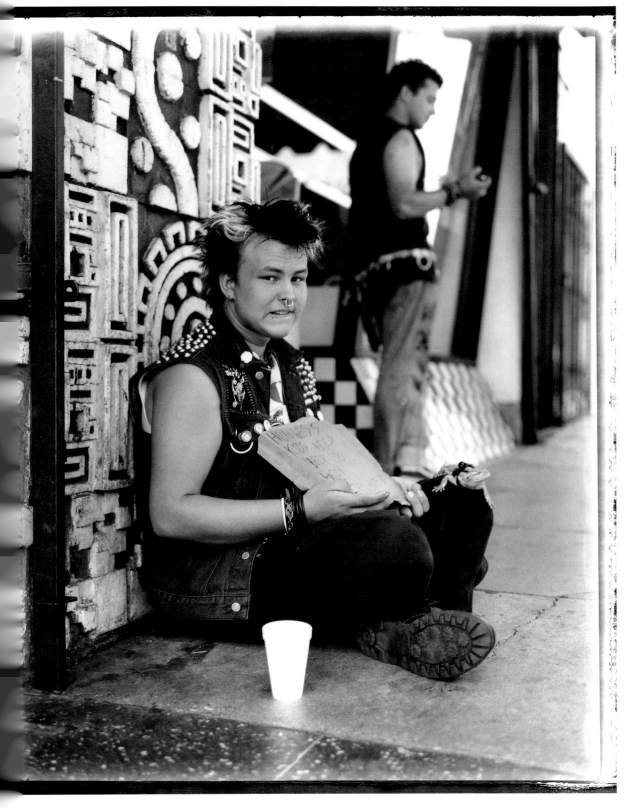

I've lived in Minneapolis, Seattle, all over southern California, Tijuana, New York, Philadelphia, and…that might be it. I hitchhike, train hop, or panhandle for a bus ticket.

My mom hates that I live on the streets, and my dad, he doesn't, like, love it, but he doesn't care 'cause he used to live on the streets and hitchhike and stuff when he was a teenager.

I have a pretty close relationship with my dad, I'd say. Yeah, I just talked to him yesterday, I think…. I talk to my family every…three weeks maybe? I try to every week, but I never remember.

I know my parents will always love me and my dad's a really good guy. I want to grow up to be like my dad. And they're always there for me—they're really cool, 'cause they can't afford to fly me everywhere and hook me up with money, but they're always there for me. I know it's tough and stuff. My family is really poor. Like, instead of candy on Christmas we'd get peanuts in our stockings.

I'm not allowed to stay with my family right now. 'Cause I was drinking…. They live in a commune with a bunch of people, and they don't allow drinking at the commune. It's a Christian community.

I used to be a Christian until about, probably about two weeks ago actually. I still believe in God, but I don't think I'm strong enough to be a Christian because it's really hard. 'Cause you're living for God, and you gotta try. Living for yourself, like I am right now, it's easy. You ain't gotta do nothing.

I sit on the street and panhandle all day, and I try to be nice to people. And people blow you off a lot and you gotta just remember that you're asking them for money, you're bothering them, you gotta just try to keep it cool….

Skunk Fuck 77
(aka Abram Kogh), age 19
CHICAGO, ILLINOIS

I don't like my school, because it's not safe. There is a lot of gang activity…. It doesn't scare me because it's not directed at me, it's just the atmosphere. I don't feel safe. I don't feel like I can function properly. We tried to change schools, but my grades are not that good because I am a truant. I'm trying to calm that down because I'm trying to get my grades up so I can go back to Catholic School. When I skip school, I just chill. Watch TV, smoke weed.

I'm in the gang, but I'm not in the gang. When you officially become part of Bloods, you get burns, from a cigarette or from a blunt. Girls get it on their right leg. I flash the colors. Red and Black. And if I see somebody with a blue or gray flag in their pocket—like around here, there's a lot of Crips, the Bloods and Crips are rivals—I have to stick up to them and question them. But I don't step—I don't go to people looking for trouble. 'Cause when you look for trouble that's when you get fucked up.

I would kill my sister if she was in a gang. It's not that I don't believe in being in a gang, it's just that I don't want her following what I do. I'm calming the gang thing down. It makes no sense. It really makes no sense at all.

Racism just makes no sense. Why you want to be racist against somebody? A white guy and a black guy—they could be the same exact person, they could have the same job and all that—but the white guy don't like the black guy just because he's black. If the white guy stepped out of his shell and got to know him, then they could be good friends. If you just open up your eyes and look. If you look past color.

Ebony Wilson, age 15
BRONX, NEW YORK

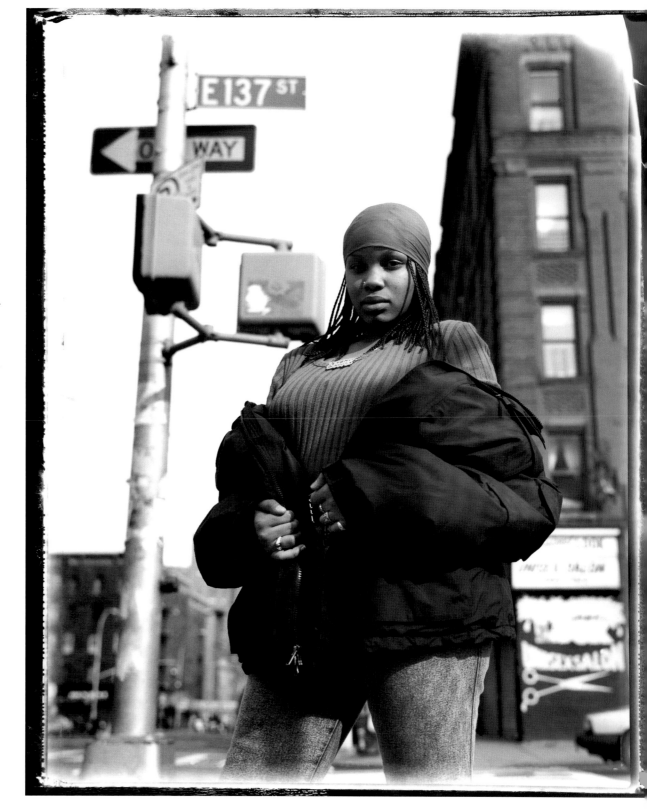

I was actually born in Columbia, in Bogota. I was adopted when I was four months old…. If I was in Columbia right now I would be dead, because I had a blood clot in my brain (that's why I have this scar and everything), and if I had been in Columbia I would have died because I would've been on the streets.

I like that I think about things from all different angles. I won't just jump to conclusions about things. I try not to, just because I've seen what that's done to people and I try to just look for the good and bad in everything. Because I think there's a lot of beauty in ugliness and ugliness in beauty.

My main focus in life is to have an impact on the world, you know? I wanna change things and I want to be heard…. I am an artist and I've sort of known since I was really young that I'm going to one day make clothes. I've always been interested in fashion and stuff. But I don't really like the word "fashion"—I think it's kind of cheesy. But I think I'm going to use that as a catalyst to bring other aspects of art and writing and photography and like everything into the broad landscape of things.

Right now, I work on the docks in Maine 'cause there's a big lobster industry up here and it's good money and it's hard work…. I shovel bait and move lobsters around….

9/11 was weird. It was sort of a process of feelings…at first I thought of it kind of as funny in a way. I was like, "Ha ha, look, we got blown up!" And then I wanted to be there and look at New York when there was just no one there. And then as I started to, like, hear and see more of what had actually happened it was horrifying and completely scary. I felt so horrible for all the people….

But after that first week I started to see, in a way, we deserved it, you know? I think that it's kind of funny that people are like, "I don't know where this came from" you know? 'Cause we've done so much horrible things to other countries and we're not really sincere about our…interactions with other countries. It's more for money and stuff. And then the whole over-patriotism of everything just sort of completely brought me down and gave me like no respect for the way that America dealt with it…. There's propaganda everywhere, and in a way I think that it would have been better if the media hadn't covered it as much. In a way that's what Osama bin Laden wanted, you know? To be a superstar and to be infamous completely…. It sort of just made me want to move out of the country.

Gage Boone, age 17
Springfield, Massachusetts

I believe in God to a certain extent…. I believe in evolution, but I believe that something had to start it. People believe that evolution began with the explosion of dust. But where'd the dust come from, I guess?

I respect my brother…. He's a really cool kid and gets along with everybody…doesn't have problems. If you don't have family than you don't really have anything. I mean, you could have money and power or whatever, but if you have no family and no one to be around, then you're just going to be lonely. It's not really worth it.

I would be a professional snowboarder if I could, but I doubt that's going to happen. In reality I have no idea. I don't know what I'm gonna be. I haven't really thought about it. Just trying to live in the moment.

Wilson Boone, age 15
Springfield, Massachusetts

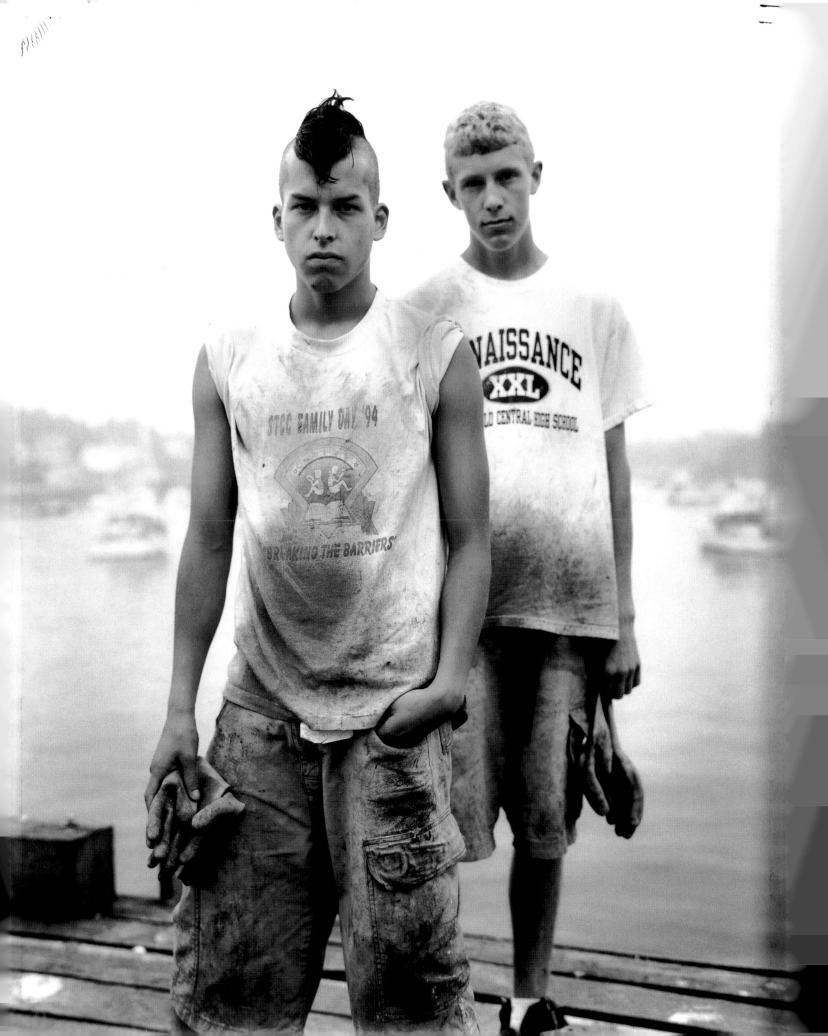

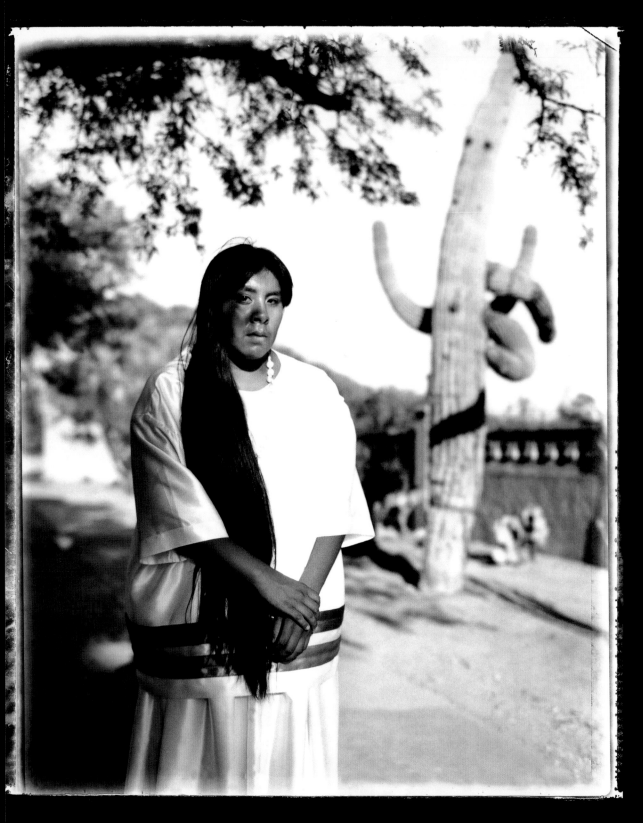

I always dreamed of becoming a professional basketball player. One of the biggest things that's ever happened to me was when I finally made my dreams come true, meeting my role model, Michael Jordan. I met him at his basketball camp. It was really shocking to see a professional basketball player I've always liked my whole life. It changed me—it just made me feel like I accomplished one of my goals. It gave me the security to continue playing basketball more.

I have a mother and a father but I really don't like my father. I live with my Grandma. Well, actually, it's my grandpa, who's my mom's father, and it's his sister. She's like a grandmother to me; she's the one who taught me how to play basketball. I have just one brother. We go to see my Dad once in a while. He promises us stuff, like that he's gonna come down and see us, but then he doesn't.

I don't think I want a boyfriend 'cause I want to focus more on my academics and sports, and not let anything get in my way.

Playing basketball and dancing makes me the happiest. I just feel happy, that's just it, happy.

Wynona Peters, age 13
Tucson, Arizona

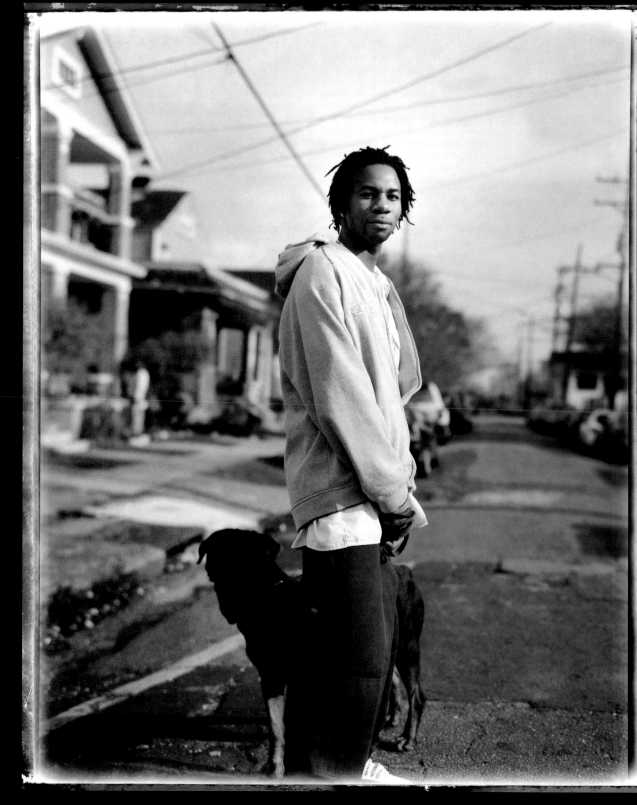

Last year I had to take this new state test, which is required for seniors to graduate. I'm nineteen and I would have graduated last year if I would have passed it, but I failed by ten points. I'm not givin' up, it's just making me just wanna strive harder. I just want to take it serious because I'm just so worried that it can be taken from me.

My dream is to become a famous, professional singer. I like to sing and I write music and I feel like that's one of my gifts from God. Reality, I think I'm gonna go to law school and probably end up bein' a secret agent.

I've been a busboy at the same restaurant for three years. I work nights. I go to work at five o'clock and I get off at 10:30. I use the money to help my mom out, and I spend a lot of money on clothes, of course, the Jordan tennis shoes and stuff like that, you know. I'm real materialistic. I gotta admit it. I like nice things and all that stuff. That's why I want to be the best at whatever I can be.

One of the most big problems in the world is violence. For instance, in our city we have the number one murder rate nationally. Guns is on the street everywhere. One of the famous rappers that was from New Orleans, he was gunned down the day before Thanksgiving Day. It's like the gangsta rap was just like feedin' into the community and there's not enough teachin' goin' on in the rapping. The music is kinda starvin' our minds and makin' our youths react in different ways, like grab guns.

I think family is the most important, because if you can learn to have unity in your house and within your family, then you can learn to have unity in the community and in your world.

James Everett, age 19
NEW ORLEANS, LOUISIANA

I like the fact that I'm always taking in information and trying to process it or use it to change me…I've been a police academy cadet for six months now, and that's definitely changed me.

I was adopted by my mother in Antigua when I was eight months old…just my mom, no father. My mom and I are extremely, extremely close. She said that's because when she was raising me, she tried—and still does—to treat me more like an equal…. She tries to ask my opinion and tries to guide me as opposed to telling me what to do.

I view family in a broad sense, and I don't know if it's because I'm adopted, but there's blood family but there's also the family that you choose—people that you have an intense relationship with….

I do want a family one day, two or three children…. I'm gay, so, a partner. The person I'm with now, we joke back and forth about this…adoption is one option, and trying to have it biologically is another option. But then there comes the issue of surrogate parents and what you want to do…do you want to ask, you know, your best friend, "Will you have my kid?"…it's kind of a strange request! …I want at least one boy; the reason I want one boy is 'cause I can't do little girls' hair. The perfect family, I think, has more to do with communication than the gender of the parents or the children.

The attitude that I've taken about telling people I'm gay is essentially, if I feel comfortable enough with a person, I don't mind sharing…. It's been a very long time since I've lied and told people that I'm straight….

I interned for two years with the Anti-Defamation League…so I have very strong feelings towards discrimination. I don't feel it's right. While I admit that I'm not perfect…every opportunity that you have to try and change something or redirect something in terms of discrimination—I'm there. Because—there's no proper way of saying it—it sucks.

I'm in college and I plan on taking my education all the way. A master's degree or doctorate. Right now I'm studying forensic psychology, but I also have an interest in law so I'm gonna get an undergraduate in forensic psychology and then try to move in to law school.

As an AIDS educator I know the notion that teenagers shouldn't be having sex is dismissable because what people should do and what people do do are two different things. My personal opinion is…if it's a great feeling to be close to the person that's one thing, but if it's to have an orgasm and move on, that's another. And you need to be really clear about that, first with yourself then hopefully with the other person.

I have a strong belief in God. I once read a story about a person interpreting God in the same way that blind men interpret an elephant, and they've never seen an elephant. If blind men all walked up to different parts of an elephant and began feeling around they'd feel different things; it'd still be the same elephant. So I would never say that one particular group or religion is right and others are wrong; I'd say that we're all trying to get to the same place and just using different roads.

The best thing about being a teenager is surprising people when they have expectations of you and you exceed them—you go past what people think you're capable of.

I'm definitely planning on having an impact on the world.

Ajani Benjamin, age 19
JAMAICA, QUEENS, NEW YORK

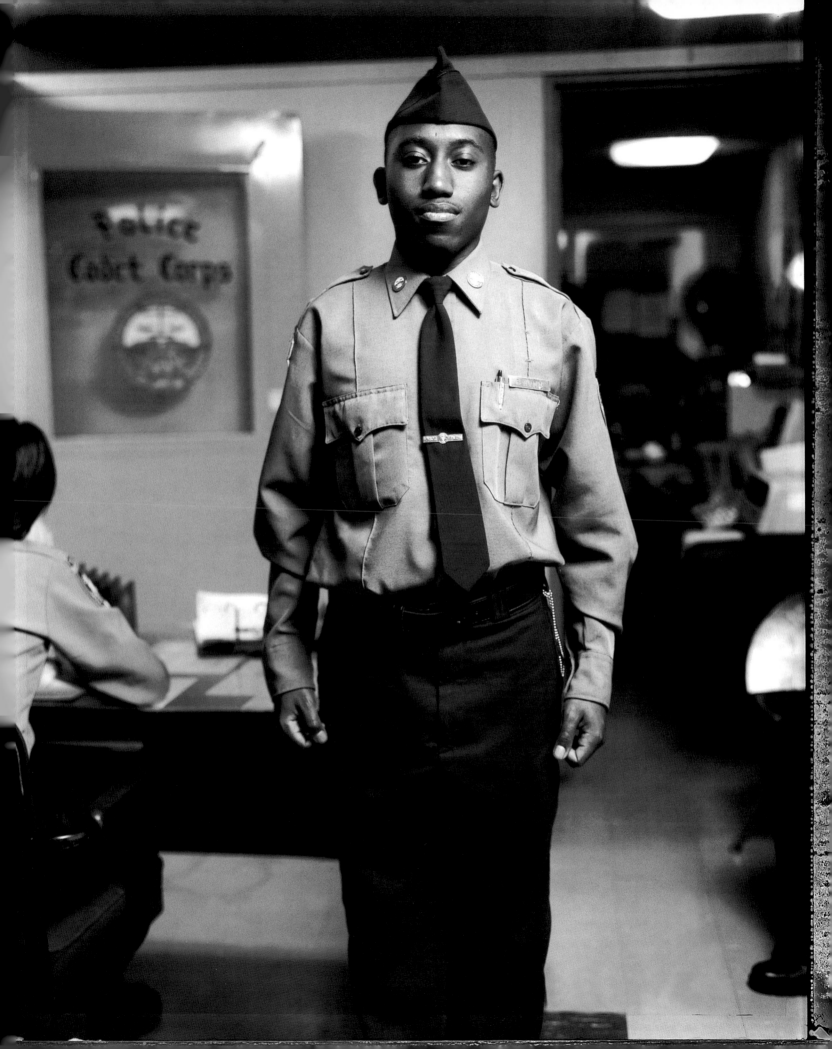

I go to the School for the Deaf and Blind in Tucson.... I came down from the Navajo reservation to learn about different cultures.... On the reservation, everybody's so prejudiced against white kids or other kids who don't look Navajo. They judge you by the color of your skin, so that's why I came down here, because I didn't like that. Because my skin's lighter than theirs.... I was born with Albinism, a gene from my parents that was passed down to me.

I don't get along so well with my parents. Because my world and my parent's world—it's like me against them. I have my own little world; they have their own little world. My parents are strict. And I look at things from a different point of view than they do, so.... There's always something wrong in a family. People will hide that they have—like, I hide a lot of things that I won't tell people, the things that go wrong in my family. There's people that fight, people that drink, people that take drugs. There's no such thing as a perfect family.

My eye moves on its own—I mean, I don't make it move. I wish I could make it move by myself. It moves around, then people think I'm moving my eyes and they think that I can't see them. But I can see them really clear.... It's like I can't see really far distance like the other people can. I have to look at things a little bit closer than most people do.... People always wonder if I'm colorblind. I say, "If I were colorblind I wouldn't be wearing matching clothes to school!"

At our school there's never been a girl that played football.... I'm visually impaired and all the boys are deaf and we have to sign together and it's hard, but I've had to communicate and have patience with the deaf kids and they've had to have patience with me. So, they encourage me. I encourage them back and we work as a football team. Like, they say that we're all brothers, even though I'm a girl.... When they see my hair long, and then the football helmet over it, they give me more of a challenge, like they know they can easily tackle me 'cause I'm a girl. I play with the boys...don't mess with me!

I believe in God, Jesus. Then in my own culture, which I believe in, too, I believe in spirits and Mother Earth.... One I pray in Navajo and one I pray in English. In Navajo I'm speaking more to Mother Earth, the moon, the sun, the sky.... I pray for basically the same thing, but sometimes I think one does more than the other. I realize that I get more response on the Navajo side than on the other.

There's so many problems in the world.... It would be better if people would just get along or something. Like if Bin Laden and George Bush would get along or something like that. People in all different countries should all get along. They still live in one world.

At school here sometimes I speak my own language, Navajo. Sometimes the school doesn't like it. This year...if they tell me not to speak my language, I'm just going to tell them to talk to my lawyer. This is a free country and you can speak your own language if you want to!

Charolette Rae Sage, age 15

PINON, ARIZONA

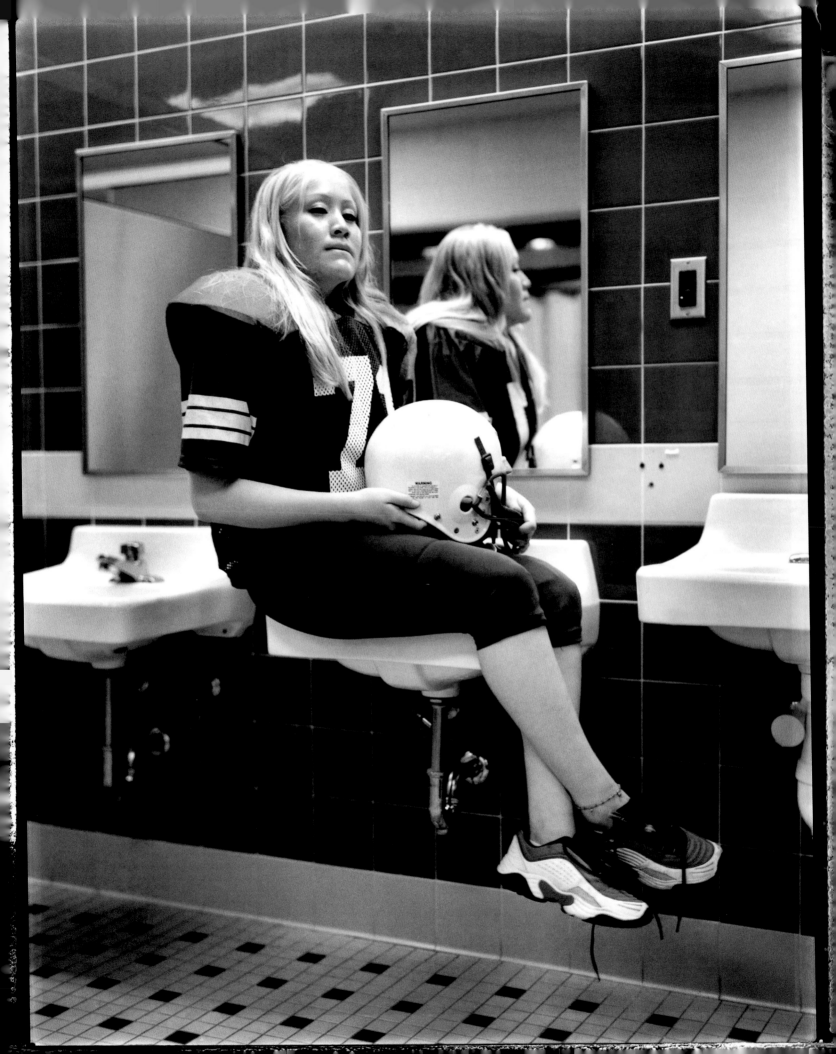

I guess I always knew I would be a debutante.... I guess because my mom did it and it's just kind of a thing you do when you turn this age. It used to be to introduce you to society. "She's okay to marry now," or things like that. But nowadays it's just more for the fun of it.... It was just a big party, I guess.

Getting into college was one of the biggest things to ever happen to me. Getting into A&M, which was my first choice. 'Cause after my first year there—it's just life changing. My whole family has gone there so it was kind of expected of me, but I also wanted to go there too.... They would have been happy as long as I didn't go to UT, which is our rival! I feel like I've become more independent and everything, because I was always sheltered in an environment like West Lake where every person has a bubble.

I grew up in the church...faith is a very strong part of me. I mean, you can just say that you believe in God, but so does the devil. So, a lot of people seem to turn to Him when things go wrong, or they turn away from Him when things go wrong. But if you really want to talk to Him daily and have a really close relationship, almost like a friend rather than being so revered, then He's there every day and can help you through anything, happy or sad.

My faith teaches me that you should wait 'til after you're married to have sex. I believe that if you can discipline yourself to save yourself for, hopefully, the perfect person, or someone who loves you that much, then you can tell him that, "I had faith that one day I would love you this much that I saved myself for you." And I also feel like, especially looking back, you go through so many learning periods. I mean, I look back just a year and think, "Oh my gosh, I can't believe I did that. Why did I act like that?" You think you're a big-time sixteen-year-old because you can drive, but...I don't think teenagers are mature enough to make the decision to have sex on their own.

I'm not a career-centered type of person. I want to succeed, but I want to have a family.... I hope I'll get married young so that I can have a family and be a young mom and everything.... Sometime soon out of college maybe, or in my twenties.

My dream is that I've always wanted to be, since I was pretty young, a successful ballerina, but that's not going to happen. I want to be a wedding coordinator. With some kind of silliness, I've just thought, like, a lawyer or a doctor, but.... And if I work really hard, you know, and do the things I'm supposed to do, hopefully that'll be my career someday.

Amy Heldenfels, age 19
AUSTIN, TEXAS

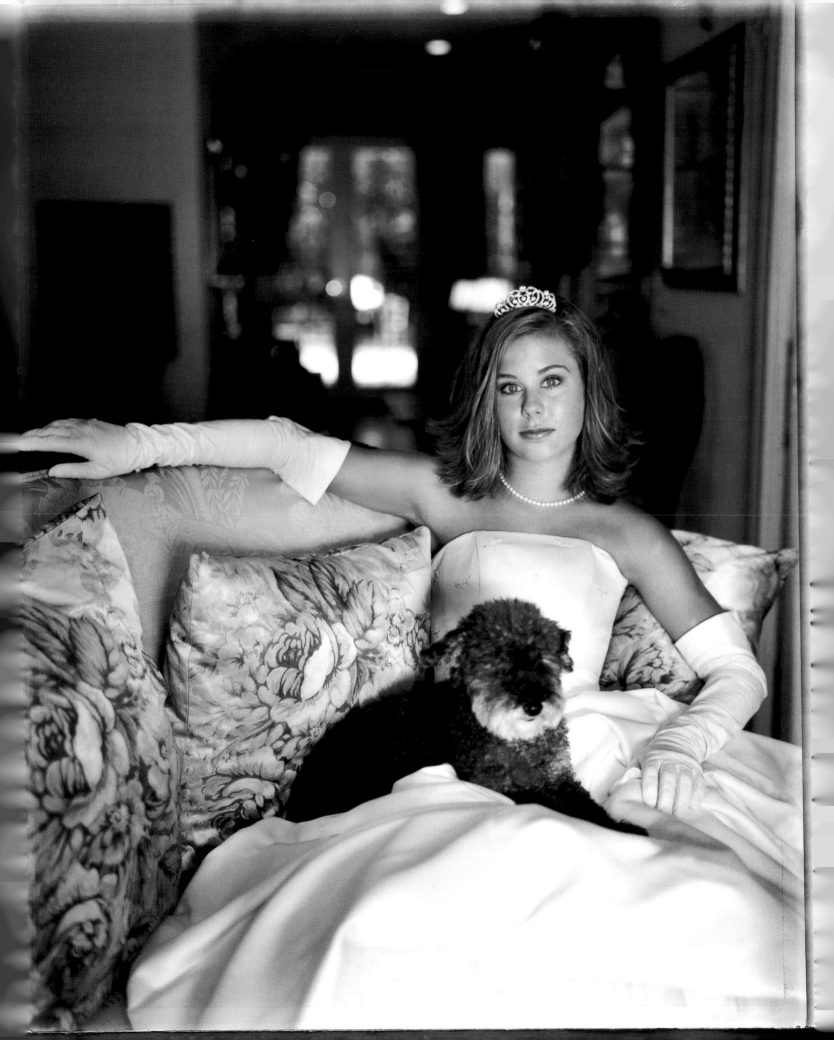

When I was twelve, I met a girl in my high school and she introduced me to crack cocaine. I got to doing $400 worth a day. This girl was dating, heavily dating, somebody who was supposedly involved with organized crime. And she was sleeping with him to get the money.

My parents knew I was doing the drugs, but I would lie to them and I would say I stopped. But you know, parents aren't stupid, so they tried to send me away to my home country, Northern Cyprus.... Eventually I got bored of everything, and one of my best friends who was there for me throughout this whole ordeal of me doing drugs, she accepted me, she actually offered to help me…and now, last Friday was one year that I was drug-free.

I think I was about seven when I realized I was gay. I knew I liked boys, and knew about homosexuality, but when I really realized that I was gay was I saw, in a magazine, homosexuality at seven. I was worried, I was afraid I'd go to hell. I did hide it for a while. I was fourteen when I came out. I really liked this boy, and I had told him, and I didn't want to hide it because I really liked him. I've had girls—not like girlfriends, but friends—who'd come to me and say, "Oh, I like this boy a lot, I like this one." And I just wanted to do that, you know?

I was thinking about getting married to a woman, and having a platonic relationship because I can't really get along with men. I've found women to be more understanding, more substantive, and much easier to get along with. Men to me, they seem to be all the same. All their interests are in sex, and they're philistines.

I'm growing closer to eighteen and I want to be in an apartment. With the money I have saved I want to eventually buy my own car. You know, I want to do things myself and say, "Hey, I did this, and I came from this, and look where I am now. I did it all by myself."

Michael Mutlu, age 17
BAYSIDE, QUEENS, NEW YORK

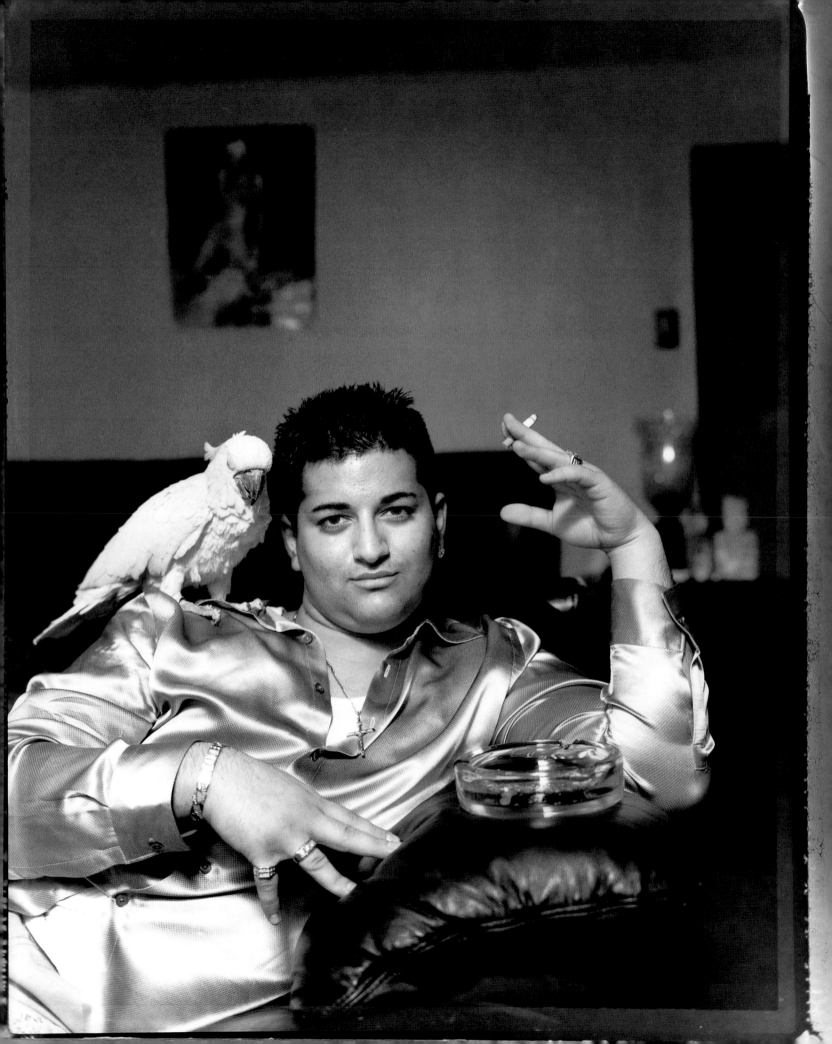

 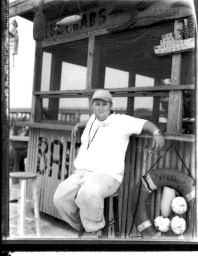 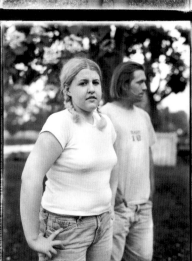 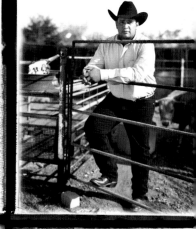

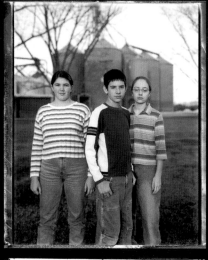 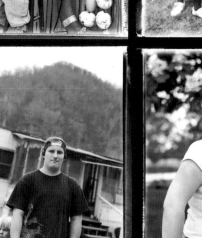 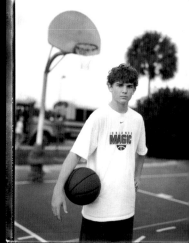

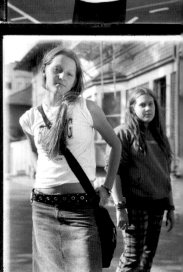

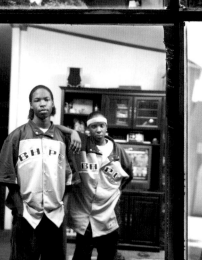 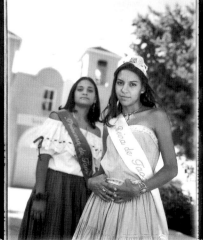 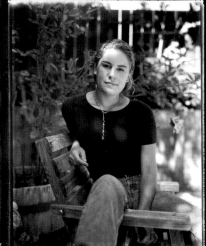 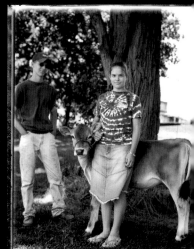

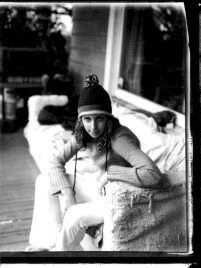 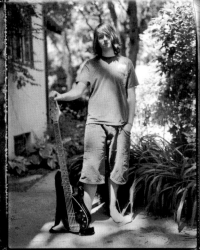 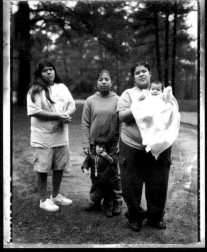 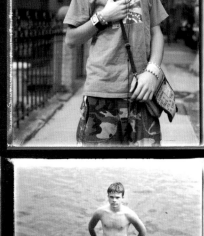

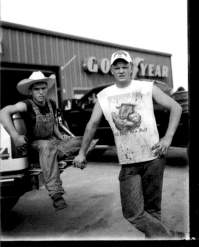 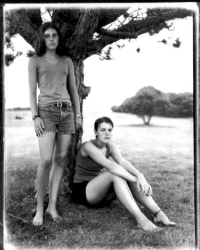 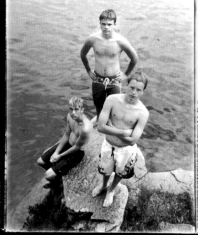

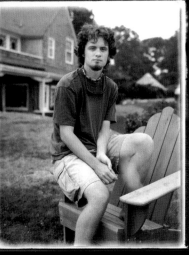 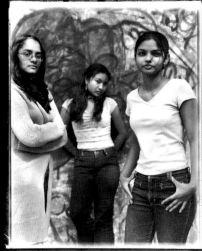 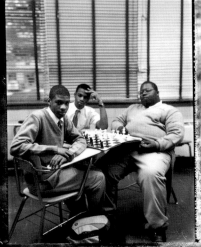 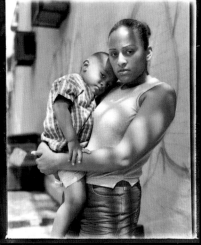

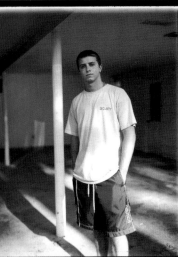 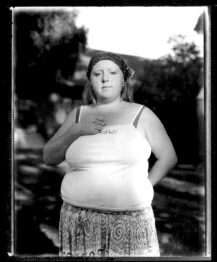 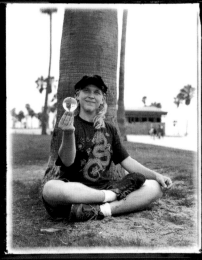 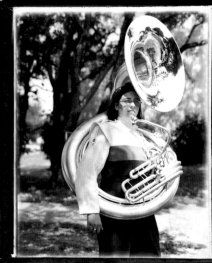

AFTERWORD

When the child psychoanalyst Erik H. Erikson came to America in the early 1930s, he was at pains to know about his newly adopted national home through the words offered him by the young people whom he got to know through his clinical work. I can still hear him marveling at the variousness of our country's youth, the depth and breadth of thought and feeling he had heard as the ever-ready new citizen of a vast land whose sovereignty stretched (in the song's phrase he loved to use) "from sea to shining sea." He himself would eventually pursue those words in the flesh, live all over America, from New England to California and back, ever eager to meet young people and learn from them. His first very important book, *Childhood and Society,* had its own way of conveying the diversity of backgrounds (social, cultural, racial) that go to make the United States so singular among countries. "We're from everywhere," a San Francisco child once told the distinguished Erikson. He would often call upon that ten-year-old when he was talking in Cambridge, Massachusetts about the young men and women he would come to know over the decades of the mid-twentieth century.

An artist before he became a psychoanalyst, and the father of an accomplished photographer (Jon Erikson's work has been published in a book that tells of a country's people, *The Middle Americans*), Erik H. Erikson was especially prone to responding visually to young people; he'd even sketch what he remembered seeing—for him the workings of the eyes and the ears strengthening one another: "When I remember the people of this country I've met, I remember how they looked, their gestures, their facial expressions, how they held themselves, and I remember their choice of words, the way they put things—often to help me 'get it straight,' as one boy remarked when he seemed to get me straight: 'Are you getting it straight, what I'm saying?' he inquired, and I replied with the only street language I could think of, 'Sure thing.'

That lad was right on target, his listener felt, even as the young people who we meet in these pages surely must have, in their own way, told themselves that Robin Bowman did indeed "get it"—got to the mind, heart, and soul of their lives. Hers was a pilgrimage of sorts across the American heart-land—a dedication by a documentary worker to the youth who are our people's future, even as in the here-and-now of this life our teenagers have their very own ideas about what will happen to them, no matter the convictions on that score held (and announced loud and clear, even at times hollered) by their parents or teachers. To turn these pages is to meet one's young fellow Americans—in the Biblical phrase, "all sorts and conditions" of them. They stand alone or together with others; sometimes they are ever so serious, even grim; at other times they manage a half-smile, or a friendly show of interest. Some are already independent—police officers, street kids, single parents. Others seem in no hurry to fly the safety of the nest—the contrast a reminder (a worrying one even) that we had best hold off on the sweeping psychological and sociological generalizations that we today find so tempting. Rather, this book's bravely energetic and inquiring observer asks us to travel with her across the borders of class and race and region, to shed our fixed notions, our ideas based on what is supposedly true of our country's youth in general. Instead, one hopes we gradually become students of this well-traveled listener and picture-taker who here presents us with evidence upon evidence, which is, in its sum, breathtakingly diverse, insistently affecting, compelling.

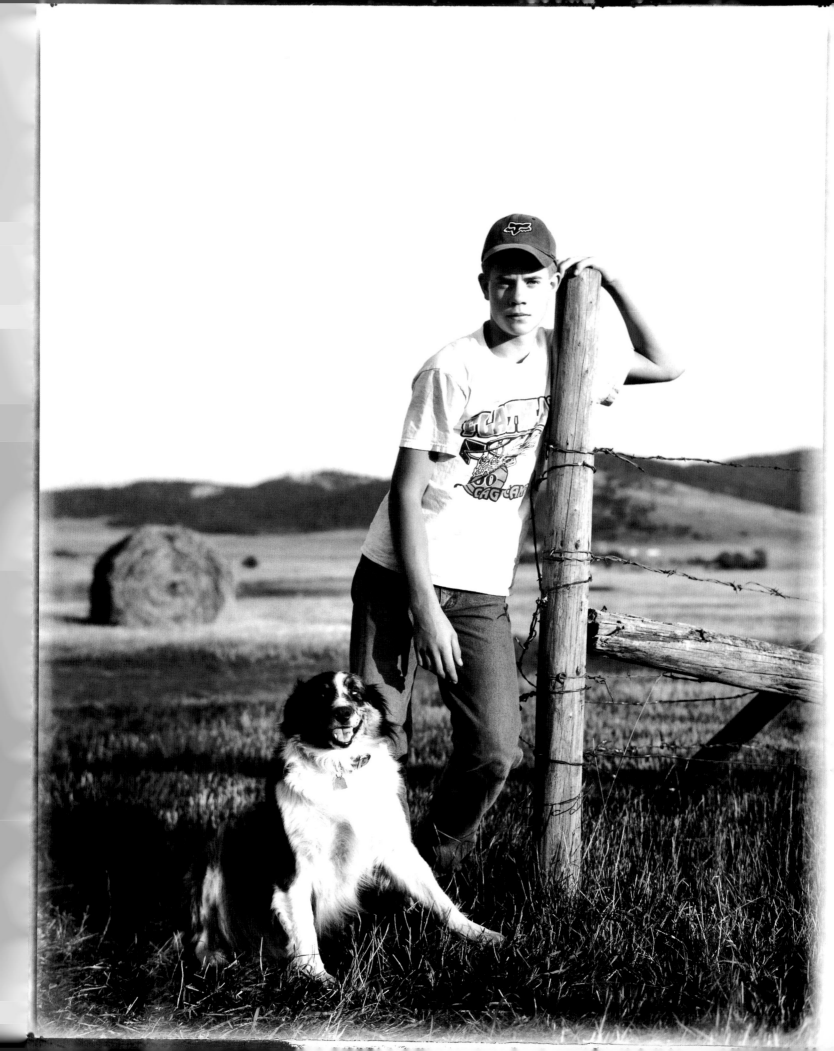

"You want to know what's happening to folks, you should go see them, and you should ask them to tell you a lot before you go telling them of yourself (who you are and what you've done!)." So said Dr. William Carlos Williams, who had a way with words, and was no stranger to drawing, sketching pictures of people he had met. His poems and short stories bring us close to the human truths of certain places and moments, as do the photographs in these pages, the transcribed oral histories, the remarks offered to a deeply interested and earnestly thoughtful "outsider," a listener who truly knows in her bones what the novelist E.M. Forster urged upon all of us: "Only connect." This book provides, in effect, evidence of just that: a witness to the possibilities of human connectedness as affirmed in hundreds of encounters, across so much space and time, which in their sum enable us to glimpse and attend American youths—see them alone and together, read their words conveying dreams and worries both, confident plans and decided apprehensions.

"In another life," Erik H. Erikson once told some of us who taught in his college course, "I'd take America's pulse by meeting its young people in their neighborhoods, not on a college campus"–and so Robin Bowman has done: ventured into streets, backyards, and fields, where a nation's young citizenry waits, wonders, watches wanly or warily: tells us lucky recipients of a field-worker's resourcefulness—how it goes for the young men and women who soon enough will be our country's grownups.

Robert Coles

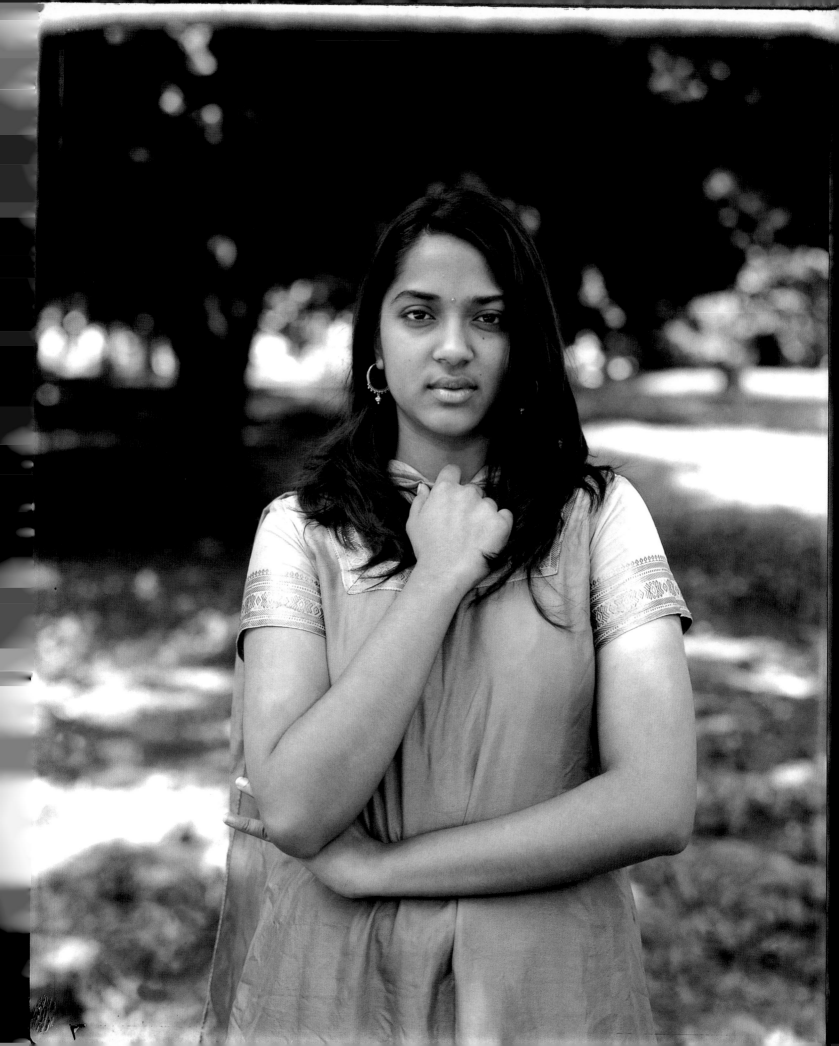

ACKNOWLEDGEMENTS

I send enormous thanks to the Universe for guiding me through this incredible journey. And what a remarkable journey it has been! This project about teenagers has been a gigantic collaboration. Without the many who helped inspire, cheer, guide, console and support me along the way this five year study could never have happened. There are many to thank, but let me first highlight my lucky stars.

Julia, Julia, Julia! I would never have gotten this far had I not found my little energetic angel agent Julia Lord who has pushed and pushed through many a door to make things happen. You are amazing and wonderful. Your selfless dedication to keeping this project alive, no matter what, is beyond comprehension. Everyone who knows you is blessed. I am blessed. Thank you from the bottom of my heart.

I am forever grateful for the constant love and multitudinous of support I receive every day from my dearest Cee Greene and her wonderful husband Paul Verbinnen. I am so lucky to have you both in my life. Thank you for helping me breathe when things were difficult along the way. And Cee, thank you for making me laugh every time! And Miss Julia Hollinger, my dear friend and valiant editor…you saved the day. As I lost sight you kept my vision on target and helped provide a visual shape without making comparisons, and in the final editing process helped chisel down the unthinkable. Thank you for being so patient with me and for parting the clouds. Roxanne Quimby. I am deeply appreciative for your generosity, and for trusting me. You are a true inspiration in your uncompromised way of life and I feel so blessed to have you as an example to follow. The world needs more of you. Thank you my dear friend Philip Jones Griffiths for all you have imparted over so many years. I wouldn't be who I am today as a photographer had I not had you as my brilliant teacher.

It took an enormous marching band to keep this dream afloat. I am so grateful to my friends who were there to help. Thank you my darling Moussie Chalfant and Nona Chalfant who provided me with the place and opportunity to start this journey. Thank you Alex Millet for preserving the sound and integrity of each teen's voice and making sense of so many words as we plowed through the edits. Thank you Michael Rainey for giving form to an idea that was only beginning to take shape and to Holly Weiner for leading me to you. Thank you Shonquis Moreno for being my unwavering cheerleader, helping me make sense of my own thoughts and for caring for my furry creatures whilst I was away hunting teens. Thank you Roz Schneider for navigating my way through the grant applications and for all your sage advice. Jay and Lynne Espy—thank you for taking care of me as I landed in Maine and for taking charge of making sure this book came to be. Thank you to Paul Stern whose enthusiasm is infectious and Hallie Overman and Micah Laaker. Thank you Alexander Kippen and MaryAnn Zoellner who helped brainstorm questions with which to query the teens. Thank you, thank you, thank you to all my interns, or not, who transcribed all the hundreds of interviews: Katarina Hartwick, Brittany Rostro, Nicky Roe, Patricia Stephenson, Jean Kuperschmidt, Melissa Martin, Alex Hennedy, Andrew Marsiglio, Lisa Dicce, Hannah Graber and Weslie Odoms. Wow, what a feat!!! Thank you Nikolai Yudanov for listening and caring and accepting. You are my sunshine.

This project kept growing and growing and needed constant care and watering. I am so grateful to so many of you who knew me and those of you who didn't yet trust me to open your doors offering a bed to sleep in, a scrumptious home-cooked meal, the family bathroom to use as my temporary darkroom, assistance in carrying equipment or lighting the shot, and connections into your worlds. And so many of you back home on the ground who offered your encouragement and advice. I feel so blessed. None of you is less important than the other in helping make this dream and endeavor possible: Amy Schwartz-Cooney, Acey Harper, Maud and Pierre Schori, Kate Boo, Lindsay French, Hilary French and Chris Foster, Tryshe Dehvney and Tim Flood, Carol Bean, Paul Browne, Chad Darbyshire, Jamison and Alison Stewart, Beth Long, Tina and Skip Rhein, Nancy LaNasa, Rand Hicks and the Integral Knowledge Study Center, Jennifer Williams, Sylvia and Wayne Odom, Cooper and Mary Mackin, Steve Bliss and Savannah College for Art and Design, the lovely Dawn Dupree, Mary Kohlmann, Michael and Karen Bowman, Michelle Oyler, Veena Ready, Vijay Vaitheeswaran, Meg and Randy Pascal, Sam and Diane Fry, Linda and Jeff Maas, Oliver Kippen, Shiloh Driscoll, Travis Rust, Deniz Perese and Larkin McPhee,

Peter and Jennifer Walsh, Yarrott Benz, Phyllis Trout, Tilly Woodward, Daphne Taylor, Maureen Mullen, Susan Sarli, Joan and David Corbin, Victoria and Steven Burns, Bryan Harding, Janie Cloin, Chris Carroll, Cara and King Milling, William Ferris, Lee Kalcheim, Amy Bordy and the School of American Ballet, Shari Brown and the Arizona School for the Deaf and the Blind, Carolyn Hawkins and the ANNC, Jim Flateau and the NYS Department of Correctional Services, Aarti Sawhney and the Harvey Milk High School, Lee Kitchens and the Little People of America, Juliette Lamontagne and Eric Gordon, Dave Yaseveli and the NYC Lab School, Donna Ridgeway, Rosetta Hostetler, Aimee Nowland, Linda Bartlett, Stephen & Kyra Kuhn, Bill and Caroline Black, Christopher Sweet, Nate Thayer, Soloman Bramble, Brent Haywood, Anthony Hudgins, Glen Barnes, Almador, Shawn Thompson, Linda Sherwood, Teresa Mason, and Jodi Bisson, Sharon Gannon and David Life.

I am so fortunate to have received a number of grants and fellowships without which I would never have gotten as far as I have. I am honored to have received a W. Eugene Smith Fellowship, which really helped put this project on the map. Thank you Helen Markus. Thank you Elisabeth Biondi at *The New Yorker* for your belief in this project and your continued support. Thank you Bill Hunt for your time, advice and charismatic spirit. Thank you Barbara Hitchcock and the Polaroid Collections for the continued support from your wonderful Artist Studio Support Program. Honestly, this program made it possible for me to keep shooting. I have to say though I am profoundly upset you have discontinued making my Positive/Negative film. I am hugely grateful to Robert Scott for offering assistance and the first opportunity to show the work at Adelphi University and to Carole Artigiani for your fervent support.

The complexity of this enormous project required advice and help from many experts. I am truly grateful for the time and advice offered by Elena Paul and Jeffrey Klein and the Volunteer Lawyers for the Arts, David Korzenik at Miller Korzenik Sommers LLP, Heidi Reavis and Deena Merlen at Reavis Parent Lehrer LLP, Alexander Kim and Tucker McCrady at Shearman & Sterling LLP NY, and Christopher Lewis.

This book specifically would not be possible if it weren't for the loving and generous help of Phoebe Bowman and John Healy, Christopher and Karen Bowman, Barbara and Charles Bickford, Annee Kim and John Alsop, Christy and David Millet, Charlie and Leisa Crane, Snow and Henry Morgan, Sissy and Sandy Buck, Francis Carey, Susan and Bob Schulz, Gro Flatbo and Kent Wommack, Leslie and Geoff Wagner, Scott and Joanie Samuelson, Tom and Willa Wright, Anne Coleman and Trish Friant, Lucie and Paul Dean, Marian Baker and Chris Wiggins, Anne Emmons, Susan and Brooks Stoddard, and Betsy Evans Hunt.

This project has been the central focus of my universe for the last six years. As I've criss-crossed the country collecting this enormous document I spent hours and hours and hours contemplating and worrying how I was going to get it out there into the world. It wasn't until Nan Richardson and Umbrage Editions came along that I felt like I had found it the right home. It was the perfect fit. I knew then that my vision would be respected and protected. Nan, thank you. I bless the gods for Unha Kim, the designer and beautiful spirit, who so courageously and smartly transformed a huge pile of photographs and words into a book. Your beautiful touch and whimsical sense of humor have allowed the work to shine. Thanks too to the very sharp Meg Gibson, Eli Spindel, and the rest of the Umbrage Editions staff and interns for their support. Thank you Robert Coles for your support over the years and for your thoughtful essay. Thank you Ruth Lauer Manenti for offering this puissant verse in class that day and lending your commentary.

And finally, and most importantly, I am eternally grateful to all of you teenagers who invited me into your private worlds and allowed me a moment's look and listen. I hope you are proud of what we have created here together, for without you this book would not exist. Our encounters were little miracles and I so wish for you all the best life has to offer. Keep twinkling!

INDEX

BIBLIOGRAPHY

BOOKS

Anderson, Laurie Halse. *Speak*. New York: Farrar Straus Giroux, 1999.

Arbus, Diane. *Diane Arbus: Revelations*. New York: Random House, 2003.

Avedon, Richard. *Evidence: 1944-1994*. Rochester: Random House, 1994.

Avedon, Richard. *In the American West*. New York: Abrams, 1985.

Avedon, Richard. *Richard Avedon Portraits*. New York: H.N. Abrams: Metropolitan Museum of Art, 2002.

Burroughs, Augusten. *Running with Scissors: A Memoir*. New York: St. Martin's Press, 2002.

Chbosky, Stephen. *The Perks of Being a Wallflower*. New York: Pocket, 1999.

Coles, Robert. *Children of Crisis; A Study of Courage and Fear*. Boston: Little, Brown, 1967.

Coles, Robert. *The Moral Life of Children*. New York: Atlantic Monthly Press, 1986.

Coles, Robert. *The Spiritual Life of Children*. Boston: Houghton Mifflin, 1990.

Coontz, Stephanie. *The Way We Never Were: American Families and the Nostalgia Trap*. New York: Basic Books, 1992.

Disfarmer, Michael. *Heber Springs Portraits, 1939-1946: From the collections of Peter Miller and Julia Scully*. Sante Fe: Twin Palms Publishers, 1996.

Elkind, David. *All Grown Up and No Place to Go: Teenagers in Crisis*. New York: Da Capo Press, 1998.

Frank, Robert and Jack Kerouac. *The Americans*. New York: Scalo, 1998.

Finnegan, William. *Cold New World: Growing Up in a Harder Country*. New York: Random House, 1998.

Hersch, Patricia. *A Tribe Apart: A Journey into the Heart of American Adolescence*. New York: Fawcett Columbine, 1998.

Kaeser, Gigi and Peggy Gillespie. *Love Makes a Family: Portraits of Lesbian, Gay, Bisexual, and Transgender Parents with their Families*. Amherst: University of Massachusetts Press, 1999.

Karr, Mary. *The Liars' Club: A Memoir*. New York: Penguin Books, 2005.

Kozol, Jonathan. *Savage Inequalities: Children in America's Schools*. New York: Crown, 1991.

Lange, Susanne and Gabriele Conrath-Scholl. *August Sander: People of the Twentieth Century*. New York: Abrams, 2002.

Lareau, Annette. *Unequal Childhoods: Class, Race, and Family Life*. Berkeley: University of California Press, 2003.

LeBlanc, Adrian Nicole. *Random Family: Love, Drugs, Trouble, and Coming of Age in The Bronx*. New York: Scribner, 2003.

MacLeod, Jay. *Ain't No Makin' It: Aspirations and Attainment in a Low-Income Neighborhood*. Boulder: Westview Press, 1995.

Mortimer, Jeylan T. and Reed W. Larson. *The Changing Adolescent Experience: Societal Trends and the Transition to Adulthood*. New York: Cambridge University Press, 2002.

Mortimer, Jeylan T. *Working and Growing Up in America*. Cambridge: Harvard University Press, 2003.

Salinger, J.D. *The Catcher in the Rye*. Boston: Little, Brown, 1951.

Tienda, Marta and William Julius Wilson. *Youth in Cities: A Cross-National Perspective*. New York: Cambridge University Press, 2002.

FILMS

Seven Up! Dir. Michael Apted. London, Granada Television, 1963.

7 Plus Seven. Dir. Michael Apted. London, Granada Televison, 1970.

21 Up. Dir. Michael Apted. London, Granada Television, 1977.

28 Up. Dir. Michael Apted. London, Granada Television, 1985.

35 Up. Dir. Michael Apted. London, Granada Television, 1991.

42 Up. Dir. Michael Apted. London, Granada Television, 1999.

Elephant. Writ. and dir. Gus Van Sant. Blue Relief Productions, 2003.

Kids. Dir. and writ. Larry Clark. Writ. Harmony Korine and Jim Lewis. Excalibur Films, 1995.

Thirteen. Dir. and writ. Catherine Hardwicke. Writ. Nikki Reed. 20th Century Fox, 2003.

WEBSITES

To continue this experience, visit **www.theamericanteenager.com**

To see more of Robin Bowman's photography, visit **www.robinbowman.com**

It's Complicated: The American Teenager
An Umbrage Editions Book

First Edition

ISBN 978-1-884167-69-0

An Umbrage Editions book
Publisher: Nan Richardson
Design and Production Director: Unha Kim
Editorial Assistant: Eli Spindel
Exhibitions Coordinator: Meg Gibson
Marketing Director: Temple Richardson
Copy Editor: Katherine Parr

Umbrage Editions, Inc.
515 Canal Street #4
New York, New York 10013
www.umbragebooks.com

A national traveling exhibition accompanies the publication.

Distributed by Consortium in the U.S.
www.consortium.com

Distributed by Turnaround in the U.K.
www.turnaround.com

Printed in China

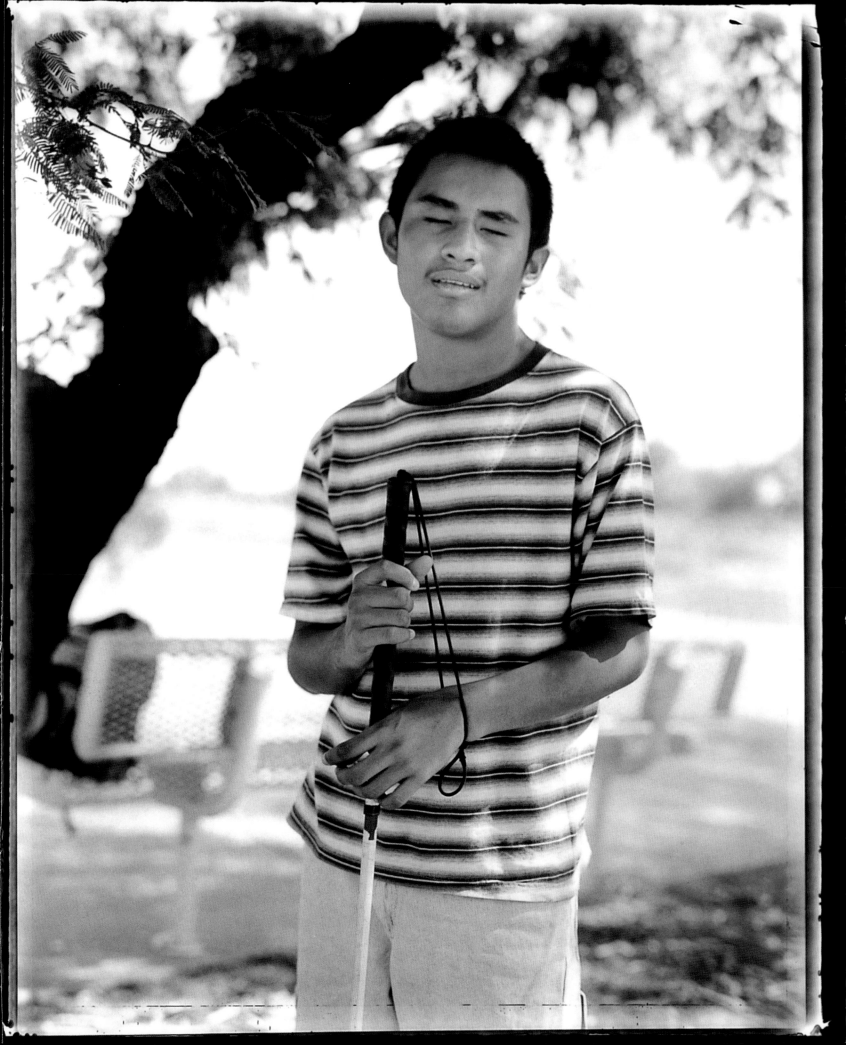